Craft Galleries Guide

A selection of applied arts from
British galleries

TENTH EDITION
2010

Compiled and edited by
Caroline Mornement

LEARNING
RESOURCES
CENTRE

BCF Books

Published by BCF Books,
Burton Cottage Farm, East Coker, Yeovil, Somerset BA22 9LS
E: cm@craftgalleries.co.uk **www.bcfbooks.co.uk**
T: 01935 862731

Printed in China through World Print Ltd.

Distributed throughout the world
(excluding North America) by
I.B. Tauris & Co Ltd
6 Salem Road, London W2 4BU
175 Fifth Avenue, New York NY 10010
www.ibtauris.com

Distributed in the United States and Canada
Exclusively by Palgrave Macmillan
175 Fifth Avenue, New York NY 10010

ISBN: 978 0 95500267 0

Craft Galleries Guide

A selection of applied arts from
British galleries

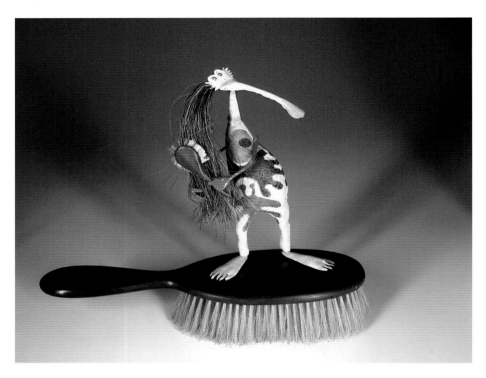

Lucy Casson pages 193 & 6

Contents

P Parking on site or nearby

C Commissions undertaken

Café/refreshments

Disabled access

0% Interest free credit scheme

* a gallery or maker who appeared in the first edition

N.B. Wherever possible galleries are placed alphabetically, within their region, but to avoid too many 'blanks,' single & half gallery pages are not always in order

The Crafts Council is the
national development agency
for contemporary craft.

www.craftscouncil.org.uk

Registered Charity Number 280956.

The Crafts Council: visit us online

The Crafts Council is the national development agency
for contemporary craft. Our goal is to make the UK the
best place to make, see and collect contemporary craft.

Visit our website to find out more about our events,
programmes and exhibitions taking place across the
UK. Content on our website is regularly updated to
keep you informed of news and events in the craft
sector and you can sign up to our e-bulletin for news
direct to your inbox.

www.craftscouncil.org.uk

oreword by
ohn Makepeace

p@johnmakepeacefurniture.com
vw.johnmakepeacefurniture.com

reach

Craft galleries fulfil a vital function in providing an outlet for artists and makers, who by temperament or circumstance, prefer to concentrate on creating new work rather than entertaining visitors at their studios. Galleries present the proprietor's personal selection from a growing number of craftspeople, so that each becomes distinctive, recognisable for a particular approach and the artists they represent. Their diversity ranges from those with an emphasis on the local to the plainly commercial or the highly specialised, attracting collectors from far and wide. They can become an integral part of the local culture like museums, cathedrals, theatres and remarkable landscapes.

Whereas the word 'craft' has traditionally been used to suggest skilled hand-work, it can increasingly include machine and computer-based processes in any number of materials. The objects may be one-off, one of an edition or unlimited in number. Craft has come to imply individual creativity, although the making is not necessarily carried out by the artist in person. Developments in digital technology are now rendering it possible to produce singular forms individually that would not previously have been economical.

Galleries are often operating from small premises so unable to exhibit larger objects. Their focus tends to be on jewellery and precious metals, ceramics, glass, resin, fibre, leather, small wood items, paintings, prints and photography. Larger items like furniture are normally commissioned directly from the maker whose studios can be visited by appointment or during Open Studio events. The public enjoys the insight this gives them to the artist's approach, but there are few substitutes for well-researched and presented exhibitions in craft galleries.

Despite the financial constraints on colleges preparing students for careers in the applied arts, where they need more diverse facilities and teaching than those studying theoretical subjects, the crafts continue to attract large numbers of imaginative young people. Whilst they may be launching themselves with less practical training, they can more than compensate with the vitality of their ideas. Galleries have a vital role in guiding, encouraging and promoting this emerging talent.

British Craft Trade Fair

bctf
British Craft Trade Fair

the UK'S premier trade event for British and Irish Crafts

BCTF is recognised as the only trade fair in the UK that purely represents British craft. Established for more than 30 years, the fair hosts in excess of 450 exhibitors, all of whom have been carefully selected to ensure the highest standards of contemporary British design and craftsmanship.

All disciplines are represented at the fair, including ceramics, glass, jewellery (both precious and fashion), textiles, metal, wood, sculpture and artwork. The range of products is vast and the fair is visited by buyers from craft galleries and independent retailers from all over the UK, as well as from the EU and further afield.

Design Edge

design edge

an on-line catalogue for trade buyers, featuring many of the UK's top designer-makers

Design Edge is a brand new on-line service for trade buyers. The catalogue features many of the UK's top designer-makers and the selection criteria are exactly the same as for BCTF – all products must be British, handmade and of high quality and design. The site is user friendly and allows registered buyers to browse for artists and product by category, region or name. Each artist has their own page within the site with a number of product images and links through to their own website. British Craft Trade Fair and Design Edge support British craft and design.

Hall 1, Great Yorkshire Showground
Harrogate
North Yorkshire.
T: 01444 246 446
E: info@bctf.co.uk
Buyers registration is through www.bctf.co.uk

E: info@design-edge.uk.com
Registration is through the website www.design-edge.uk.com

Editor's View

I have always intended to reach the tenth edition of these Guides, but quite often doubted that it would become a reality. As one economic or social disaster after another took over the country and caused anxiety amongst gallery owners. We survived the foot and mouth epidemic, which shut down the countryside preventing tourists reaching many of the more far flung galleries, followed by the Iraq war and now we are in the grip of the worst recession that any of us can remember. Our way of life will change and, as many of the interesting essays point out, galleries will have to adapt to keep up with these new attitudes - they may benefit the craft world in the end. Most of the writers are full of 'enthusiasm' for their own craft or gallery and 'hope' that the craft world will thrive in spite of everything.

Meanwhile compiling this Guide has been the greatest challenge to date, as so many galleries have decided to close, change their profile or have been forced to stop any form of advertising. Although, in a few areas there are thriving galleries who continue as if nothing has happened. There are also nearly as many brand new galleries as usual, being launched by their enthusiastic owners. It is this enthusiasm, once again, which will carry them through.

I am particularly impressed to see that two galleries have faithfully taken part in every edition - Montpellier and Dansel Galleries. It is

1st 1992/3

2nd 1994/5

3rd 1996/7

4th 1998/9

5th 2000/1

good to have them in the book again. Peter Burridge, who owns Montpellier has also written an essay. As the entries started to arrive for this book I noticed a handful of makers who also appeared in the first edition. I have marked them with an * and congratulate them on their successful careers. At the other end of the scale it is heartening to read Lynn Walters' essay, a new maker in 1992 she too is now running a thriving career.

I have been fine tuning this edition from a Greek island mountain top, an idyllic situation but not conducive to work ! We have had a holiday house there since 1989 and have seen many changes but the magical essence of the island is still the same. I do hope that will be what happens in the world of makers and craft galleries; the changes will happen around them but their creative essence will remain intact.

As Peter Layton and Guy Taplin mention the never ending discussion about art versus craft continues, which each generation raises at some point; equally there is always debate about the web taking the place of books. I hope this will never happen and believe that the many craft buyers, who use this Guide, find it far more satisfying to take a book with them, on their craft research trips, than a flimsy print-out from their computer; let us hope that books will win.

6th 2002/3

7th 2004/5

8th 2006/7

9th 2008/9

10th 2010 -

Artemidorus

and the following nine galleries all took part in the first edition and are still in business, nearly all with the same owners. The small image, beneath each name, is a copy of their original page.

The text on the right is from their current advert. **Except** in this case - where the original text has been edited instead.

The launching of Artemidorus (the name of a Greek philosopher and soothsayer who offered 'the interpretation of dreams') coincided with the publication of first edition of the Craft Galleries Guide. The gallery went on to take part in the next two editions. Having been founded in the midst of a recession Artemidorus continued to grow and is still in business, a fact which should encourage other new businesses who are considering opening just now.

Set in Herne Hill where the shops end and before the houses start, its singularity catches the eye. Narrow, suggesting perhaps a chapel it appears to be Victorian, but was built in 1989. The owners renovated the interior, one room up and one down. Though never forgetting the slimness of the rooms, which is part of their appeal, there is a sense of light as you enter a space filled with colour.

In the first edition Amanda Wallbank, the owner, highlighted three of her makers including Sophie Harley a jeweller and Jitka Palmer a ceramic/artist I was delighted to discover (when checking the internet) that they have both continued to build very successful careers, with lively websites to keep us informed - progress! CM

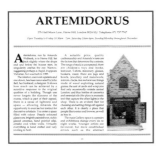

JITKA PALMER
Ceramics
Born in 1959, Jitka is from Czechoslovakia. Although she has been working with clay for over 12 years, her path has not been particularly straightforward or conventional. After qualifying as a doctor, she married an Englishman and settled in London. The transition led her to leave medicine and to further her study of ceramics at Croydon College of Art & Design. She later received a Crafts Council grant.

In Jitka's own words 'I make clay vessels and wrap them up in paintings. The paintings do not necessarily follow the shape of the vessel. I do not seek perfection. I make clay shapes my own way, like a sculpture. Then I paint 'the picture' using traditional glazes, slips, oxides and stains ... always figurative. It is people I am interested in, living people — imperfect, spontaneous, moving ... past, present and sometimes imaginary ... each piece is individual.'

The scope of Jitka's work is varied from large wall pieces and ceramic kites to more practical bowls, jugs and vases. Her work is expressive and alive.

27b Half Moon Lane
Herne Hill
London
SE24 9LU

T: 020 7137 7747

Illustrations from the first edition, from left: ;
Jitka Palmer & Sophie Harley

Dansel Gallery

Visit Dansel Gallery to see cutting edge contemporary woodwork made by over 200 designer crafts-men working in the UK with many from the South West.

Set in a delightful thatched converted stable block near the centre of the village, Dansel houses a superb collection of high quality handmade items with everything on display made in wood and chosen for its design and quality finish. The range includes individually designed pieces of furniture, elegant jewellery boxes, one-off decorative carving and turned work to practical kitchenware, ideas for office items, toys for children and wooden jewellery. Everything is for sale and highlights the inventiveness and versatility of the woodworker.

Selwyn and Danielle Holmes opened the gallery in 1979. It was initially dedicated to selling their own work but soon welcomed other artists in wood to join them. This has created a fascinating selection of woodwork displaying a huge range of timber varieties.

A small café serves fresh coffee and teas. The gallery is near the centre of the village with a private customer car park.

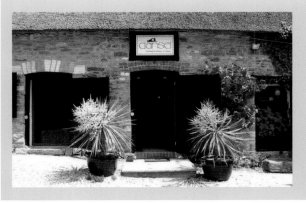

Rodden Row
Abbotsbury
Weymouth
Dorset
DT3 4JL

T: 01305 871515
E: danielle@danselgallery.co.uk
www.danselgallery.co.uk

Open: 10am - 5.30pm everyday

P
C
0%

Devon Guild of Craftsmen

The largest contemporary crafts centre in the South West with Jubilee Gallery, extensive Craft Shop and The Terrace café.

The Devon Guild is the focus of crafts activity throughout the region. Representing over 250 Members (makers) across the full spectrum of crafts from textiles to sculpture, jewellery and mixed media. Membership is open to all working makers (through a rigorous selection process) across the region from Devon, Cornwall, Somerset, Wiltshire, Gloucestershire, Dorset, Bath, Bristol and Swindon.

An inspiring events programme at the Riverside Mill includes talks, workshops, private views, social occasions and trips for a network of Friends, Members and supporters. A Guild flagship event is the Contemporary Craft Fair held in the adjacent Mill Marsh Park in June featuring 160 of the UK's finest designer-makers. Touring exhibitions to national venues, including a 2010 exhibition by John Makepeace the acclaimed furniture maker, put the Guild increasingly at the forefront of contemporary craft culture in the UK.

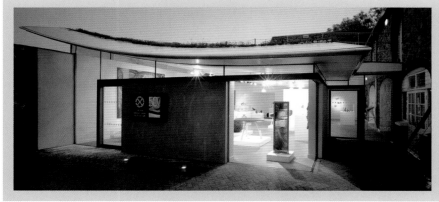

Riverside Mill
Bovey Tracey
Devon
TQ13 9AF

T: 01626 832223
E: devonguild@crafts.org.uk
www.crafts.org.uk

Open: Daily 10am - 5.30pm
Free admission

P
C
🖥
♿
0%

Simon Drew

The gallery has been open since 1981 and comprises three rooms of ceramics by a variety of makes and the artwork and greetings cards of Simon Drew.

Ceramicists include Colin Kellam, whose stoneware sculptures of cockerels, geese, runner ducks and other creatures figured in our recent exhibition celebrating his 40 years of potting.

The wonderfully quirky clocks of Ross Emerson and the witty sculptures of David Cleverly (truly antiques of the future) sit alongside the delicate, tiny and comical figures of Jenny Southam.

The dazzling modern colour of pottery by John Pollex, offset the traditional transfers on Virginia Graham's mugs and tap-topped teapots. Sculptures by Christy Keeney and by the Rudge family show grace, craftsmanship and originality.

Over the years we have been selling pottery, some names have stood out as masters of their crafts. This is a challenging but exciting time to be selling pottery. Taste have become more sophisticated and more daring. And more willing to accommodate humour. Functional tableware is as popular as ever, but dramatic sculpture can also thrive.

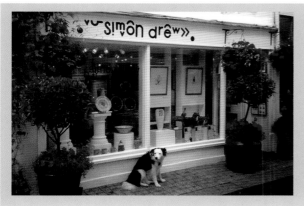

13 Foss Street
Dartmouth
Devon
TQ6 9DR

T: 01803 832832
E: info@simondrew.co.uk
www.simondrew.co.uk

Open: Mon - Sat 9am - 5pm

Fire and Iron Gallery

Fire and Iron Gallery was founded in the 1980s in response to a global resurgence of interest in forged iron as a creative medium. Its aim was to showcase the work of British blacksmiths and provide a platform for the promotion of a national craft showing small sparks of life after decades of decline.

Through the nineties and noughties, owner Lucy Quinnell expanded the scale and the scope of the gallery to incorporate other disciplines within the field of art metalworking. Today, Fire and Iron represents 200 British and international makers working in technically diverse ways with iron, steel, stainless steel, aluminium, zinc, copper, bronze, brass, tin, pewter, silver, gold, titanium and scrap metal. Special exhibitions and demonstrations complement extensive permanent displays.

From jewellery to sculpture, commissions are undertaken by Fire and Iron's exhibiting makers, and also on site by Lucy and her husband Adam Boydell, who together form an award-winning team specialising in public art projects.

Fire and Iron Gallery is set in the picturesque out-buildings and gardens of a Plantagenet house built in 1346, and is proud to be a green company.
RHS Gold Medallist 2008

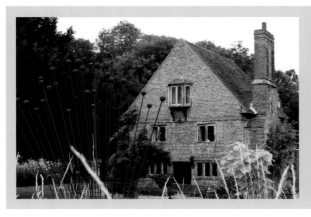

Fire and Iron Gallery
Rowhurst Forge
Oxshott Road
Leatherhead
Surrey KT22 0EN

T: 01372 386453
E: lucy@fireandiron.co.uk
www.fireandiron.co.uk

Open: Mon - Sat 10am - 5pm

Gowan Gallery

The Gowan Gallery was opened 1988 by designer jeweller Joanne Gowan. It is situated in an 18th century shop with a long history as a jewellers, in the small picturesque town of Sawbridgeworth on the Hertfordshire / Essex border. Joanne's intention was to provide a high quality outlet with professional staff for the sale of a wide range of craftwork and her own jewellery made on the premises, including occasional exhibitions.

21 years on the Gallery is still going strong and has expanded and developed as shown in the two photographs below. The gallery specialises in designer jewellery with the work of over 20 makers on display. There is also a selection of beautiful and unusual glassware, ceramics, wood and metalwork by well established and 'up and coming' artists.

Bespoke precious jewellery in gold, platinum, silver, palladium and gemstones is made on the premises by Joanne Gowan, gallery manager Sally Andrews and jeweller Emma Turpin. We also offer a free designing service, free jewellery cleaning and friendly professional advice. Commissions with other makers can also be arranged.

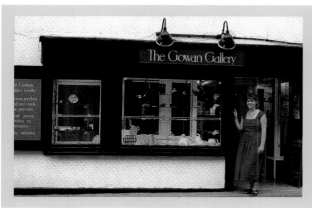

3 Bell Street
Sawbridgeworth
Herts.
CM21 9AR

T: 01279 600004
E: sales@gowan-gallery.co.uk

Open: Mon - Sat 10am - 5pm
Closed Sun, Bank Hols & Christmas - New Year

P
C

Makers

Between the Quantock and Blackdown Hills lies the Somerset County town of Taunton where Makers, a thriving craft co-operative, is located. Close to the town centre, Makers can be found in Bath Place, a picturesque, narrow street dating back to the 17th century.

Since its formation in 1984, Makers has gained a reputation for having one of the West Country's finest selections of contemporary crafts. Makers is owned and managed by the makers themselves marketing a varied collection of their own work. A maker is always on duty in the shop to assist visitors or to discuss ideas for individual commissions. Exhibitions by guest artists and craftsmen are held regularly in the gallery upstairs.

Work includes: knitwear by Buffy Fletcher, jewellery by Bernard Berthon, Pippa Berthon, Holly Webb and Solange, painted silks by Sibylle Wex, pottery by Clio Graham, John Harlow and Mary Kembury, prints and paintings by Mary George and Julia Manning, wood turning by Robert Parker, applied textiles by Ilse Coxon and sculpture by Melanie Deegan.

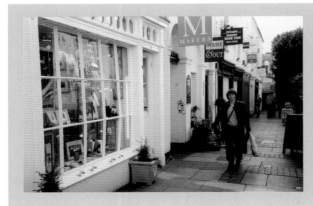

6 Bath Place
Taunton
Somerset
TA1 4ER

T: 01823 251121
E: info@makerstaunton.co.uk
www.makerstaunton.co.uk

Open: Mon - Sat 9am - 5pm

P
C
&
0%

Mid Cornwall Galleries

Mid Cornwall Galleries is open throughout the year and located on the A390 east of St. Austell. Housed in a former Victorian School, the space has proved a perfect Exhibition space.

We choose the work we display for its quality and originality and even, after all this time (we opened in 1980), we never cease to be amazed and delighted at the shows resulting from the incredible diversity of work by our nationally and internationally renowned artists, craftsmen and women living in the UK and Europe.

At regular intervals, throughout the year, we gather together new collections of paintings, etchings, prints, ceramics, (many by Fellows of the Craft Potters Association), blown and formed glass, silks, jewellery, figures in clay, wood and bronze, paper sculptures, turned wood, clocks and mirrors, textiles, collages and many other wonderfully made pieces to create our next display.

We hope you will visit us and enjoy seeing some of the finest original work in the country. A warm welcome awaits you.

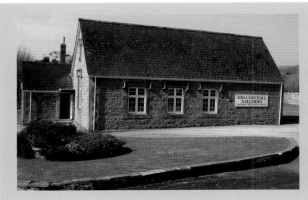

St.Blazey Gate
Par
Cornwall
PL24 2EG
T: 01726 812131
E: info@midcornwallgalleries.co.uk
www.midcornwallgalleries.co.uk

Open: All year round, Mon - Sat
10am - 5pm. January 10am - 4:30pm
and 11am - 4pm Bank Holidays.

P
C
&
0%

Montpellier Gallery

Montpellier Gallery has been established in the heart of Stratford-upon-Avon since 1991, and can be found opposite the Shakespeare Hotel near the centre of the town. Set in a 400 year old building, the gallery has three adjoining rooms, opening to a delightful tiny courtyard, which floods the rooms with natural light.

We have built a strong reputation for the broad selection of contemporary works we show, giving the gallery its visual excitement, colour and a refreshing stylistic diversity – whether ceramics, studio glass, paintings, printmaking or contemporary jewellery, pieces are always selected using a discerning eye for their quality, originality and form. We are strongly committed to promoting an awareness of the hand-made process and originality in all media.

The gallery always carries a comprehensive range of pieces from the artists and craftsmen we represent and regularly feature solo or group exhibitions by new and established makers.

The gallery is owned by Peter Burridge, a trained jeweller/silversmith and printmaker, bringing his broad knowledge of the fine arts and crafts to create the gallery's breadth of choice and selection.

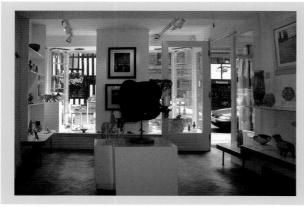

6 Chapel Street
Stratford-upon-Avon
Warwickshire
CV37 6RP

T: 01789 261161
E: info@montpelliergallery.com
www.montpelliergallery.com

Open: Mon - Sat 9.30am - 5.30pm

New Ashgate Gallery

New Ashgate Gallery and shop is an educational charity, which exhibits the best contemporary fine arts and crafts in a beautiful grade II listed building, conveniently located in the historic Georgian town of Farnham.

A varied collection of ceramics, paintings, prints, glass, jewellery, textiles, wood and metalwork, and a wide range of prices ensures something for everyone.

You are welcome to browse or buy in a relaxed and friendly environment. Our aim is to make viewing and collecting art an enjoyable and rewarding experience. We have continually changing exhibitions of quality work, by highly regarded artists and makers, alongside new and exciting talent. We promote fine art and craft through our programme of exhibitions, projects with artists and educational events

Any purchase is helping to support the charity and to provide a livelihood for all the artists and makers who exhibit here, and at the same time you are taking away a quality, handmade, and unique item. The gallery operates the Arts Council's Own Art interest free loan scheme which offers loans between £100 and £2000, gift vouchers, a wedding list service, and online purchasing from our website.

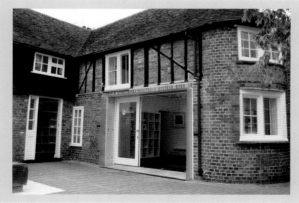

Wagon Yard
Farnham
Surrey
GU9 7PS

T: 0252 713208
E: gallery@newashgate.org.uk
www.newashgate.org.uk

Open: Tues - Sat 10am - 5pm

P
C
0%

10 Essays

To mark the achievement of reaching the 10th edition I have invited 10 makers and gallery owners, who have written for the guide or been connected with it during the last 20 years, to write an essay from their own point of view. Combined with several gems, reprinted from the first and second editions, these essays highlight the important role that craft galleries play in our culture and reflect on the changes seen in the craft world since 1992

Illustration: Little + Collins Shadow Tree rug page 113

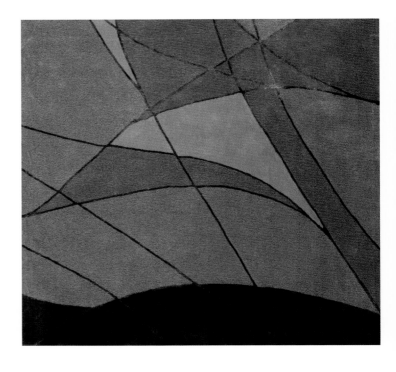

Alan Caiger - Smith

As I grew up near Aldermaston Pottery (Alan's base) I was lucky in being able to call in and see the potters at work and admire their wide range of pots, displayed in the rickety loft above the pottery. We still have a selection of domestic pieces in daily use at our home. Later, when I opened a craft gallery in East Coker, in the late 80's, Alan kindly agreed to have an exhibition of his work including some stunning lustre pieces, which was a great success. When the first Craft Galleries Guide was published in 1992 Alan again gave his support by writing the piece re-printed opposite. With our East Coker connection I am particularly interested in his Eliot quote. CM

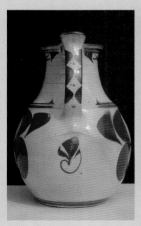 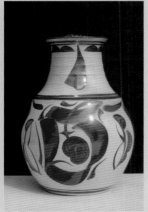

In the beginning I was drawn to pottery partly because it is concerned not only with art but with things that play a part in life and are actually used and handled, either day by day or on special occasions, not just art-objects put aside on a pedestal. The basis of pottery is extremely simple – a vessel that holds something and that is itself holdable. I keep returning to this point of reference but it extends into infinitely subtle variations of form, colour, design and imagery. Behind them all, however, remains the basic requirement of holding and being holdable. Whatever decoration I use refers back to that.

When pots are not actually in use, they are put aside and seen and enjoyed, and this is where decoration and colour come in. What I aim for in decoration is not just an attractive embellishment. I think of it as a dance of colour and line and brush-work, rather as TS Eliot meant when he described a Chinese jar as *'moving perpetually on its own stillness'*. The still form and the design belong completely together.

There are many kinds of decoration. On a plate it may be very subtle line and colour, taking its place amongst many other things on a table. On a more 'important' vessel, a large bowl or vase or jar, it can be relatively complex, a system of colours and rhythms comparable to a painting, something that satisfies the eye and is a focus for feelings and associations. Decoration at its best can never grow stale; it is life-enhancing and is always being seen in new ways, something unexpected.

The challenge to me as a maker is to produce pots that serve a purpose and are something more besides. It's a very open-ended pursuit, and it continues to involve me in new ideas, new projects, and in technical experimentation, especially in the field of wood-fired lustre, where the colours are especially evocative.

Pitcher blended copper and silver lustre, h 26cms, approx 1989

The late Michael Casson

In 1994 I asked Michael to write a piece about Craft Galleries he produced 'The Rise of Craft Galleries'. This comprehensive essay provides a fascinating synopsis of the history of the craft gallery, from the mid 40's through to the 90's. As many readers will know Primavera (now in Cambridge) was the first gallery to concentrate on promoting the applied arts. I am therefore very pleased that they have taken a few pages in this edition. CM

In the mid 40's I actually sold a few paintings and continued to paint instead of turning into a potter there was no difficulty in finding outlets from which to sell; as there was a long tradition of galleries exhibiting painting and sculpture. Until Henry Rothschild opened Primavera in Sloane Street in 1945 there was none that catered exclusively for a would-be craft buying public. Although I write here mainly about ceramics, what I say applies in general to other craft disciplines. The crucial factor was the gradual emergence of a significant section of the public who wanted, for whatever reason, to look at and purchase craft objects. Some would buy for purely domestic use as an alternative to the industrial product, others as serious collectors or just to possess an individual item made by a craftsperson. The patterns of these buying habits changed as time went on. By the 60's for example, hand-made pottery was bought in quite large quantities for use in the home, almost as a house style, to go with the wholemeal bread and growing wholefood ethic. By the 80's, however, individual ceramic pieces seemed to be the order of the day. By then a hierarchy among craftspeople had built up, bolstered by growing reputations, also by the auction houses responding to the needs of new collectors. These circumstances plot not only the story of the galleries but the changing face of society of the last 50 (*now 70 years*) years.

Many factors contributed to the rise of public awareness; from the forerunners of the galleries themselves, such as craft societies, handicraft shops and the department stores of post-war years to the eventual proliferation of magazines, books, and later even television coverage of craft activities. Above all, it was the developments in education which finally introduced a different product; one eminently suitable for gallery display and expertise.

To return to these earlier craft display facilities, we as young aspiring potters or whatever, had to deal with the Craft Societies like the Arts & Craft Exhibition Society started by William Morris. These showed the work of their selected members, annually, to a

small audience. There were other such 'clubs' in the regions, they all played their part in bringing crafts before a small but discerning number of people.

When in 1950 the government funded the opening of the Crafts Centre, Hay Hill in London's Mayfair, membership was restricted to five such societies. This was a real breakthrough; the first centre for the Crafts. There were also a few fine art galleries which would occasionally give over their gallery to pottery. In the 50's the Berkley Gallery exhibited the work of Lucie Rie, Hans Coper and Michael Cardew's new work from Africa; they were exciting occasions. Even Gimpel Fils, a gallery renowned for avant-garde abstract painting, for many years showed the individual ceramics of the late James Tower.

At the start of the 50's, Primavera, John Farleigh's Craft Centre together with the historical examples in the V & A were the meccas to which we went for inspiration. To try to earn a living by selling pots on a regular basis many of us turned to the most rewarding source: the department store. Although my very first customer was Betty Hope, a craft shop in Beauchamps Place behind Harrods, it was Harrods and above all Heals of Tottenham Court Road and Woolands of Knightsbridge who took my work and came back for more. These stores with their whole floors of well displayed crafts lasted well into the 70's with this policy. In the 70s they were a major factor in the growing awareness of the public, but they were different from the many galleries now opening. Heals for example always ordered 'stock' repeatable items, in sets, in a recognisable matching style. I do not belittle this system by any means, but it is not what a gallery does best. One of the triumphs of the Craftsmen Potters Association's shop in Lowndes Court (opened in 1970) and later in its present position in Marshall Street (currently based in Somerset House), was that it combined both functions. In racks stock was piled high, whilst in the central section individual items were displayed as in a gallery. This was a real breakthrough in the technique of selling. Conran opened Habitat a little later; education, now the route by which most young people became potters, weavers, or whatever, underwent a major change at the same time. It was a change that led eventually to a full B.A. (Hons) degree in a craft subject; a development that sought out individuality and innovation – the very characteristics on which galleries in the main depend. In the early 70's the Crafts Advisory Committee (now Crafts Council) called upon these new graduates to spearhead the way for the crafts, the scene was set for a dramatic increase, of galleries owned by people who responded to this scenario, people who had a love of craft objects and a personal point of view. Few countries in Europe developed such a range of top quality galleries which in turn helped to support the growing numbers of crafts people. Certainly compared with countries like France, Britain has an enviable record.

Some critics said that as art, painting and sculpture, becomes more and more esoteric, individual craft objects become more accessible, understandable and ultimately more desirable. What we undoubtedly have in the 90's, even in difficulty economic times, is a network of galleries displaying crafts across the widest possible spectrum. Some concentrate on function, others on sculptural aspects, there is no end to the diversity because each gallery owner is responding to an inner conviction. What galleries can do better than anyone else is to show the specialness of each object – whether a humble mug or anything else made, as Bernard Leach said: 'with head, heart and hand'.

Peter Burridge

Peter is an artist and the owner of Montpellier Gallery, one of only two galleries to have participated in every edition of the Craft Galleries Guide. Dansel Gallery in Abbotsbury is the other one. Compiling this Guide has not always been easy, due to economic and other outside pressures, so the support of these two loyal galleries and many the others, has been most reassuring. I also appreciate Peter's discerning comments! CM
www.montpelliergallery.com

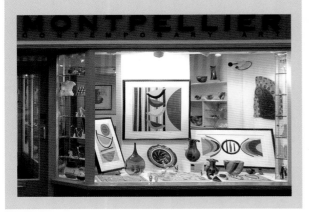

I am extremely proud to have participated in every book since Caroline's first edition back in 1992. To launch a comprehensive guide to the regional crafts was a brave step back then, and her sheer determination, dedication and perseverance has resulted in an ever changing snapshot, showing the extraordinary variety, creativity and quality of British Crafts and where they can be found - a fact often overlooked by the arts establishment. Also reassuring has been the escalating number of participating galleries, bearing testament to the flourishing regional craft gallery and the public appetite for the work they display and promote.

Acknowledging her contribution, we all need to triumph the independent galleries throughout Britain, who without the 100's of mixed, solo and themed annual exhibitions would not bring us the joy and beauty of a piece of craft. Over 350 individual galleries now strive to develop a public awareness and introduce both the seasoned collector and the purely inquisitive to the stunning breadth of skills, beauty and creative talent that resides in Britain's studios and emerges from our Art colleges and Universities.

Much has changed though in 20 years – gone, the 5 day week, early closing and lunch breaks, the A4 binders stuffed with curly artists' cuttings and the simple customer card index! Now the pixillated screen and the mouse relentlessly beckon - email, blogging, slick web design, PDQ payments, parking restrictions and red tape all seem to fill the day. But it is still the enthusiasm, discernment and the specialist knowledge of an owner, coupled with a gallery's special ambience that is fundamental to success.

This guide keeps to these fundamentals, essentially cutting through the confusion of technology and mass information, con-centrating and distilling into an easily accessible reference, bringing makers into contact with galleries and gently introducing the pubic to some of the richest sources of craft available. Britain has some fabulous galleries, use them, search them out, they will certainly reward you if you do.

Ben Casson

Son of the late Michael Casson, Ben is a furniture maker who also helps to run Wobage Makers Gallery, a delightful venue which has featured in a great many of these Guides. CM
www.wobagecrafts.co.uk

We find at Wobage these days that we are selling to a better informed public, the last few years has seen a great media interest in high quality, handmade objects of all kinds. Television programmes following building projects or interior design are not always good but have raised awareness or created a reaction. Radio and magazines have also given sympathetic coverage to the craft world. Craft fairs such as Origin, formerly the Chelsea Craft Fair and our local Hereford Contemporary Craft Fair to name only two, have increased in prominence and provided the public with the opportunity to meet the makers. They in turn have been able to explain their methods and motivation as we do at Wobage, being in the unusual position of being a gallery run by the makers who stock it.

Our customer base has shifted accordingly, many younger people furnishing homes and wanting to use pots and furniture not mass produced in this globalized world have joined the ardent collectors and regular stalwarts who attend Wobage exhibitions. The crafts in general seem to inspire incredible customer loyalty. Interest in commissioning also seems to have increased and we find people are very keen to get involved in the process, influence design and to know where materials have been sourced. The makers themselves have responded to this by continuing to innovate and develop techniques, sometimes making small improvements and other times radical changes in their work, but all within the ethos of truth to materials and functionality that were so important to my late father Mick. He was such an enthusiastic communicator and exponent of all craft disciplines.

Craft galleries play a central role in putting customers in touch with thousands of makers who are part of the lively British craft scene. Their work, in supplying outlets, informing buyers as well as selecting work to sell and feeding back to the makers has undoubtedly helped to make crafts such a success in Britain.

Paul Caton

I first met Paul back in the 80's when he was an exhibitor at Alpha Gallery, the gallery I opened in East Coker. I was interested in the way his work seemed to follow his philosophy for life so I invited him to write for the first edition. It is therefore a great pleasure to welcome him back and to read how his life and work have progressed. CM
www.paulcaton.com

I have now been practicing as an artist/craftsman for 40 years. I say practicing, as whilst working and earning a living, it is a long journey of learning. It has been greatly helped by the owners of galleries where I have either sold my work and had joint or one man exhibitions in Britain and Internationally. As craftsmen, our talents are in our hands and in the many ways we use raw materials to create pieces that we hope people will like and buy. Certainly, in my case I do not have the special skills needed for marketing, promotion, pricing and selling. I need an agent! This is where the gallery owner's expertise comes in. It's a partnership in which I respect the different way of thinking essential to a viable enterprise.

Now that our children have grown up, my wife, Gill, is still by my side and our home has not been repossessed; this surely is a measure of success - to survive. To recharge the vitality of our creativity, we need to explore new avenues but remain true to our core values and aspirations. The intuitive calling of tradition is maybe for many, a step back and as a reaction there is the desire for innovation. If this is accompanied by maturity of thought and technical physical skills, then new traditions may evolve for future reference. Is the vernacular fossilised or does it reinvent itself on a cyclical timescale?

Working mainly in wood but also in stone and bronze provides me with a variety of materials, techniques and possibilities. Now working on large scale projects with the Carpenters Fellowship gives a different scale of making. Many of us teach to earn extra income but also to meet others and pass on our skills and discoveries. In these difficult times we need to be inventive and adaptable; the partnership with and guidance of the Crafts Council and craft galleries in a spirit of being mutually beneficial will see us through. If what we make is, both well made, beautiful and practical then we should be fulfiling worthy criteria central to the ethos of the modern and traditional artist/ craftsman.

Jack Doherty

Jack has recently retired from his role as the chairman of the Craft Potters Association. As he has taken on a challenging but exciting job as Lead Potter, at the recently opened Leach Pottery & Museum in St. Ives.
I am grateful that he was able to take time out to give his views on the craft scene. CM
www.leachpottery.com

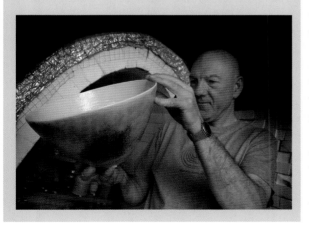

Reflection on the craft scene.
Craft Galleries Guide has become established as a reference point, a starting place and guiding light for many journeys into the world of contemporary craft. Since its first edition in 1992 the guide has also been a barometer, registering the changes and developments in both the practice of crafts and its market place. The past decade has seen profound changes in crafts education. The loss of many specialist courses, including some which are internationally respected, has made it more difficult for makers to find even the most basic training. This displays an institutional lack of awareness. It limits choice and makes it harder for talented and motivated people to develop a career in the creative industries.

The way that the crafts are supported nationally has also changed. The re-branding of craft as applied art and its alignment with the fine art world has set new standards and created space for work with greater artistic vision. But it has also had a divisive effect. Seeming to diminish and undervalue the work which has a domestic context, the beautiful things made to be used every day.

The loss of a national craft gallery has taken away what was a focal point for excellence and debate. Fortunately these roles are being played at regional locations in both funded and privately owned galleries. In Britain makers are fortunate to have, still, an extensive and diverse network of galleries. Owned and run by people who share a passion for beautiful things, they are the front line, the first point of contact between artist and the public. The Craft Galleries Guide presents a collection of these places, each of them displaying an individual stamp of ownership, but together showing the full range and breadth of contemporary crafts.

The past 18 years have seen the evolution and expansion of the crafts as a cultural and economic force. In the harder times which we are all currently facing I see that the place of makers and artists is to produce work, which reconnects us with the bedrock values of truth and reality.

Andrew Geoghegan

Andrew has been a regular participant in the Craft Galleries Guides. The images he presented were always highly professional, allowing his work to stand out from the crowd of jewellers competing for attention. It is interesting to read how he believes the style of craft galleries must change to move with the times.

www.andrewgeoghegan.com

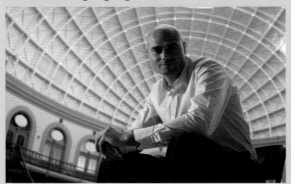

Basileus Reveal

As a jewellery designer, with 50 outlets many of which are craft galleries, I see at first hand the way the 'craft' market has changed with regards to jewellery. In the late 90's I was producing mainly silver pieces, with semi-precious stones, readily stocked by the galleries; it appeared this type of jewellery sold. After a few years the focus of my business changed and silver turned to gold; semi-precious stones to diamonds. Whereas many of my stockists embraced this higher value product, the craft galleries were more cautious: security implications, insurance premiums and finances all influenced them. Slowly but surely the gallery owners, understood the potential revenue, inspired by enquiries they started investing in engagement and wedding rings. This was fuelled by a change in consumer patterns; customers looking for an engagement ring, who had an eye for design manufacture but also the special quality of the product were making their way to craft galleries. The choice of hundreds of claw set rings, in the sterile environment of some high street jewellers does not impress, whereas a smaller and more eclectic mix offered by many galleries does. There is a huge competition for traditional designs, ultimately devaluing the product; with this over-saturation, well designed and beautifully crafted products shine through and for many, the craft gallery is their destination. Inspite of competition from web outlets the majority of discerning customers still want the experience of seeing and trying on the actual ring before buying.

Galleries need to keep pace with change, security must be a priority and staff education is essential. Potential customers spending between £1/5,000, must be given all the 'ins and outs' of precious metals and stones. A basic understanding can be the difference between a sale or not. The customer needs confidence in the staff. A strong and lucrative future can be realised even in the present financial climate. Two groups are emerging; the price conscious and those who strive for quality in every sense. The latter group is where the craft galleries will succeed and profit.

Peter Layton

Peter's stunning glass vessels appear throughout this guide and in many previous ones. It is sad to read that he fears for the future of glass-making although as he says:
'I look forward to a day in the not so distant future, when glass is no longer seen as a Cinderella medium, but recognised as an equal among art forms.'
www.londonglassblowing.co.uk

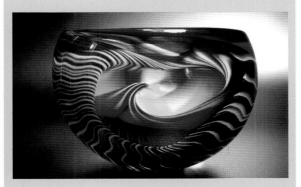

Spirale

'The times they are a changing.' Bob Dylan
While the world has changed radically in the past 20 years – politically, economically, environmentally and perhaps even spiritually, but there remain areas where its pace is so slow that, as people search for fundamental values, things appear to be going in reverse. While progress is not necessarily linear, particularly as one's perception of change is entirely subjective. The vexed and interminable art/craft debate rumbles on – my own view is that the terms art, craft and design are terms best used interchangeably – with good and bad as the salient criteria.

International growth of interest in glass has been phenomenal – there is now hardly any country untouched by the contemporary glass movement. Museums, collections and exhibitions are proliferating. At SOFA (Sculptural Objects and Functional Art) - arguably the best art/craft show in the world, glass dominates in quality and quantity.

However, in Britain, despite a promising start with the Glass House in Covent Garden in the late 60's, progress has been slow. The common perception of glass as a cheap expendable material on the one hand, and the historic view of cut glass as the epitome of good taste on the other, is only just beginning to disappear, and many British artists in glass of international standing still sell most of their work abroad. While glassmaking studios, university departments and specialist galleries have come and gone, I am proud that London Glassblowing Workshop has survived the vicissitudes of various recessions, to become Europe's longest running studio, I am also aware that the current economic situation may have serious adverse effects on its future. The glass factories have been decimated with repeated closures in the USA, UK and even the Czech Republic and it has been said that in a few year's time China may be the only place where glassmaking will survive. Meanwhile the studios have become the new industry and I am optimistic that as public awareness grows so too will the market for Contemporary Glass.

Lucy Quinnell

Lucy's Fire & Iron Gallery was included in the first edition. In the second, her father Richard Quinnell kindly wrote a very informative piece. So, this thoughtful article, written by Lucy, provides a strong link with the past. CM
www.fireandiron.co.uk

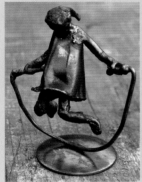

"If a man is truly an artist, he must impose on an unwilling public standards of perfection to which it is not accustomed. Do not blame the public for asking what is bad. Yours is the responsibility, for you are the educators of the public. It is part of your mission to spread the beautiful."
Samuel Yellin

Photo: Andy Newbold

On the shelf above my fireplace is a tiny assemblage of a steel rod, a few snippets of sheet metal and some blobs of weld. Combining the skills of his artist's eye and his worn, practised, craftsman's hands, sculptor Len Clatworthy has breathed life into almost nothing to create a gentle, evocative skipping figure that brings immeasurable joy.

Upstairs, we have a new window. The oak was carefully selected, expertly worked, neatly pegged and finished to a Burmese cat sheen by joiner Dave Vincent. Now glazed and installed, it makes me glad when I catch sight of it from the garden, and it gives me satisfaction when I open and close a casement that fits its frame so perfectly, and is so perfectly fit for purpose.

The power of a well-crafted object to uplift is extraordinary, perhaps now more than ever before. In the second Craft Galleries Guide, my father Richard wrote about the Utopian vision of crafts-people – "the perfection of society…..achieved through the creative hand-work of individuals, and the accompanying elevation of spirit" – in the context of "the highly stressful and competitive society that most of us live in today." ' (1994)

I could summarise here the gist of my father's entire commentary, and it would not seem 15 years out of date. I would, unsurprisingly, judge the world of 2009 even more harshly than he did that of 1994. He condemned a desert of mediocrity; shoddy buildings, and ugly, unreliable and mundane domestic appliances-come-groundfill. He described the prevalent "mania for cheapness", that he firmly believed would soon end. He could not have imagined that there was quite so much starving and shaking of society still to go before the values exemplified by the fine craft-worker (quality, integrity, honesty, responsibility, real value) might constitute a philosophy not just yearned for but actually adopted as an aspiration by more than the unconventional few.

My father was optimistic in 1994, and I am now. As we brace ourselves for possible aftershocks, and prepare for things to finally

settle into a new shape, our clarified distaste for greed, fast living, exploitation and cheapness devoid of value demands a new order. We know what threads from the past hold strong, and what we should discard. With good governance, the weaving together of vigorous old strands and robust new ones can now repair the damage and extend the lease.

Fortunately, many craft skills have survived the turbulence, linking the days when excellent making was normal to a future where resourceful souls working creatively with their hands will surely be greater in number and valued more highly again. Many makers I knew in 1994 are still making, and their work has become impressive. Some talented and innovative new makers have joined them, and international making has been embraced as a vital source of inspiration. Reassuringly, some of the current work produced is so aesthetically pleasing and technically superb that it provokes wonder, even amongst a maker's expert contemporaries.

It has been hard for these survivors and newcomers to stay afloat. I run a gallery with my husband, and we are also makers. I have spoken to ten or more craftspeople each working day of the past 18 years, and I know what a hand-to-mouth profession ours can be in lean times, and what knife-edges must be balanced upon in pursuit of this difficult but highly-rewarding career.

As the tide of cheap and worthless turns, the swell of enthusiasm for the crafts is rolling in just in time, and I suspect that expert makers are about to have their day. There is a thirst for excellence and morality, and a new reverence for those who never abandoned the skills and ethos society now craves. All credit to those who through thick and thin have steadily worked on, keeping standards high and providing an invaluable glimpse of the hand-made to the hands-off generation.

Making is a wonderful, tangible thing. Making something that is admired by another is uplifting. Making something that a stranger wants to own, give as a gift, or commission from, is a remarkable and affirming experience. For the stranger to come into contact with the crafted object, that object must be displayed in the public realm. Craft galleries provide this essential exposure, making craftwork visible, available and familiar. A good gallery provides a space conducive to the contemplation of work; it acts as a conduit between makers and collectors, encourages excellence and enables new work, educates and enthuses its visitors.

In turn, the craft galleries need exposure in order to thrive and to be of real benefit. Most are self-reliant, but just as one good patron can be a lifeline to a craftsman and a gift to the world of making, one enthusiast has made a vast contribution by recording and promoting craft galleries in the UK and now further afield. In doing so, she has raised the profile of craftspeople, and brought pleasure and interest to many by enabling easier public access to craftwork. Caroline Mornement's Craft Galleries Guide turns nation into showcase; the exhibits within are the galleries, beautifully displayed and clearly labelled. Within the galleries, like jewels in boxes, are the wares of the makers, well-crafted objects that reflect, appeal to and inspire the most constructive aspects of human nature.

"If something is well-designed, if something is beautiful, why would you ever want to throw it away?" Stephen Bayley

Richard Quinnell

As mentioned earlier, Richard wrote for the second edition in 1994. Here are a few quotes from his interesting piece. Like his daughter Lucy, in the previous essay, he was praising the philosophy of hand-crafted work, while despairing that mass production might overtake us; however, as you will read, he had hope for the future. CM

Lucy's husband Adam Boydell teaching

Quotes from Richard's 1994 essay:
"This philosophy of the spiritual value of honest workmanship, presented by Morris in "News from Nowhere", has been reinforced by such diverse 20th century writers as Nevile Shute ("Round the Bend"), Bernard Leach ("A Potter's Life"), Robert Persig ("Zen and the Art of Motorcycle Maintenance") and David Pye ("The Nature and Art of Workmanship").

Can the Utopian dream offer any hope to this sad reality? I think that it can: people are hungry for Quality – and the best of the "fine" craftmakers exemplify just that; and in so doing provide a model for how, starting perhaps with the building crafts, qualities of fitness, durability, and pleasure in making and ownership could be revived when the present mania for cheapness comes to an end, as surely it must.

My own experience of the worldwide revival of Artist-Blacksmithing in 20 short years from a quaint, moribund activity to the dynamic phenomenon that it is now, with gifted young metalsmiths providing beauty, utility and originality in a vast range of styles and scales, from jewellery to monumental architectural work, with great commercial professionalism, convinces me of this.

Why all this in a directory of craft gallereis?
Because the galleries and their owners provide the essential interface between the makers and the public; they bring into one place the work of many makers, and show work that might otherwise be known to only a very few; the best are very knowledgeable about the makers they represent, and the fields of craftsmanship in which they specialise, and work hard both to lead customers to a greater appreciation of the creative process, and to help the makers to develop, and to achieve a sensible commercial return for their work. They represent oases of excellence in a desert of mediocrity, and fortunately it is the greatest pleasure to give them the support they deserve."

Lynn Walters

A participant in the Second Steps Portfolios, also published by BCF Books to promote the work of new graduates, Lynn is now a regular entrant in the Craft Galleries Guides. It has been satisfying to watch her succeed with such an unusual material. It is great to hear that these books have been able to help launch her career. CM

www.lynnwalterssculptures.co.uk

I am a designer maker of metal and wire sculpture, I love wire, dream in wire, see everyday life in wire, making objects out of wire is what I was born to do. After studying Contemporary Textiles at Cardiff School of Art and Design in 2002, I specialised in metal and wire sculpture. The project which launched my passion was inspired by a Wren House, which I came across at the Museum of Welsh Life in St. Fagan's, Cardiff. It was used during Twelfth Night celebrations in many parts of rural Wales. The custom involved placing a body of a dead wren in a decorated box/bier. From this I made a series of twelve tiny houses, each one differently constructed exploring metals, wire, felt and recycled materials.

I then progressed to researching other homes for birds and pigeon houses perched on the mountainside became a fertile source of imagery, from there came the images born out of the Welsh valleys, depicting the people, houses and churches, and their relationships with the winding roads, mountains and railway tracks.

I feel my work is both humorous and grave, a blend of caricature and technique, whimsical and rigorous. Pieces are inspired by my memories, vibrant street scenes are evocative of anywhere that people inhabit. Coloured houses represent their occupants. Figures are playing, walking their dogs and sitting on benches. Everyday life in wire and metal.

The success of my sculptures has been helped with BCF Books and editor Caroline Mornement, who has given me lots of support since graduating in 2002. My work first appeared in the Second Steps Portfolio in 2003, this gained plenty of interest from galleries inviting me to show my work and join exhibitions. I also took part in Second Steps Portfolio 2, this was to show a makers progression. My work also appeared on their website, this catapulted my profile and I received many orders and enquiries from both the public and gallery owners.

Guy Taplin

At my invitation, because I loved his work and had bought one of his early pintails, Guy wrote a delightful piece in the second edition, see below and opposite. It is therefore with great pleasure that I am able to include an up todate example of his wise thoughts. CM.

STANDING IN THE DOORWAY OF A TIME LONG AGO

I have been fortunate and have visited America many times. During visits in the seventies I was able to meet the last remaining men from the earlier tradition, Madison Mitchell, Havre de Grace and Lem Ward of Crisfield, all now dead. Their deaths closed a chapter on a fascinating way of life. On those visits I was able to research from local people, authors and collectors more about the way those men lived. They had built their homes beside the water where they fished, hunted and made wooden birds from 1870 to 1920. Elmar Crowell, the Dudley brothers, Ben Dye, James Holly, Bill Bowman, Odediah Verity and many more.

Quite by chance these men created the world's finest bird sculptures; one family stands out — the Cobbs. In the early part of the 19th century Nathan Cobb Snr and his family sailed from Cape Cod to Oyster in Virginia where they bought a barren island. They salvaged wrecks and saved lives; hunted and fished and made fabulous decoys from ships' masts and driftwood. Nowadays decoys by Nathan Cobb Jnr are auctioned from $80,000-$100,000 plus.

The family flourished on their island where they built an hotel and cottages for guests, ran a mainland farm and steam boat. Unfortunately a powerful hurricane in the 1890s destroyed all that they had built. Cobbs' Island has now reverted to how it was before they were there, a 7 mile stretch of sand facing the Atlantic. However, they did leave a legacy behind them — their wooden birds.

Decoys are now big business in the U.S.A., one auction house alone exceeded $4,000,000 in sales of decoys in 1993. Where once they attracted the winter migrants they now decoy the rich collector of folk art.

Guy Taplin

Photo: Courcoux & Courcoux

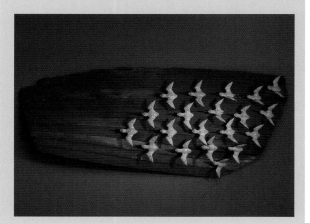

'Craft or Fine Art, to be or Not to Be'

As one who has wandered the wilderness of the title and ended up in art galleries, I ponder my wayward journey as a so called 'self-taught'. I find after 30 years that passion and obsession have held me in their sway with a few wrong turnings - but that's another story.

Perhaps the name/title of craft should be changed. What was it, when Hans Coper and Lucie Rie first earned a thousand for their pots, suddenly contemporary fine arts? Fine art galleries rushed to have them on show - for cuedos and price?

Abstract art and the human form have always ruled the roost or at least recently and yet there are as many, if not more, craftsmen of great quality than fine artists. Does fine art speak more to the heart than craft? Does it really matter? As long as the maker or artist is doing and making the work and giving it their all over many years; because that's what it takes to live on the so called edge and beyond and to make it your life. It should be as comfortable in the end as the workshop, armed with a cuppa and Radio 4. Of course selling is very important, not for the money, but because somebody out there wants your work; do you remember the elation of selling your first piece probably to a friend - a whole new world opens up!

There is no path, I make one just by going. Good luck to the craftsmen and artists, have a great adventure on the way.

Illustration:
Blue boat panel with flying sanderlings
Photo courtesy of Courcoux & Courcoux

Guy Taplin (1992)

In this fascinating piece Guy first described how he grew up in the East End of London before being evacuated to Hereford. Where he saw a hedge sparrow's nest for the first time, which left a lasting impression. It appears that the question of art and craft, discussed in his new essay has been an on-going puzzle. CM

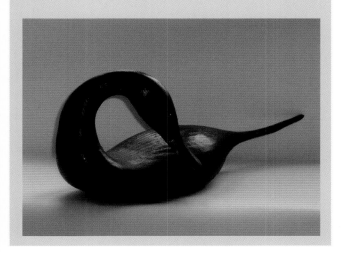

Why do I work in a shop when an artist works in a studio and a craftsman in a workshop?

I had always been interested in birds and the places where they were to be found. I had been a wild fowler on the Essex coast, and at the same time I developed an interest in Zen. All this culminated in a job looking after the wild fowl on the lakes in Regent's Park. I began making wooden birds and selling them to antique shops. Eventually carving birds became a full-time occupation, and the first gallery that bought my work was the Portal Gallery in Grafton Street. A free-lance journalist wrote an article about my work in Crafts magazine, and since it appeared I have had 15 years of continuous work.

My approach to my work is strongly rooted in the tradition of decoy carving which grew up on the east coast of the United States 100 years ago. My work spans the divide between fine art and folk art, and I have been called an artist, a sculptor, a craftsman and a wood carver. Historically my work is based on the latter, I prefer to call myself an artist. I do not make things well enough to be called a craftsman, and I am more interested in the finished object than the exact method of making my birds. Why is it that craftspeople attach so much importance to the process, whereas art does not? Why do craftspeople get so little for their work compared with artists of the same calibre?

It seems that art is concerned with making a statement about the human condition. I have often wondered why I haven't been asked to write about the history of decoys for magazines. Some decoys are quite stunning in form and finish, possibly this reflects the colourful lives of their makers. Maybe this special area has been overlooked, and so I have been able to claim it as my own. I am entirely self-taught, but I do regard my feeling for birds as a special gift.

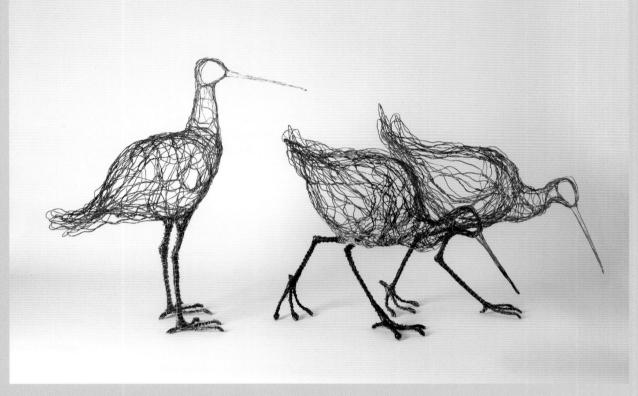

Celia Smith - page 231

South West

Baxters

Baxters is situated on the corner of Foss St and Flavel St in the beautiful town of Dartmouth in the South Hams. The bright and airy space shows off an excellent selection of contemporary art, printmaking, craft and jewellery. Sarah Duggan took over the gallery, previously known as Hartworks in 2006 and has introduced a wide selection of artists plus 3D work in a variety of materials including ceramics, wood, metal and glass. An interesting selection of contemporary jewellery in silver, enamel, glass and semi-precious stones is also available. The atmosphere is relaxed and friendly allowing you to enjoy the interesting mix of established artists and new talent. Having been a keen personal collector of art and craft, Sarah hopes to pass on her love for pieces that in particular make you smile.

Several themes are evident, a strong inspiration from the Devon and Cornwall coastline captured by many of the artists. Other work reflects a definite sense of humour or the quirkiness of animal-life. A programme of changing exhibitions and the introduction of new work ensures an interesting visit.

The website is enjoyable for browsing and shopping and shows the majority of work available.

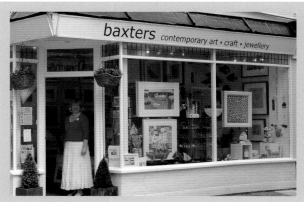

12 Foss St
Dartmouth
Devon
TQ6 9DR

T: 01803 839000
E: info@baxtersgallery.co.uk
www.baxtersgallery.co.uk

Open: Mon - Sat 10am - 5pm, Sun (seasonally) 11am - 4pm

1
Jane Reeves
glass

2
Simon Griffiths
ceramics

3
Lucy Fraser
shell collage

4
Abbott & Ellwood
metal jewellery

5
Michael Turner
metal

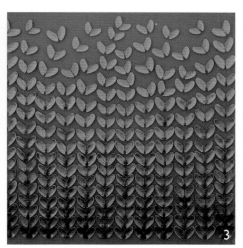

The Burton Art Gallery & Museum

The Burton Art Gallery and Museum is North Devon's premier venue for the visual arts and craft. Set against the backdrop of Bideford's Victoria Park the gallery was established in 1951. It includes two major exhibition spaces, the craft gallery, Bideford Museum, a cafe, an education space, tourist information and the gallery gift shop. The Burton hosts a changing programme of exhibitions featuring local, national and international artists, accompanied by a range of educational activities. It also houses the Bideford Museum and is home to a rich array of artefacts, documents and treasured items representing the diverse history of the town.

One of the real gems in the Burton's crown is the nationally acclaimed craft gallery, showcasing work by an impressive list of the region's artists, designers and craftsmen, Including Jewellery, locally made pottery, textiles, ceramics, wood carvings and metalwork, the Craft Gallery displays an eclectic and inspired range of work. Artists featured include Hilary Paynter, Blandine Anderson, Clive Bowen, Svend Bayer, Carry Akroyd, Irene Jones, Erin Cox, Shirley Smith, Victoria Lindo, Jenny Southam, and John Butler.

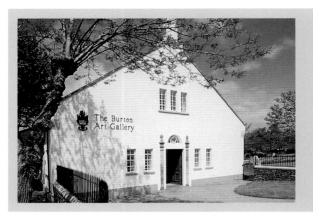

Kingsley Road
Bideford
North Devon
EX39 2QQ
T: 01237 471455
E: burtonartgallery@torridge.gov.uk
www.burtonartgallery.co.uk

Open: July - Sept, Mon - Sat 10am - 5pm, Sun 11am - 5pm, October - June, Mon - Sat 10am - 4pm, Sun 11am - 4pm

P
0%

1	2	3	4	5
Shirley Smith *woodcut*	John Butler *woodcarving*	Jenny Southam *ceramics*	Carry Akroyd *screenprinting*	Irene Jones *mixed media*

1

2

3

4

5

The Chapel Gallery

The Chapel Gallery is set within the tranquil Grade II listed gardens that make up the 18th century Saltram Estate. The former chapel retains its character with a vaulted ceiling and huge gothic windows, giving natural light and a beautiful backdrop to the varied crafts shown. With a long history of the arts, Saltram has an art collection that includes the work of Sir Joshua Reynolds, Thomas Chippendale and Angelica Kauffman.

The Chapel Gallery continues the tradition for supporting contemporary arts and crafts. Throughout the year exhibitions are regularly renewed to promote local artists and craftsmen.

The gallery's aim is to give a welcoming atmosphere, creating a mood conducive to peaceful browsing for our visitors. The wide variety of work in the lower gallery includes original paintings and prints, ceramics and glass, textiles and jewellery. The upper gallery is dedicated to solo exhibitions of both established and newly discovered artists. Each year three craft fairs are held at Saltram displaying a huge range of local handmade crafts items.

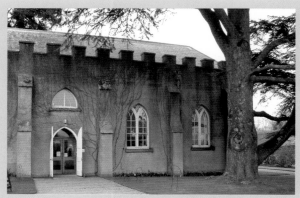

Saltram House
Plympton
Plymouth
Devon
PL7 1UH

T: 01752 347852
E: shirley.margison@nationaltrust.org.uk

Open: Daily, except Friday, 11am - 4pm

P
C

1
Joanna Martins
cold cast bronze

2
Gregg Anston-Race
glass

3
Peter Reeves
jewellery

4
Brett Humphries
acrylic painting

5
Carol Scott
ceramics

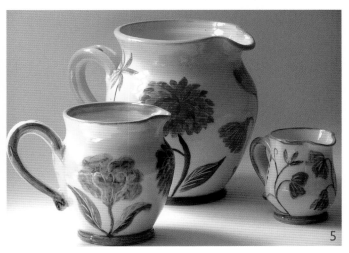

Coombe Farm Gallery

 P C 🖥 ♿ 0%

Dittisham
Dartmouth
Devon
TQ6 OJA

T: 01803 722 352.
E: tina@coombefarmstudios.com
www.coombegallery.com

Open: Mon - Sat 10am - 5pm
Sun by appointment

Coombe Farm Gallery was first established in 1983 as part of the Coombe Farm Studios educational complex. Situated in a tranquil valley the gallery has developed it's great reputation through the dialogue of it's artist owners and the creative people it is privileged to represent. The gallery plays an active role in promoting new talent alongside internationally acclaimed artists. On show you will find carved and turned wood, jewellery and ceramics. Do also visit our sister gallery at 20 Foss St Dartmouth. Both galleries are members of the Independent Craft Galleries association – they are selected for excellence.

1. Avis Murray
2. Nick Agar
3. *Laurel Keeley

*Simon Drew

The gallery has been open since 1981 and comprises three rooms of ceramics by a variety of makers and the artwork and greetings cards of Simon Drew.

Ceramicists include Colin Kellam, whose stoneware sculptures of cockerels, geese, runner ducks and other creatures figured in our recent exhibition celebrating his 40 years of potting.

The wonderfully quirky clocks of Ross Emerson and the witty sculptures of David Cleverly (truly antiques of the future) sit alongside the delicate, tiny and comical figures of Jenny Southam.

The dazzling modern colour of pottery by John Pollex offsets the traditional transfers on Virginia Graham's mugs and tap-topped teapots. Sculptures by Christy Keeney and by the Rudge family show grace, craftsmanship and originality.

Over the years we have been selling pottery, some names have stood out as masters of their crafts. This is a challenging but exciting time to be selling pottery. Tastes have become more sophisticated and more daring. And more willing to accommodate humour. Functional tableware is as popular as ever, but dramatic sculpture can also thrive.

Illustration :
'Charles Darwin Dreams of Mauritius' by David Cleverly

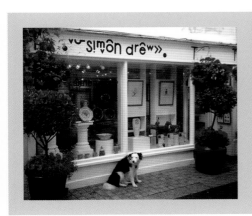
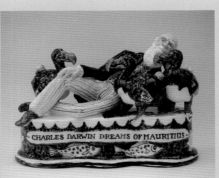

13 Foss Street
Dartmouth
Devon
TQ6 9DR

T: 01803 832832
E: info@simondrew.co.uk
www.simondrew.co.uk

Open: Mon - Sat 9am- 5pm

P
C
0%

Cornwall Contemporary

Cornwall Contemporary opened in the summer of 2006 and quickly established a reputation as a leading gallery in the West Cornwall arts scene. Situated at the top of historic Chapel Street and spread out over three floors, this spacious, quirky gallery provides an ideal setting to view paintings, sculpture, print-making, ceramics and artist made jewellery. Exhibitions change monthly and there is always mixed work by gallery artists on display in the upper gallery rooms.

Regular exhibiting artists include Neil Pinkett, Simon Stooks, Maggie Matthews, Anja Percival, Paul Lewin, Alasdair Lindsay, Jamie Boyd, Fiona Millais, Daphne McClure, Emma McClure and Richard Ballinger amongst others. Ceramics and jewellery is an integral part of every exhibition and always on display. Makers are sourced locally and also from further afield to provide something that little bit different. Regular ceramicists on display include Charlotte Jones, Christine Feiler, Alice Gaskell and Helen Beard whilst jewellers include Kaz Robertson, Nancy Pickard, Emma Clarkson, Fay Page and sculptors include Nancy Pickard and Alex Smirnoff.

The gallery stages an annual exhibition in London and is happy to include people on their email list if you wish to be invited to private views or to be notified of special events. See details below.

cornwall contemporary

1 Parade Street
Queens Square
Penzance
Cornwall
TR18 4BU

PC 0%

T: 01736 874749
E: sarah@cornwallcontemporary.com
www.cornwallcontemporary.com
Open: All year round
Mon - Sat 10am - 5pm

1
Nancy Pickard
'Paved With Good
Intentions'
sculpture

2
Daphne McClure
'Between the
Rocks'
oil on board

3
Fay Page
jewellery

4
Charlotte Jones
ceramic

5
Neil Pinkett
'To the Top of
Chapel Street'
oil on board

The Cowhouse Gallery

Situated in the picturesque village of Perranuthnoe between Marazion and Helston, the Cowhouse Gallery is one of West Cornwall's best kept secrets of the county.

The gallery is run entirely by a group of local artists and active craftspeople and this independence allows them to offer a wide range of original arts and crafts at very affordable prices.

Cowhouse members are subject to a careful selection process to ensure that only the very highest quality of work is exhibited. Painting, sculpture, printmaking, photography, ceramics, Jewellery, textiles woodturning and leatherwork are all beautifully displayed in this bright light art space. The gallery also has a changing list of guest exhibitors.

A stroll away is Perranuthnoe Cove with it's secluded, safe, sandy beach. The coastal walks have panoramic, breathtaking sea views of Mounts Bay and St Michaels Mount.

Just off the A394, The Cowhouse Gallery is a short distance from Penzance, Helston and St Ives.

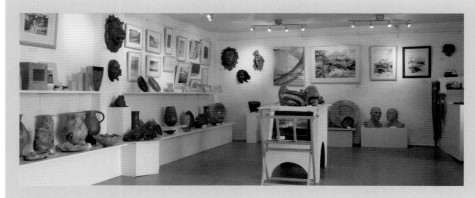

Lynfield Craft Centre
Perranuthnoe
Cornwall
TR20 9NE

P
C

T: 01736 710538
E: info@cowhousegallery.org.uk
www.cowhousegallery.org.uk
Open: Daily 10am - 5pm.
Nov - March reduced hours, see website for details

1
Dave Jones
wood

2
Katharine Mair
oil painting

3
Kay Cotton
mixed media

4
Chloe Williams
jewellery

5
Cyd Jupe
stoneware crank

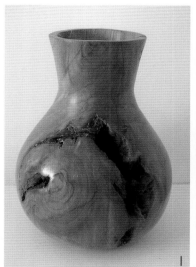

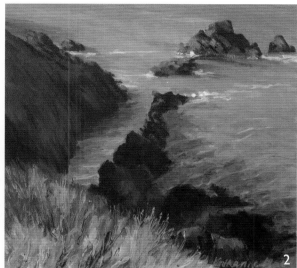

Cry of the Gulls

Cry of the Gulls has developed a strong reputation for showing work of the utmost excellence produced by a diverse range of skilled artists from across the UK.

The gallery showcases the work many established and emerging artists, jewellers, potters and sculptors.

Gallery directors Liz and Julian Davies are both artists with many years experience of working in the arts and supporting artists and makers through many creative and innovative projects.

In 2007 a second gallery was opened in Brighton, managed by their son Nathan Davies.

The successful and easy to use gallery website now includes online shopping facilities, news pages and other useful information.

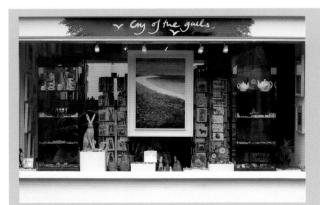

2 Webb Street
Fowey
Cornwall
PL23 IAP

T: 01726 833838
E: info@cryofthegulls.co.uk
www.cryofthegulls.co.uk

Open: Mon - Sat 10am - 5.30 pm
 Sun - 11am - 4pm

P
C
0%

1
Janie Textiles
wool & machine embroidery

2
Mark Houlding
spirit stain on wood panel

3
Les Grimshaw
gold & diamond rings

4
Mark Smith
ceramic/wood sculpture

5
Peter Reeves
silver and 18ct gold amethyst ring

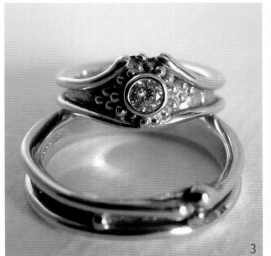

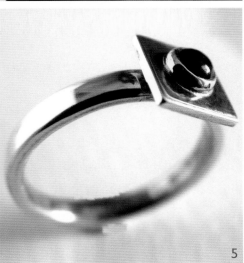

The Devon Guild of Craftsmen

The largest contemporary crafts centre in the South West with Jubilee Gallery, extensive Craft Shop and The Terrace café.

The Devon Guild is the focus of crafts activity throughout the region. Representing over 250 Members (makers) across the full spectrum of crafts from textiles to sculpture, jewellery and mixed media. Membership is open to all working makers (through a rigorous selection process) across the region from Devon, Cornwall, Somerset, Wiltshire, Gloucestershire, Dorset, Bath, Bristol and Swindon.

An inspiring events programme at the Riverside Mill includes talks, workshops, private views, social occasions and trips for a network of Friends, Members and supporters. A Guild flagship event is the Contemporary Craft Fair held in the adjacent Mill Marsh Park in June featuring 160 of the UK's finest designer-makers. Touring exhibitions to national venues, including a 2010 exhibition by John Makepeace the acclaimed furniture maker, put the Guild increasingly at the forefront of contemporary craft culture in the UK.

Riverside Mill
Bovey Tracey
Devon
TQ13 9AF

T: 01626 832223
E: devonguild@crafts.org.uk
www.crafts.org.uk

Open: Daily 10am - 5.30pm
Free admission

1	2	3	4	5
Anne Claxton	Merlyn Chesterman	John Makepeace	Fabrizia Bazzo	Charlotte Rose Harris
ceramics	*print*	*furniture*	*stained glass*	*wallpaper*

The Guild of Ten

The Guild of Ten is a co-operative of Cornwall's finest designer makers who run their own independent outlet from a grade two listed building nestled behind Truro Cathedral. The aim of the Guild is to showcase a diverse range of high quality Cornish made goods whilst supporting the local economy and community of craftspeople. It has been successfully trading for over 30 years.

The Guild is comprised of 16 members who work in all kinds of materials. Five clothes designers create exclusive garments for children and adults using linen, super soft Italian wool and specially dyed cottons and silks. Our well known jewellers produce cutting edge pieces from contemporary hand cast resin, colourful enamelled silver, through to unusual but classic silver and gold. We have two renowned glass designers: one producing exquisite blown glass vessels and the other, artistic fused glass. There are turned bowls, amusing automata and cleverly created puzzles in wood, together with porcelain and oven to table stoneware. Lastly, original cards and hand stitched notebooks are created by our published illustrator.

19 Old Bridge Street
Truro
Cornwall
TR1 2AH

T: 01872 274681
E: info@guildof10.co.uk
www.guildof10.co.uk

Open: Mon - Sat 9.30am - 1.30pm, 2 - 5.30pm

P
C
&

1
Jane Birchley
wood Opi Toys

2
Mike & Gill Hayduk
wood puzzle

3
Corrinne Carr
knitwear

4
Oriel Hicks
stained glass

5
Daisy Dunlop
jewellery

The Guild of Ten

*Malcolm & Jean Sutcliffe

Malcolm has been making glass for over 30 years and for most of that time Jean has worked with him, the Fern bowls have resulted from their first collaboration. Malcolm blows the bowls using rich colours and enjoys the creation of the form and simplicity of the colour; Jean decorates them with the delicate sandblasted fern leaves. 'Coming to live and work in Cornwall has been a very good move for us. My glass has developed and become more free and now Jean is involved in the designs, it has added a whole new dimension.' says Malcolm.

Jenny Yates

Jenny has been creating beautiful hand made gold and silver jewellery in Cornwall for over 20 years. The secret of her success lies in her inventive, unconventional yet wearable designs.

As a result she has a strong following of customers across the country. Her bangles are cut out by hand and worked in such a way as to resemble the feel and look of Cornish granite. Jenny then adds a secret message to the piece.

Leach Pottery Gallery

Higher Stennack, St Ives
Cornwall TR26 2HE
T: 01736 799703
E: office@leachpottery.com
www.leachpottery.com
Open: March - Oct incl. Mon - Sat
10am - 5pm, Sun 11am - 4pm
Check website for all other times.

The gallery showcases the best in traditional and contemporary studio pottery sourced locally, nationally and internationally.

The new Leach tableware is a range of contemporary domestic kitchenware designed by our Lead Potter and made in the Leach studio. Jack Doherty's vision continues the legacy of producing high quality studio pottery and follows Bernard Leach's philosophy that functional everyday objects should also be beautiful.

We also stock a wide range of specialist ceramics books, magazines and postcards, limited edition prints by Breon O'Casey and commissioned jewellery by Daisy Dunlop.

The gallery has a regular and diverse programme of changing exhibitions and events.

"Beauty is here in potfuls!"

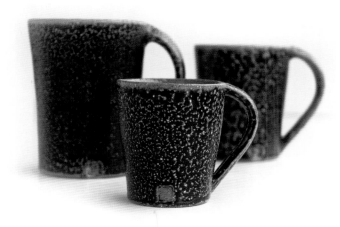

Leach tableware designed by Lead Potter Jack Doherty

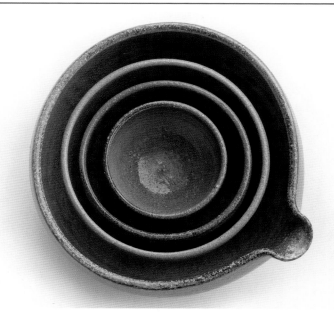

*Mid Cornwall Galleries

Mid Cornwall Galleries is open throughout the year and located on the A390 east of St. Austell. Housed in a former Victorian School, the space has proved perfect for our changing exhibitions.

We choose the work we display for its quality and originality and even, after all this time (we opened in 1980), we never cease to be amazed and delighted at the shows resulting from the incredible diversity of work by our nationally and internationally renowned artists, craftsmen and women living in the UK and Europe.

At regular intervals, throughout the year, we gather together new collections of paintings, etchings, prints, ceramics, (many by Fellows of the Craft Potters Association), blown and formed glass, silks, jewellery, figures in clay, wood and bronze, paper sculptures, turned wood, clocks and mirrors, textiles, collages and many other wonderfully made pieces to create our next display.

We hope you will visit us and enjoy seeing some of the finest original work in the country. A warm welcome awaits you.

St.Blazey Gate
Par
Cornwall
PL24 2EG
T: 01726 812131
E: info@midcornwallgalleries.co.uk
www.midcornwallgalleries.co.uk

P
C
&
0%

Open: All year round, Mon - Sat 10am - 5pm. January 10am - 4:30pm and 11am - 4pm Bank Holidays.

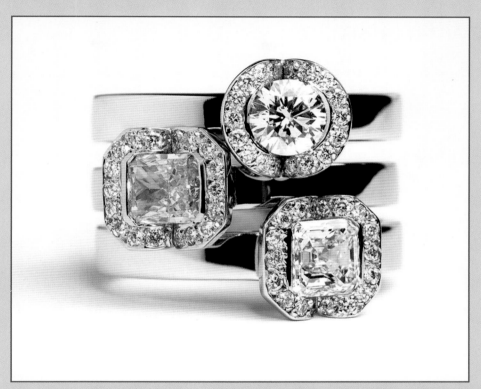

Andrew Geoghegan - Fission cluster trio
page 30

New Craftsman

The New Craftsman is the oldest established gallery and contemporary craft shop in St Ives.

It was started by Janet Leach, an acclaimed potter in her own right and the wife of Bernard Leach. In the 60's she was joined by Boots Redgrave, a highly respected art collector, together with Michael Hunt as manager, a position he still holds today.

The gallery is now owned by Ylenia and Paul Haase Their passion for quality art and craftsmanship continues to maintain the high standards and international reputation for which the New Craftsman is known.

Specialising in paintings by artists living and working in Cornwall, studio ceramics, jewellery and a further range of contemporary crafts including glass, automata, wood and metal sculpture, the gallery aims to have something of quality for everyone. New Craftsman can be found at the foot of the hill that leads from Fore Street to the Barbara Hepworth Museum.

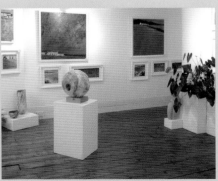

24 Fore Street
St Ives
TR26 1HE
T: 01736 795652
E: info@newcraftsman.com
www.newcraftsman.com

Open: Mon - Sat 10am - 5pm
Please phone for winter
opening times

1
John Ward
ceramic

2
Peter Layton
glass spirale dropper

3
Linda Styles
ceramic

3
Sarah Watson
jewellery

4
Guy Royle
jewellery

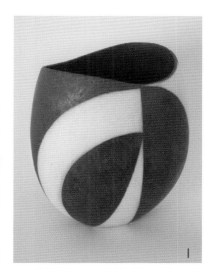

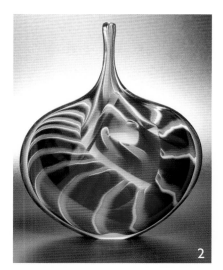

1
Rie Tsuruta
ceramic

2
Rebecca Polyblank
sculpture

3
Tamsyn Trevorrow
ceramic

4
Lawrence Murley
Serpentine clawed crab sculpture

Yew Tree Gallery

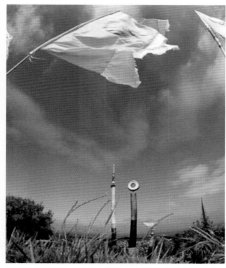

Keigwin,
near Morvah and Pendeen
West Cornwall
TR19 7TS
(On B3306 coast road St Ives-St Just)
T: 01736 786425
E: gilly@yewtreegallery.com
www.yewtreegallery.com
Open: (during exhibitions) Tues - Sat
10.30am - 5.30pm

A fine and applied art gallery for 37 years, Yew Tree Gallery is now in its most attractive location - overlooking the sea in West Cornwall, with moors and ancient sites as a backdrop.

There is a distinct character to the exhibitions curated by Gilly Wyatt Smith - all different but carrying a certain note of continuity. Recent and current exhibitors include potters Sutton Taylor, John Maltby, Charlotte Jones, Prue Cooper, Sue Binns, and Judith Rowe; jewellers Guy Royle, Duibhne Gough, Daisy Dunlop, Gina Cowen and Rita Seres and glass artists Jane Charles, Brian Blanthorn, Malcolm Sutcliffe. Among painters showing now are Breon O'Casey, Rose Hilton, Andrew Waddington, Michael Sheppard and Biddy Picard.

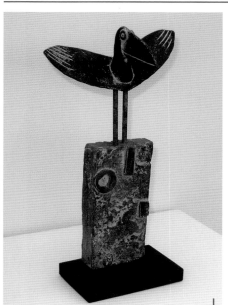

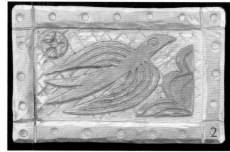

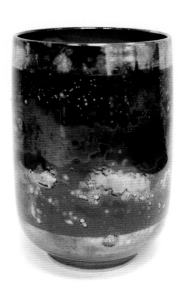

1. John Maltby *'Proud Bird on a Wall'*

2. Guy Royle *silver brooch*

3. Sutton Taylor *tall lustre pot*

Mark Houlding - page 53

Wessex

303 Gallery

Showcasing the best of local talent, the 303 Gallery combines a bright modern space with an informal, welcoming atmosphere. Many of our local artists and craftsmen are internationally renowned; some are just starting out so you can view them here first. Our wide range of art and craft is constantly changing and developing - there is always something fresh to see and enjoy.

Based in a working wood mill, the 303 is the largest gallery in the area, allowing us to display work to suit all tastes, from traditional elegance to fun and funky designs. Fine art and prints, jewellery and glass, silks and sculpture, woodwork and ceramics - most media is represented and we select the very best.

The Gallery is found just off the A303, part of Yandles award winning Woodcentre, in the picturesque and ancient town of Martock. The site is also home to an excellent Hobbycentre which provides all the materials you could want to produce your own work. Round off your visit at The Cedar Tree Café to enjoy freshly prepared lunch or afternoon tea. Access is easy; parking is free.

Yandles Woodcentre
Hurst
Martock
Somerset.
TA12 6JU

T: 01935 825 891
E: 303gallery@yandleandsons.co.uk
www.303gallery.co.uk

Open: 7 days a week from Mon - Sat 10am - 5pm
Sun 11am - 4pm, closed on Bank Holidays

1	2	3	4	5
Prue Biddle *jewellery*	Bev O'Brien *fused glass*	Nicky Clarke *'November Mood' painting*	Bernard Pearson & Ian Mitchell *mixed media sculpture & painting*	Sue Burne *'Siamese Fighting Fish' intaglio glass engraving*

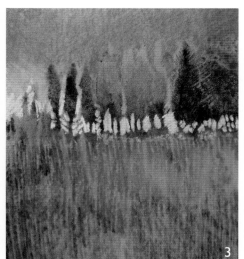

1

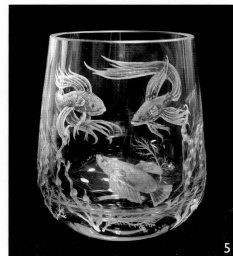

2

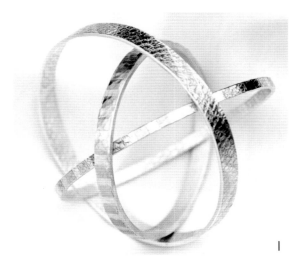

3

4

5

1
Wendy Hermelin
'Road to Litton Cheney' textiles

2
Sue Heys
orchid mirror, stained glass

3
Argento - Rita Harker & Marie Nash *jewellery*

4
Sue Heys
dragonfly lamp

5
Heather Hughes
jewellery

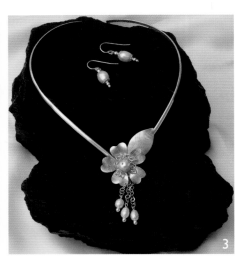

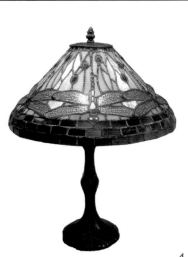

Bluestone Gallery

Guy and Jan Perkins opened the Bluestone Gallery in May 2000. Guy has been a full time professional potter since 1977, and for 20 years lived and worked in the middle of Avebury Stone Circle. Janice shares her time between her education consultancy and jewellery making.

The gallery, in a listed building, is situated in a group of attractive independent shops and cafes. The ancient market town of Devizes is situated close to both Avebury and Stonehenge monuments. The town possesses many architectural gems and boasts the longest flight of canal locks in Britain.

The Downs to the west of Devizes are peppered with burial mounds that once held ancient artifacts made by unknown prehistoric craftsmen. The long tradition of creative British craftsmanship is flourishing to this day, and is given expression in the wide variety of contemporary work to be found in the gallery. We display the work of over 100 potters, jewellers, glass makers, wood turners, print makers and others. You will be made welcome in the peaceful and friendly atmosphere.

8 Old Swan Yard
Devizes
Wiltshire
SN10 1AT

T: 01380 729589
E: guy@bluestonegallery.com
www.bluestonegallery.com

Open: Mon - Sat 10am - 5pm

P
C
0%

1
Jan Perkins
jewellery

2
Mark Sanger
spalted beech

3
Emily Richard
brooch

4
Adam Frew
ceramics

5
Christiane Fischer
jewellery

1

2

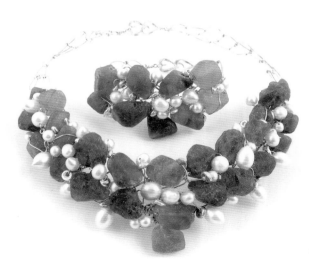

3

4

5

1
Rebecca Lewis
jewellery

2
Peter Berry
stained glass

3
Poppy Dandiya
jewellery

4
Pauline Barnden
ceramics

5
Roelof Uys
ceramics

1

2

3

4

5

Jo Verity

Jo creates beautiful jewellery by using varnished paper beads which she rolls from special origami and hand-printed paper. Combining them with semi-precious stones, glass and silver, this eclectic mix creates colourful distinctive pieces. Paper bead rolling was a traditional craft, popular at the turn of the 19th century.

"By using a traditional technique I feel that I am helping to preserve a small piece of our rich cultural past by giving a historical skill a modern twist.'

Martina Fabian

Martina trained as a Goldsmith and Jeweller in Germany. She now works mainly with gemstones set in silver or gold. The stones provide the starting point for her work. Martina's signature lies in her unusual use of contrast between roughly textured precious metals and beautifully cuts stones in offset or central designs. "Whatever catches my eye inspires my work - purely for the pleasure and joy it gives when designing and making my pieces, but most importantly, the pleasure in wearing the jewellery"

Church House Designs

Church House Designs has been established since 1986 and has the reputation for high quality and imaginative work, with particular emphasis on ceramics, glassware, jewellery and textiles.

We represent over three hundred artists including, Holly Belsher, Amy Cooper, Peter Layton, Tony Laverick, Clare Malet, Debbie Moxon, Nic Rees, Shakspeare Glass, Margo Selby and Richard Wilson.

Artists are selected nation wide to ensure a consistently high level of originality. The gallery is selected for quality by the Crafts Council and is a member of the Independent Crafts Galleries Association.

The friendly and stimulating atmosphere of the gallery has contributed much to the lively village of Congresbury. You can find us in the middle of the village just off the main A370 from Bristol to Weston-super-Mare and within a few miles of Junction 21 of the M5 motorway.

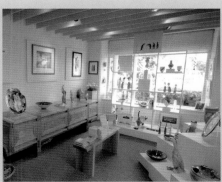

Broad Street
Congresbury
Bristol
North Somerset
BS49 5DG
T: 01934 833660
E: robert-coles@btconnect.com
www.churchhousedesigns.com

Open: 10am - 1pm & 2.15pm - 5pm
Closed Weds, Suns and Bank Holidays

*Dansel Gallery

Visit Dansel Gallery to see cutting edge contemporary woodwork made by over 200 designer craftsmen working in the UK with many from the South West.

Set in a delightful thatched converted stable block near the centre of the village, Dansel houses a superb collection of high quality handmade items with everything on display made in wood and chosen for its design and quality finish. The range includes individually designed pieces of furniture, elegant jewellery boxes, one-off decorative carving and turned work to practical kitchenware, ideas for office items, toys for children and wooden jewellery. Everything is for sale and highlights the inventiveness and versatility of the woodworker.

Selwyn and Danielle Holmes opened the gallery in 1979. It was initially dedicated to selling their own work but soon welcomed other artists in wood to join them. This has created a fascinating selection of woodwork displaying a huge range of timber varieties.

A small café serves fresh coffee and teas. The gallery is near the centre of the village with a private customer car park.

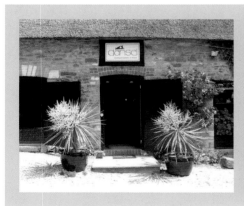 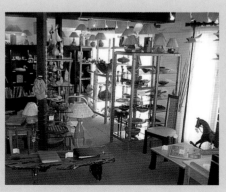

Rodden Row
Abbotsbury
Weymouth
Dorset
DT3 4JL

T: 01305 871515
E: danielle@danselgallery.co.uk
www.danselgallery.co.uk

Open: 10am - 5.30pm everyday

Mark Sanger

After 12 years in the civil sector I became disillusioned and wanted to pursue a creative lifestyle working with wood, this had started during my childhood alongside my grandfather in his workshop.

Woodturning started as a hobby, then I was drawn to the creative side enabling me to express my feelings and thoughts. I produce a variety of turned work enhanced with carving, colour, other media or may just be left in simple form depending on the mood. My work constantly evolves, I see it as an endless journey.

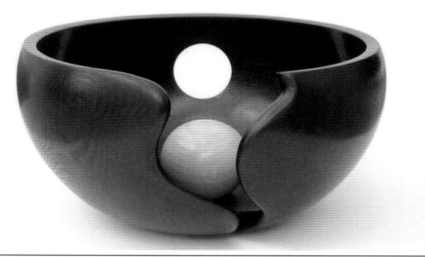

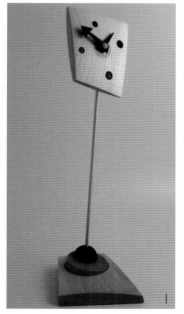

1. Colin Gosden

2. Selwyn Holmes

3. Terry Gilding

Liquid Glass Gallery

The Liquid Glass Gallery displays a varied and changing selection of glass from contemporary British makers, and shows a diverse range of items and techniques, including blown vessels, sculpture, wall art, lighting, tableware, jewellery, recycled glass and glass books and DVDs, there is also a selection of glass and glass related products on the website.

The gallery aims to promote the talent of British glass makers and organises exhibitions at the gallery and other venues. The gallery also showcases the work of the artists in residence, Kim and Thomas Atherton.

The gallery is within The Liquid Glass Centre, which is the UK's foremost independent glass school. The centre is situated in a wonderful riverside location in the beautiful Wiltshire countryside. It offers a year round programme of short courses in glass-making, from glassblowing, bead-making, kiln-formed glass, jewellery and more, for information and a prospectus please check our website. Visitors to the gallery and centre can watch glass making demonstrations and you can book a short lesson by appointment. During the summer months there are cream teas and camping.

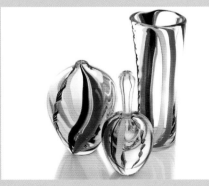

Stowford Manor Farm
Wingfield
Trowbridge
Wiltshire
BA14 9LH
T: 01225 768888
E: info@liquidglasscentre.co.uk
www.liquidglasscentre.co.uk

P C
0%

Open: Tues - Sat 10am - 4pm
 Sun & Mon by appointment

*Makers

Between the Quantock and Blackdown Hills lies the Somerset County town of Taunton where Makers, a thriving craft co-operative, is located. Close to the town centre, Makers can be found in Bath Place, a picturesque, narrow street dating back to the 17th century.

Since its formation in 1984, Makers has gained a reputation for having one of the West Country's finest selections of contemporary crafts. Makers is owned and managed by the makers themselves marketing a varied collection of their own work. A maker is always on duty in the shop to assist visitors or to discuss ideas for individual commissions. Exhibitions by guest artists and craftsmen are held regularly in the light gallery upstairs.

Work includes: knitwear by Buffy Fletcher, jewellery by Bernard Berthon, Pippa Berthon, Holly Webb and Solange, painted silks by Sibylle Wex, pottery by Clio Graham, John Harlow and Mary Kembury, prints and paintings by Mary George and Julia Manning, wood turning by Robert Parker, applied textiles by Ilse Coxon and Jesmonite sculptures by Melanie Deegan.

6 Bath Place
Taunton
Somerset
TA1 4ER

T: 01823 251121
E: info@makerstaunton.co.uk
www.makerstaunton.co.uk

Open: Mon - Sat 9am - 5pm

P
C
♿
0%

Quay Arts

Converted from a 19th Century brewery warehouse, Quay Arts is the Isle of Wight's leading art gallery and venue for live events. Pleasantly located in Newport, the heart of the island, it overlooks the River Medina. Facilities include three galleries, a studio theatre, an award-winning Café/Bar and a Crafts Council listed gallery shop. The Craft Shop is seen as a gallery space within Quay Arts, showcasing quality, contemporary craft from Island and regional makers. Work from over 60 artists is prepresented including; ceramics, glass, textiles, metalwork, wood and jewellery. The atmosphere is welcoming and friendly and visitors are encouraged to browse and enjoy the extensive range of work that is on offer.

Quay Arts aims to support local artists and provides resource through its workshop complex, Jubilee Stores. This second site comprises seven artist studios including a traditional printmaking studio and state-of-the-art jewellery and ceramics suites.

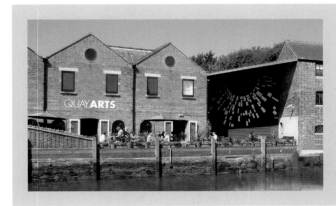

Quay Arts
Sea Street
Newport Harbour
Isle of Wight
PO30 5BD
T: 01983 822490
E: info@quayarts.org
www.quayarts.org

Open: Mon - Sat 9:30am - 5pm
& Thur until 8pm.

1	2	3	4	5	6
Gillian Connor	Nina Bulley	Catherine van Giap	Union of Opposites	Sophie	Dennis Fairweather
wood/driftwood	*jewellery fused glass*	*stained glass*	*jewellery*	Honeybourne	*wood*
(opposite page)			*Photo by Kelly Yates*	*jewellery*	

Rostra & Rooksmoor Galleries

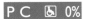

5 George Street
Bath
BA1 2EJ
T: 01225 448121
E: info@rostragallery.co.uk
www.rostragallery.co.uk

Open: Mon - Sat 10am - 5.30pm
Sun & Bank Hols 11am - 4pm

Informal and inviting, Rostra & Rooksmoor Galleries has a refreshing exhibition schedule showcasing all that is new and exciting in printmaking, painting, ceramics, sculpture, designer-made jewellery and craft. One of the South West's most established art galleries we are situated in the centre of the World Heritage City of Bath. Open seven days a week we offer a conservation standard framing service, interest free credit, gift vouchers and an attractive wedding list service.

As well as visiting us we invite you to browse our regularly updated website. See and buy new work from nationally renowned artists such as Sir Peter Blake RA and David Inshaw RWA as well as many other local artists - see some examples below.

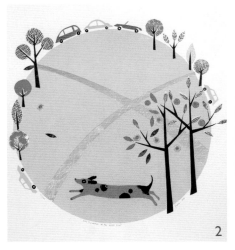

1. Janine Partington *enamel on copper*
2. Jane Ormes *printmaker*
3. Suzie Marsh *sculpture*

Sladers Yard

 P C ▣ ⬧ 0%

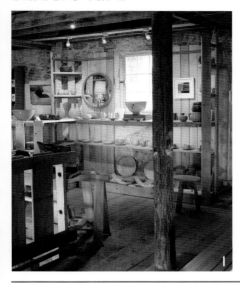

West Bay
Bridport
Dorset DT6 4EL
T: 01308 459511
E: gallery@sladersyard.co.uk
www.sladersyard.co.uk

Open: Tues - Sat 10am - 5pm
Sun 11am - 5pm
Please check times as nights draw in.

Previously a Georgian rope warehouse in West Bay harbour, Sladers Yard's original timber interior makes a stunning showroom for selling exhibitions of contemporary artists and studio ceramicists including Peter Swanson, Joanna Still and Claudia Lis with furniture by Petter Southall.

Interiors, gift and domestic ware by leading British designers and makers include Miss Print's wallpaper, cushions and lampshades, Asaf Tolkovsky's trays, Wallace Sewell and Margo Selby's woven scarves, throws and bedspreads, Jocelyn Pardoe's jewellery, Matt Fothergill's leatherware, baskets, knitwear, clothes, lamps and mirrors. Whatever you need, we can help you find beautiful objects just right for this time and this place.

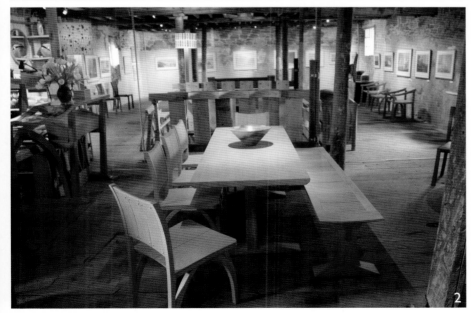

Award-winning designer maker Petter Southall has been making his sculptural furniture at the i tre studio outside Bridport since 1991. His designs are made by hand using boat-building and fine cabinet making techniques. He steam bends solid hardwoods into the arches, twists, curves and rings which distinguish his designs. Finished with natural oils and tactile textures, his furniture is made for everyday use bringing inspiration to the home, office or public space.

1. Claudia Lis ceramics &
 Wallace Sewell textiles
1 & 2. Petter Southall furniture

Strawberry Fish Gallery

`PC`

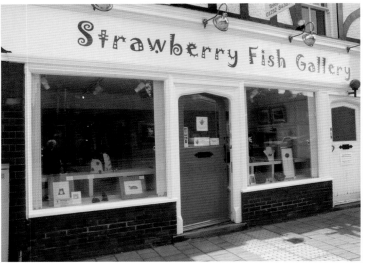

High Street, Hartley Wintney
Hampshire
RG27 8NY
T: 01252 843679
Open: Tues, Thurs, Fri & Sat 10 – 5pm
Wed 10 – 4pm & Sun 11 – 4pm

* quality paintings, prints & photography
* picure framing
* unusual ceramics
* designer jewellery
* stunning glass
* bronzes
* hand embroidered silk handbags & accessories
* design led greetings cards
* exquisite gifts

1. John Connolly *painting*

2. Christine Cummings raku

3. John Connolly *'On the Way to Glencoe'*

Walford Mill Crafts

Walford Mill Crafts is the place to visit if you are looking for the very best quality in contemporary craft and design.

The Mill opened as a craft centre in 1986 and is selected for quality by the Crafts Council. On the northern edge of the market town of Wimborne, the eighteenth century mill is a local landmark set in the idyllic grounds by the ancient Walford Bridge beside the River Allen. It is now a popular attraction, both for local residents and for visitors to Dorset.

This centre of excellence presents high quality craftwork by local and national makers in its craft shop including textiles, wood, jewellery, glass, ceramics and metal work. There are approximately seven different exhibitions annually in the gallery, featuring work by local, national and international contemporary makers.

Walford Mill is managed by Walford Mill Education Trust, a registered charity. An active programme of workshops and exhibition-linked events for adults and children as well as for the whole family are run throughout the year.

Meet the resident designers and makers in silk weaving and jewellery to appreciate their expertise in creating designs and creating special commissioned pieces.

Walfod Mill Crafts
Stone Lane
Wimborne
Dorset BH21 1NL

T: 01202 841400
E: info@walfordmillcrafts.co.uk
www.walfordmillcrafts.co.uk

Open: Mon - Sat 10am - 5pm.
Sun 11am - 4pm

P
C

0%

Shop Interior

Debby Kirby

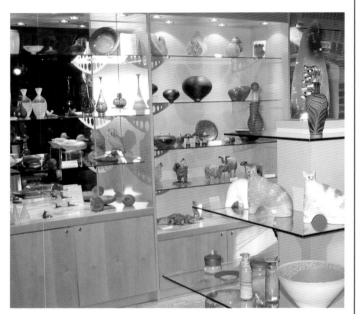

The Mill has a licensed restaurant The Bistro at the Mill. Whether you want to relax with a cup of coffee, enjoy a bowl of soup, spoil yourself with a cream tea or you wish to sample a delicious home-made 'special' dish of the day, the Bistro is the place to visit.

There is an adjacent car park for Walford Mill's visitors. The gallery, craft shop, restaurant and grounds are fully wheelchair accessible with facilities for disabled visitors.

Debby Kirby has her workshop on the mezzanine floor at Walford Mill Crafts, which is open to the public most days. She hand dyes fine silk and, designs and weaves it into a wide range of individual colourful items. Her range includes scarves, bags, purses and cushions, as well as wall hangings and framed pieces, that incorporate hand printed paper.

'My ideas come from different sources, mostly beginning with studies of light in nature and the environment. I am also inspired by architecture and interesting buildings, and sky-lines. My designs are usually simple in structure allowing the silk to speak for itself.'

There is always a wide selection of work for sale direct from her workshop.

For opening times please call 01202 841400.

Kathryn Arbon

Kathryn Arbon has been designing and making jewellery for over 15 years. She has developed different ranges, exploring new techniques. Her work takes inspiration from many sources, patterns and textures from nature, and many feature unusual pieces in silver and 18ct gold.

At present Kathryn is making a colourful range of Anodised Aluminium jewellery in which some pieces incorporate semi-precious gemstones, silver and gold. Every piece is printed with a chosen design and then hand painted, the colour being built up gradually in a controlled manner, each item of jewellery is different.

Kathryn has always had an interest in gemstones, and is currently studying for her FGA Diploma in Gemmology by correspondence. With this in mind, it is always a pleasure for her to design privately commissioned pieces, particularly Wedding and Engagement rings.

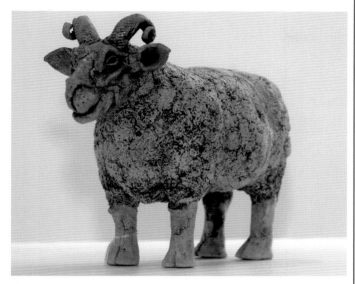

Anne-Marie Marshall

Anne-Marie has drawn and modelled animals from an early age. She gained a degree in ceramics from Middlesex University in 1992 and went on to set up her studio in the New Forest, where she was inspired by the animals.

Her travels around the world enabled her to study wild animals first hand, in Africa, America and Australia. Anne-Marie's more recent work is based on domestic animals and current pieces feature hares, rooks and dogs.

Anne-Marie uses a variety of techniques to construct her work including slab building, press moulding, pinching and coiling. Interesting surface textures are achieved by experimenting with rolling the clay on a variety of materials. The pieces are coloured with oxides and under glazes and fired up to 1200 centigrade.

Yarmouth Gallery

Located at the most westerly corner of the Isle of Wight, you will find us tucked away at the far end of Yarmouth High Street, just off the Square, five minutes stroll from the harbour and ferry terminal. The artist run gallery was established in 1997 and hosts a rolling exhibition of ceramics, glass, jewellery, textiles, paintings, art prints and photography. We show work by artists from the Island and around the UK in a calm, white space. We try to create a balanced display which includes well established names and talented new designer makers.

If you need more than one reason to visit, add in the river estuary nature reserve, Henry VI I I castle, nice pubs, restaurants and cafes. Yarmouth is the start point for several glorious walks and from here it is also easy to access all parts of the Island by bus.

Foresters Hall
High Street
Yarmouth
Isle of Wight
PO41 0PL
T: 01983 760226
E: info@yarmouthgallery.com
www..yarmouthgallery.com
Open: All year 10am - 5pm Mon - Sat,
11am - 4pm Sun
(hours may vary in winter)

P
C
0%

1	2	3	4	5	6
Gillian Chapman *textiles felt (opposite page)*	Paul Smith *sculpture*	Alli Allen *wire crochet jewellery*	Isle of Wight Studio Glass	Bill Mount *wood*	Neil Tregear *ceramics*

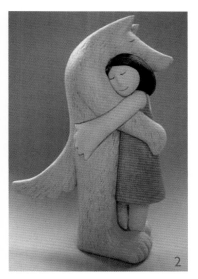

2

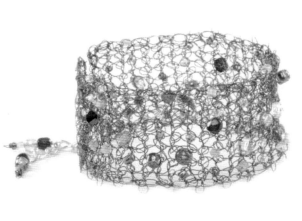

4

3

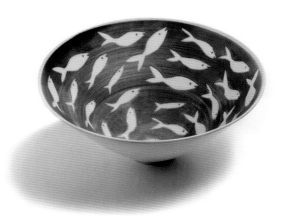

6

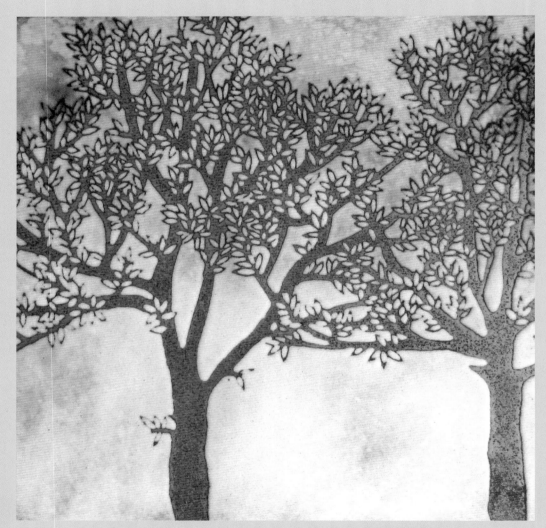

Janine Partington - pages 82, 90 &156

London & South East

Blue Duck Gallery

The Blue Duck Gallery is situated in Caversham which is just north of the Thames river and forms part of the Thames Valley town of Reading. We are 25 minutes from London and just 10 minutes from the beautiful Henley-on-Thames.

Opened in 2005 by Clare Varley, the gallery has gone from strength to strength. Our varied content has been carefully selected by Clare, and as a result we have managed to build a reputation for quality which extends right across the ranges we exhibit. There is a wonderful mix of work by leading artists from around the UK and also by some of the best artists and crafts-people in the local area.

We have become particularly well known for our fantastic jewellery collections by such names as Goodman Morris, Alexis Dove, Emily Nixon and Karen Van Hoff and also for our stunning paintings by local artists Paul Gunn and Howard Birchmore. The choices don't end there however. We also have ceramics, glass, prints, Hannah Nunn lighting, wood, mixed media sculpture and cards and recently we have added a small collection of children's clothes and toys.

16 Hemdean Road
Caversham
Reading
Berks
RG4 7SX

T: 0118 9461003
E: info@theblueduckgallery.co.uk
www.theblueduckgallery.co.uk

Open: Tues - Sat 10am - 5.30pm, Sun 11am - 4pm

P
C
&
0%

1	2	3	4	5
Kirsten Jones	Goodman Morris	Karen Van Hoff	Paul Gunn	Jo Barry
painting	*jewellery*	*jewellery*	*painting*	*etching*

1

2

3

4

5

Brass Monkeys

Jewellers and silversmiths Samantha Maund and Jenifer Wall originally set up the aptly named Brass Monkeys in a freezing mechanic's garage in February 2002. It quickly evolved into a busy, creative workshop with 12 makers, and became a popular venue on the Brighton Festival Art Trail.

Following its success, Samantha and Jenifer decided to relocate to warmer premises. They found an old second-hand furniture shop to renovate and transformed it into a delightful gallery in 2007, with workspaces for eight resident makers. They have quickly established a reputation for selling beautiful, unusual and affordable hand made jewellery and metalwork by over 35 established and emerging British designer-makers. The range includes colourful earrings made from recycled bottle tops, forged and etched pendants, gem studded rings and fused glass cufflinks.

Brass Monkeys also showcases an exciting mix of silverware and metalwork, with hand raised and etched bowls, anticlastic work, spectacles cases and lockets. Solo exhibitions and featured artists ensure regularly changing collections of work throughout the year whilst the on-site workshops enable bespoke commissions.

109 Portland Road
Hove
East Sussex
BN3 5DP

T: 01273 725170
www.brassmonkeys.org.uk
E: brassmonkeys@me.com

Open: Tues - Sat 10am - 5pm

P
C
&

1
Gabriella Casemore
silver pendant

2
Ruth Wood
silver gilt glass ring

3
Alison Macleod
Victoriana necklace with curiosity

4
Jenifer Wall
silver and gold pendants

5
Samantha Maund
silver tubular brooch

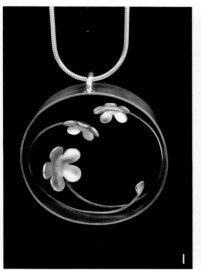

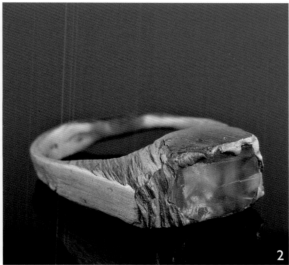

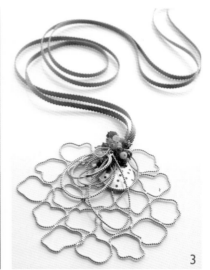

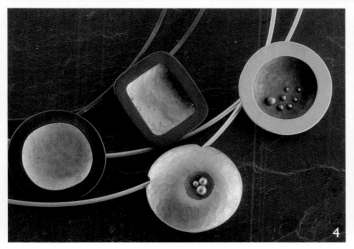

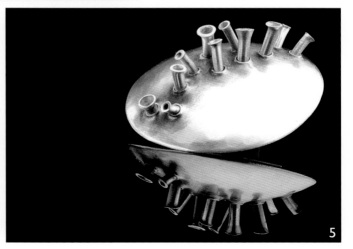

Contemporary Applied Arts

Contemporary Applied Arts (CAA) is London's flagship venue for the appreciation and purchasing of the best of British contemporary craft.

Situated in the West End, CAA profiles the work of 300 members, representing the UK's leading talent. Our members include established makers and those who are at the beginning of their careers.

CAA has a dynamic exhibition programme which runs nine main exhibitions a year and a series of focus showcases alongside it.

The changing annual exhibition programme explores the disciplines of glass, ceramics, textiles, wood, metal, jewellery, and silver. Contextual material offers insight into the various making processes involved and their creative enterprise.

CAA has a wide range of changing purchasable stock and a full commissioning service.

1

2

2 Percy Street
London
W1T 1DD

T: 020 7436 2344
E: sales@caa.org.uk
www.caa.org.uk

Open: Mon - Sat 10am - 6pm

P
C
&
0%

1	2	3	4	5	6	7
Sun Kim	Mark Nuell	Claire Curneen	Katie Walker	David Clarke	Michael Ruh	Anna Raymond
ceramic	*jewellery*	*ceramic*	*furniture*	*metal*	*glass*	*textiles*
(opposite page)	*(opposite page)*					

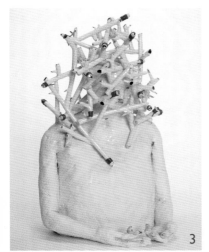

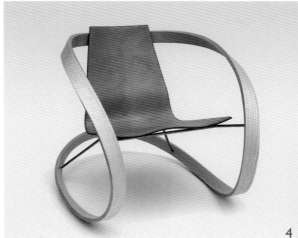

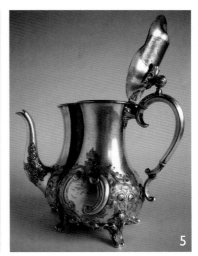

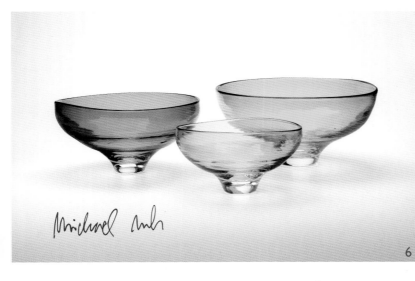

Cry of the Gulls

Cry of the Gulls is now established as one of Brighton's brightest contemporary art and craft galleries and can be found in Meeting House Lane. The gallery space is exceptionally light and airy with a welcoming atmosphere and helpful staff.

Cry of the Gulls in Brighton is the second gallery to be opened by husband and wife Julian and Liz Davies. They are now joined by their son Nathan, a painter who manages the Brighton gallery which, like their gallery in Fowey, showcases the work of many well-established and emerging artists, jewellers, potters and sculptors.

Cry of the Gulls has gained a strong reputation for showing work of the utmost excellence. The successful and easy to use gallery website includes online shopping facilities, news pages and other useful information. Please check our website for more details.

32 Meeting House Lane
Brighton
BN1 1HB

T: 01273 734347
E: info@cryofthegulls.co.uk
www.cryofthegulls.co.uk

Open: Mon - Sat 10.30am - 5.30pm,
 Sun 11am - 5.00pm

P
C
⬛
♿
0%

1
Ben Barker
porcelain

2
Rokz
jewellery

3
Stonesplitter
raku clock

4
Kevin Warren
ceramics

5
LeJu Naturally Dyed
ivory and silver

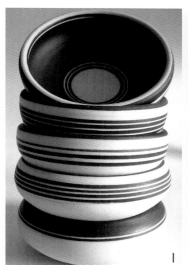

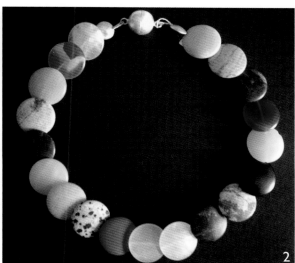

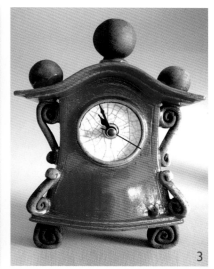

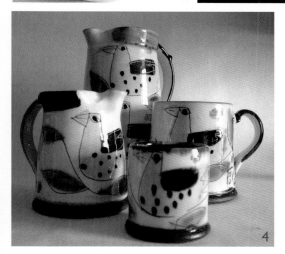

Contemporary Ceramics

Contemporary Ceramics opened at Somerset House in March 2009. The Gallery showcases the best in contemporary studio ceramics by the members of the Craft Potters Association. Nationally and internationally renowned makers such as John Ward and Walter Keeler can be seen alongside emerging makers.

A changing exhibition presents individual makers whose work illustrates the current diversity of thought and making processes practised across this discipline. The venue provides a striking and lively context in which both contemporary and traditional studio ceramics sit side by side, a setting where the everyday function of handmade mugs and bowls can be enjoyed alongside the aesthetic considerations of stand-alone pieces.

Contemporary Ceramics is located in the Courtyard Room, within the South Wing. It is close to the Seamen's Hall, which links the Fountain Court and River Terrace, where coffee and cakes from The Deli café can be enjoyed.

Contemporary Ceramics moved from its previous venue on Marshall Street. The gallery is also looking for larger premises in the Bloomsbury area. Please check the blog for details.

Contemporary Ceramics
Somerset House
The Strand
London
WC2R ILA

T: 0207 836 7475
E: contemporary.ceramics@virgin.net
www.contemporaryceramics.blogspot.com

Open: Tues - Sun 10.30am - 6pm

London Glassblowing

Peter Layton's London Glassblowing is a hot glass studio focused on the creation and display of contemporary glass art. The studio has a reputation as one of Europe's leading glassmaking workshops with a particular flair for the use of colour, form and texture.

Peter Layton produces individual pieces of decorative glass in sculptural and functional forms. The work is free blown, permitting a greater degree of involvement and attention to detail than is possible on standardised production and ensuring the individuality of each piece. It is the studio's philosophy that each object should be a one off and signed by the artist.

Visitors to London Glassblowing may experience the heat and magic of the ancient craft of glassmaking while watching a gather of molten glass evolve into something of value and beauty.

Peter Layton's glass is available through the studio's own Glass Art Gallery in addition to galleries and exhibitions in the United Kingdom, Europe and America.

Illustrations from left:
Paradiso Shellform & Skyline both by Peter Layton

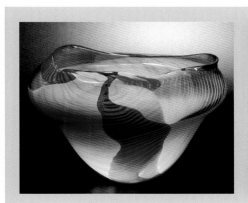
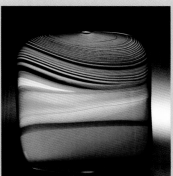

London Glassblowing &
Glass Art Gallery

For more details please contact:

E: info@londonglassblowing.co.uk
www.londonglassblowing.co.uk

*Fire and Iron Gallery

Fire and Iron Gallery was founded in the 1980s in response to a global resurgence of interest in forged iron as a creative medium. Its aim was to showcase the work of British black-smiths and provide a platform for the promotion of a national craft showing small sparks of life after decades of decline.

Through the nineties and noughties, owner Lucy Quinnell expanded the scale and the scope of the gallery to incorporate other disciplines within the field of art metalworking. Today, Fire and Iron represents 200 British and international makers working in technically diverse ways with iron, steel, stainless steel, aluminium, zinc, copper, bronze, brass, tin, pewter, silver, gold, titanium and scrap metal. Special exhibitions and demonstrations complement extensive permanent displays.

From jewellery to sculpture, commissions are undertaken by Fire and Iron's exhibiting makers, and also on site by Lucy and her husband Adam Boydell, who together form an award-winning team specialising in public art projects.

Fire and Iron Gallery is set in the picturesque outbuildings and gardens of a Plantagenet house built in 1346, and is proud to be a green company.

RHS Gold Medallist 2008

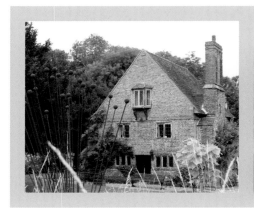
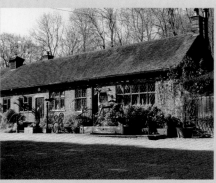

Fire and Iron Gallery
Rowhurst Forge
Oxshott Road
Leatherhead
Surrey KT22 0EN

T: 01372 386453
E: lucy@fireandiron.co.uk
www.fireandiron.co.uk

Open: Tues - Sat 10am - 5pm

P
C
0%

1
Lawrence Walker
balustrade panel
mild steel

2
Claire Malet
vessel
steel, gold

3
Jenny Pickford
sculpture
galvanised steel &
glass

4
Martin Jakowitsch
wheelbarrow spoon
found object,
recycled metal

5
Carlos Dare
fox
aluminium

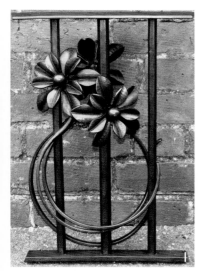

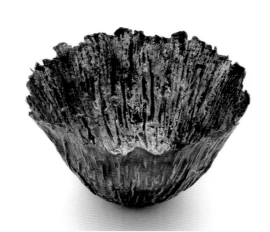

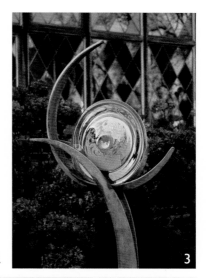

*New Ashgate Gallery

New Ashgate Gallery and shop is an educational charity, which exhibits contemporary fine art and craft in a beautiful grade II listed building, conveniently located in the historic Georgian town of Farnham.

A varied collection of ceramics, paintings, prints, glass, jewellery, textiles, wood and metalwork, and a wide range of prices ensures something for everyone.

You are welcome to browse or buy in a relaxed and friendly environment. Our aim is to make viewing and collecting art an enjoyable and rewarding experience. We have continually changing exhibitions of quality work, by highly regarded artists and makers, alongside new and exciting talent. We promote fine art and craft through our programme of exhibitions, projects with artists and various educational events.

Any purchase is helping to support the charity and to provide a livelihood for all the artists and makers who exhibit here, and at the same time you are taking away a quality, handmade, and special item. The gallery operates the Arts Council's Own Art interest free loan scheme which offers loans between £100 and £2000, gift vouchers, a wedding list service, and online purchasing from our website.

Wagon Yard
Farnham
Surrey
GU9 7PS

T: 0252 713208
E: gallery@newashgate.org.uk
www.newashgate.org.uk

Open: Tues - Sat 10am - 5pm

P
C

0%

1	2	3	4	5
Justin Cooke	Jane Muir	*Ruta Brown	Sanders & Wallace	Emma Dunbar
painting	*sculptural ceramics*	*jewellery*	*glass*	*painting*

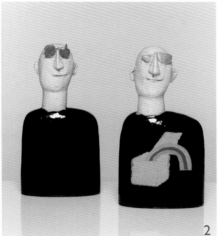

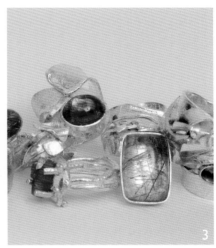

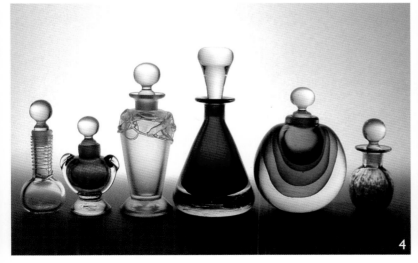

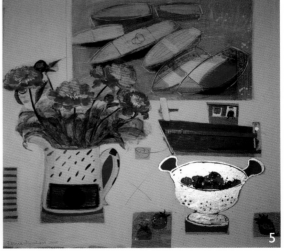

Oxo Tower Wharf & Gabriel's Wharf

You may have walked along London's Southbank, and passed the landmark Oxo Tower, once the home of the OXO cube, which was made and exported from here all over the world. It is now a thriving mixed use development including galleries community housing, shops and design studios and restaurants.

The following pages present a taste of the selection to be found at the Oxo Tower Wharf and nearby Gabriel's Wharf.

All those featured are small businesses run by designer makers. There is also a range of bars, cafés and restaurants with indoor and outdoor seating, where you may relax after exploring these Aladdin's Caves.

Gabriel's Wharf also started life over 20 years ago, as a tenuous community of designer makers, amidst the major changes which were happening along the Southbank. It has now grown into a flourishing group of established designer workshops, restaurants and bars and hosts a number of summer festivals and music events.

Please check the logos, in the title bars, to see where each gallery is situated - Oxo or Gabriel's Wharf.

Oxo Tower Wharf
Bargehouse Street
South Bank
London
SE1 9PH

Both - E: oxo@coin-street.org

Gabriel's Wharf
56 Upper Ground
South Bank
London
SE1 9PP

www.gabrielswharf.co.uk

Southbank Printmakers

P C ▣ ⬚ 0%

Unit 12, Gabriel's Wharf
56 Upper Ground SE1
T: 0207 928 8184
www.southbank-printmakers.com
Open: Daily from 11.30am

GABRIEL'S WHARF

Southbank Printmakers is a co-operative of contemporary print-makers who run their own gallery in Gabriel's Wharf. A wide range of work is available, with all printmaking methods represented. Many of the artists exhibit regularly at the Royal Academy Summer Exhibition and the Royal Society of Painter-Etchers.

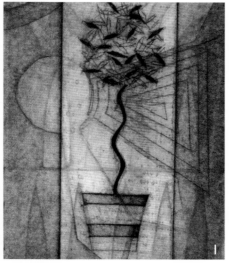

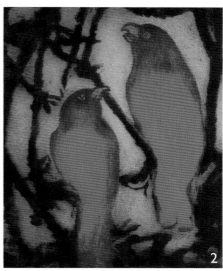

1. Diana Croft - *Garden Forms 2*
2. Susie Perring - *Repeat After Me*
3. Mychael Barratt - *Venus and Mars Multitasking*
4. Karen Keogh - *Forest*
5. Emiko Aida - *Koinobori*

David Ashton

G2 OXO Tower
Ground Floor Riverside
Barge House Street
Southbank
London SE1 9PH
T: 020 7401 2405
E: info@davidashton.co.uk
www.davidashton.co.uk
Open: Tues - Fri 11am - 5.30pm,
Sat 11am - 5pm.
Sun during summer Noon - 4.pm.
Closed Monday.

David has recently moved to the OXO tower, ground floor riverside. Working in 18ct Gold, Platinum and the very finest gemstones, a majority of work is to commission. The shop and workshop are combined allowing the customer to directly interact with the manufacturing process.

David is known for producing jewellery to the very highest standards, and his signature style is combining yellow and white 18ct Gold to create striking effects. If a stone is required, Davids extensive knowledge and stock of loose gemstones allows the customer to select something they understand, truly love and is special to them.

Sotis Filippides

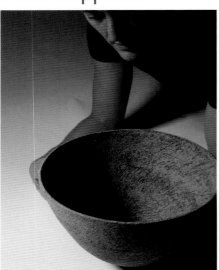

The Wheel, 16 Gabriel's Wharf,
56 Upper Ground, South Bank
London SE1 9PP.
T: 020 7401 2782
M: 077 3315 1276
E: sotis@sotis.co.uk

GABRIEL'S WHARF

Open: Weds - Sun 11am - 6pm
or by appointment.

The Wheel, owned and run by Sotis Filippides offers a wide range of ceramics with a true passion for nature. It is fresh and inspiring to find these handmade pieces. After humble beginnings as an enthusiastic young artist, Sotis developed his love of ceramics and 3D arts after graduating from Athens School of Ceramics.

Natural oxides - copper and iron are used, with rustic and deep earthy tones being married perfectly with bright colours. Rough textures and surprisingly light ceramics are a trademark for Sotis.

There is an element of simplicity to the glazed shapes, without doubt the intention of the artist. He also intends the work to represent organic matter. A truly fascinating array of pieces can be found with prices starting at £70.

Josef Koppmann

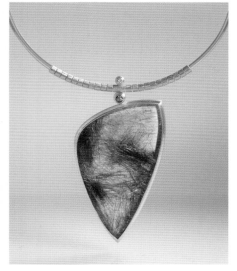

P C 🖳 ♿ 0%

1.22 OXO Tower Wharf
Barge House Street
London SE1 9PH
T: 020 7928 6252
M: 07960 456 976
E: mail@josefkoppmann.com
www.josefkoppmann.com

Open: Mon - Sat 11am - 6pm
(or by appointment)

My collection is constructed and forged of sterling silver and 24ct gold with unusual semi precious and precious stones. I add playful elements to clear solid forms and tactile finishes; the stone's shape often dominates and leads the direction. Playing with symmetry my new line is transgressing from the organic and leaning towards more geometrical shapes. The abstractly textured, rich pure gold, is offset by the coolness of the brushed silver. A carefully chosen range of new coloured stones, such as transparent quartz in which copper coloured, black/golden needle formations create, breath-takingly beautiful patterns. Each piece is individually crafted, creating bold dimensions and a dramatic statement.

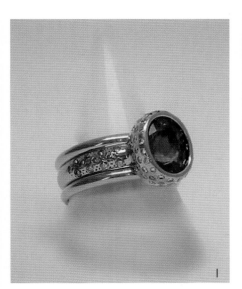

1. David Ashton - *Emerald, yellow and white diamond ring, set in 18ct Gold and Platinum*
2. Sotis Filippides
3. Josef Koppmann *Silver and 24ct gold ring with rutilated quartz*

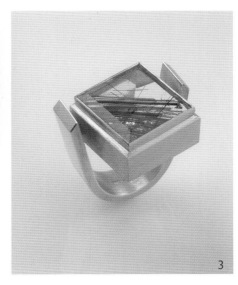

Skylark Galleries 1 & 2

The Skylark Galleries are based in a central location, just minutes from Tate Modern and the London Eye, and near Waterloo station. These two artist-run galleries have been operating in Gabriel's Wharf, South Bank, London since the mid 90s and in Oxo Tower Wharf since 2001.

Skylark 1 Gallery, the original one, is nestled in Gabriel's Wharf along-side many other colourful, original shops and cafes. Skylark 2 Gallery, is situated in the nearby Oxo Tower Wharf, over-looking the Thames from the first-floor walkway.

Much of the galleries' success comes from the fact that they are run by the artists whose work is on display there. The galleries are friendly and inviting and visitors soon discover with interest that they are talking to an artist.

Skylark Galleries provide a perfect opportunity for developing and established artists to show and sell their work from a central location, while gaining valuable experience of running a gallery. The group of over 30 artists also form an informal network for sharing ideas, skills, knowledge and supporting each other in their careers.

As well as running the two galleries on the South Bank, gallery artists also take part in several art fairs and external exhibitions throughout the year which allow them to promote the Skylark Galleries in different parts of the country.

1.09 Oxo Tower Wharf
(First Floor Riverside)
Bargehouse Street
T: 020 7401 9666
Gabriels' Wharf
56 Upper Ground
T: 020 7928 4005
both at: London SE1 9PH
E: info@skylarkgalleriescom
www.skylarkgalleries.com

Loli Cardenoso

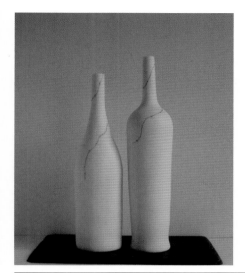

Loli has been a member since 2008, her porcelain work focuses on every-day simple, contemporary vessel forms and wall plaques. Her pieces are often unglazed and her use of colour is sparing but striking.

"Painting and traditional pottery are the main points of inspiration. I find still-life compositions particularly compelling due to the quiet contemplation they suggest."

She studied at Central St Martins and has taken part in numerous exhibitions both nationally and inter-nationally and in many publications.

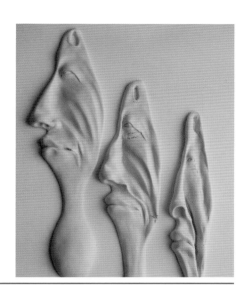

Gill Hickman

Artist Gill Hickman has been the Director of Skylark Galleries since 1999. Her work derives from textures and layers in the environment and is autobiographical in nature.

She creates embossed collages using fine papers and highly textured mixed media paintings inspired by Healthy Human Cells often embellished with gold and silver leaf.

1
William Frost
Butterfly City mixed media & acrylic on canvas

2
Ruty Benjamini
'Emerge' Stoneware Jug Form, ht 35cm. Photo: Peter Donnelly

3
Michelle Ewell
Amaryllis limited edition digitla print

4
Clare Johnson
Temple to Power 3 Lmited edition screen print

Little + Collins

Little + Collins was established over 15 years ago by Jenni Little and Teresa Collins to design and produce contemporary hand tufted rugs, runners and wall hangings. These are individually made and a selection can be seen at their studio gallery on the second floor of the Oxo Tower. Creativity, craftsmanship and quality are recognised hallmarks of theirs.

Jenni Little and Teresa Collins are textile designers, renowned for their use of delicious colour and refined texture. The limited edition collections have a distinct design identity and sensual colour palette which is inspired by landscape and architecture, creating an appeal that is as much tactile as it is visual. The latest rug collection has an organic feel due to the added dimension of silk, which has the effect of enriching the subtle colours and textures.

Bespoke commissions are welcome and we often work in close partnership with clients to create a one-off, beautiful and functional textile artwork.

Illustration: 'Shadow Tree'

2.10 Oxo Tower Wharf.
(2nd floor courtyard)
Barge House Street.
London SE1 9PH
T: 020 7928 9022
E: jenni.teresa@littlecollins.co.uk
www.littlecollins.co.uk

Open: Mon - Fri 11am - 6pm,
other times, weekends and
commissions by appointment

Alan Vallis at OXO

Alan Vallis at OXO with its newly refitted gallery and workshop space provides Alan with a central London location to showcase his collection of jewellery. The gallery on the second floor overlooks the Oxo courtyard where coffee shops provide meeting places for both local business people and visitors wishing to explore the cultural hotspots of London's South Bank.

A new selection from the Pevsner ring series is illustrated, see images nos 1, 2 & 5.

Opposite page:
'Stacking Rings' are one of Alan's most enduring and versatile ring series. The decorative patterns, textures and colours of the Middle East influenced these rings, which consist of multiple bands worn together as a group. The two outer bands, form 'book-ends' to the rest of the group, which can be textured, smooth or patterned. Stones can be mounted on the central bands to form a coherent and exciting combination of form colour and pattern. The two necklaces are one off specially commissioned pieces.

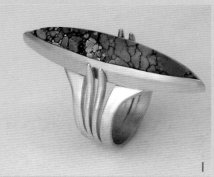

1

209 OXO Tower Wharf
Bargehouse Street
London
SE1 9H

T: 020 7261 9898
E: alan@AlanVallis-oxo.com
www.AlanVallis-oxo.com

Open: Tues - Sat 11am - 6pm

1
Pevsner marquise cut mottled turquoise, gold setting on silver shank

2
Pevsner ring in 18ct. white gold with Aqua-marin

3
Rubelite stone, white diamonds - strung on faceted black diamond beads

4
Stacking ring in 18ct white gold with diamond 'swish' and pink Sapphire

5
Pevsner with marquise cut Chalcedony

6
Commission - antique carved coral cherub and three rows of coral beads

7
Stacking ring with marquise cut Opal, Diamond, Ruby and Tanzanite

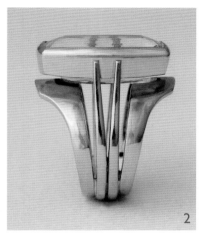

2

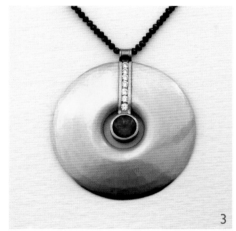

3

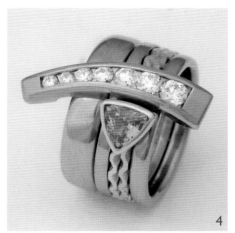

4

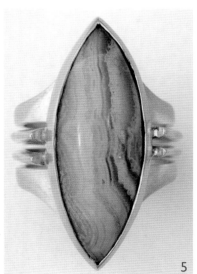

5

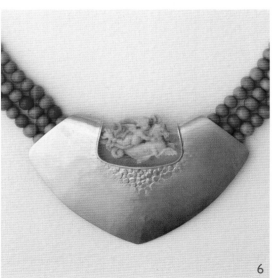

6

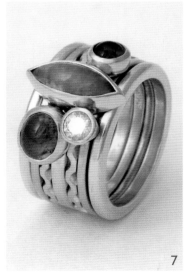

7

Sussex Guild Gallery

The Sussex Guild Shop can be found in the stunning 17th century Southover Grange, just minutes from Lewes train station, where there is a car park, or there is metered parking in the roads around the Shop. Adjacent to the Shop, in the lovely Southover Gardens, is a refreshment kiosk, open during the summer months, offering excellent sandwiches, drinks and delicious homemade cakes.

The Shop is staffed by Guild members and visitors will find a diverse range of contemporary fine crafts. Members' work includes a dazzling selection of hangable and wearable art: glass, silversmithing, jewellery, furniture, printmaking, ceramics, metalwork, textile art and much more.

The Sussex Guild was established in 1970 and is a selected group of 90 professional designer-makers from Sussex and the surrounding counties. The Guild's aim is design excellence, innovation and the promotion of the highest quality in contemporary and traditional crafts.

Sussex Guild Contemporary Craft Fairs are held in beautiful rural locations all over the county. Each show displays a variety of members' work, they provide the opportunity to see some demonstrations and meet the makers.

Illustration: Mohammed Hamid at his wheel at Michelham Priory.

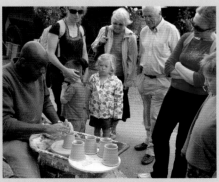

North Wing
Southover Grange
Southover Road
Lewes
East Sussex
BN7 1UF
T: 01273 479565
E: guildshop@thesussexguild.co.uk
www.thesussexguild.co.uk
Open: 7 days a week 10am - 5pm

P
C
0%

1 Harriet Appleby
scarves

2 Helen Millard
glass

3 Lorraine Gibby
cuffs

4 Alexis Dove &
Justin Small
stacking rings

5 Julian Stephend
silver

6 Sylph Baier
ceramic teapot

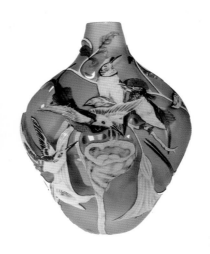

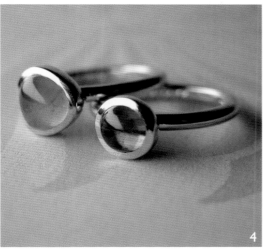

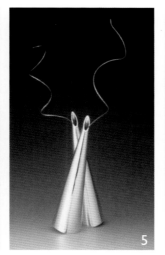

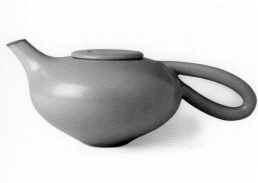

Vessel Gallery

 P C ▣ ⬚ 0%

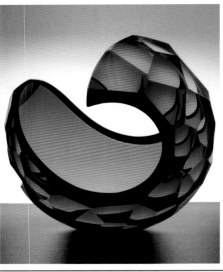

114 Kensington Park Road
London
W11 2PW

T: 0207 727 8001
E: info@vesselgallery.com
www.vesselgallery.com

Open: Mon - Sat 10am - 6pm

Vessel Gallery is the authority on contemporary glass, design and lighting, a destination for all those who appreciate beautiful pieces both to look at and use.

From the stunning simplicity of Scandinavian crystal, via flamboyant Italian art glass, to the best of British creative talent, all the work has been carefully edited to show an un-paralleled selection of contemporary design and craft, the complete antithesis to the generic glass and crystal ware that is so often found in larger department stores.

Vessel also consults for interior and corporate projects, providing a truly bespoke service resulting in an entirely individual work of art
Illustration:
Lena Bergstrom - *crystal*

Zest Contemporary Glass Gallery

P C ⬚

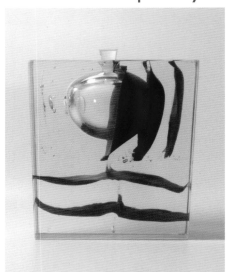

Roxby Place (end of Rickett Street)
London
SW6 1RS

T: 020 7610 1900
E: nell@zestgallery.com
www.zestgallery.com

Open: Tues - Sat, 10am - 6pm

Zest Gallery is internationally recognised as London's destination for contemporary glass art. Founded in 2003 by glass artist Adam Aaronson, Zest brings outstanding British and international glass to a wider audience through an exciting exhibition programme alongside an extensive collection of Adam's work.

We run varied and innovative events throughout the year, as well as offering visitors the chance to enjoy a fascinating insight into the skilled process of glass making in Adam's adjacent studio.

If you're feeling more adventurous you can try your hand at glassblowing on one of our half-day courses!

Illustration: Metamorphosis 0109
by Adam Aaronson
Photo: Corinne Alexander

Eastern

Artworks-mk

artworks-mk is based at Great Linford Arts Workshop, situated in the beautiful surroundings of Great Linford Park in Milton Keynes. The heritage site comprises a 600 hundred year old barn which houses the main exhibition space, coffee bar and general office. Across the court-yard is the Radcliffe building which is home to a large Ceramics studio, a fabulous light and airy Art Room, a 3d workshop with a range of lathes and wood working equipment and a specialist silver-smithing and jewellery studio. A delightful row of 17th century almshouses provide studio spaces for artists and makers and two pavilions provide further work-shop, meeting and studio provision for artists including the Milton Keynes Print Makers.

artworks-mk have an on going programme of exhibitions, averaging 8 – 10 per year, showing contemporary craft and art from established and emerging artist / makers. There is a Craft Sales Area within the coffee bar showing new work every three months.

artworks-mk is an arts education charity and provides a diverse range of artist led activities, workshops and events, throughout the year. Workshops are tailored for groups, including schools, community groups and individuals.
Illustration:
Glass by Carla Sealy

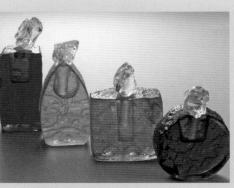

Great Linford Arts Workshop
Parklands
Great Linford
Milton Keynes
M K14 5DZ
T: 01908 608108
E: info@artworks-mk.co.uk
www.artworks-mk.co.uk
Open: Mon - Fri 10 am - 4 pm
Sat 10 am - 12 pm
Closed Suns & Bank Holidays

P
C

Bircham Gallery

0%

14 Market Place
Holt
NR25 6BW

T: 01263 713312
E: birchamgal@aol.com
www.birchamgallery.co.uk

Open: Mon - Sat 9am - 5pm,
10am - 5pm Bank Holidays

A light and spacious gallery situated on the Market Place in the Georgian town of Holt. Bircham Gallery stocks the work of over 200 artists and craftspeople, displaying a superb collection of unusual and beautiful art from East Anglia and beyond. Our innovative exhibition programme includes the work of established contemporary artists, acclaimed modern masters and emerging new talent. The gallery operates the Arts Council 'Own Art' scheme for interest-free credit.

With over 20 years experience you can be assured of our commitment to quality and service.

Merlyn Chesterman page 55

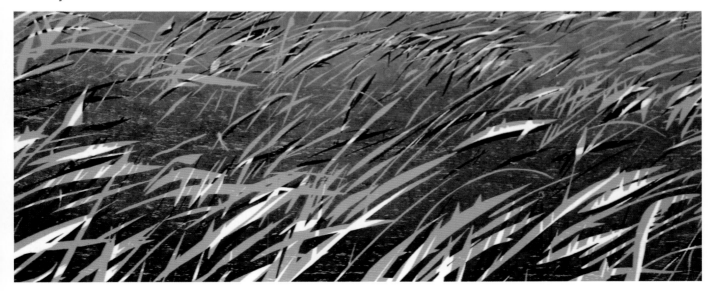

*The Gowan Gallery

The Gowan Gallery was opened 1988 by designer jeweller Joanne Gowan. It is situated in an 18th century shop with a long history as a jewellers, in the small picturesque town of Sawbridgeworth on the Hertfordshire/Essex border.

Joanne's intention was to provide a high quality outlet with professional staff for the sale of a wide range of craftwork and her own jewellery made on the premises, including occasional exhibitions.

21 years on the gallery is still going strong and has expanded and developed as shown in the two photographs below. The gallery specialises in designer jewellery with the work of over 20 makers on display. There is also a selection of beautiful and unusual glassware, ceramics, wood and metalwork by well established and 'up and coming' new artists.

Bespoke precious jewellery in gold, platinum, silver, palladium and gemstones is made on the premises by Joanne Gowan, gallery manager Sally Andrews and jeweller Emma Turpin. We also offer a free designing service, free jewellery cleaning and friendly professional advice. Commissions with other makers can also be arranged.

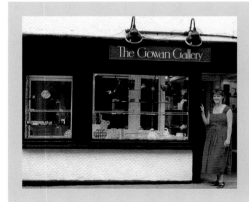

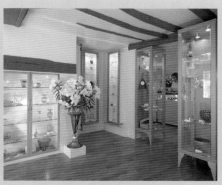

3 Bell Street
Sawbridgeworth
Herts.
CM21 9AR
T: 01279 600004
E: sales@gowan-gallery.co.uk

Open:
Mon - Sat 10am - 5pm
Closed Sun, Bank Holdays, Christmas & New Year

The Hub
National Centre for
Craft & Design

The Hub is the National Centre for Craft & Design. Converted from an old warehouse it opened in 2003 and sits most attractively alongside the river Slea, in the market town of Sleaford in Lincolnshire.

The Hub's purpose is to celebrate promote and exhibit the very best of international craft and design. The centre's two galleries offer the largest spaces in England entirely devoted to craft and design and are complemented by an excellent craft and design shop, a riverside café and spaces for learning. The main gallery offers five exhibitions a year and the roof gallery offers seven annual shows. Increasingly the Hub is originating and curating its own exhibitions, a proportion of which now go on national and inter- national tours.

Forthcoming exhibitions include:

'Out of the Ordinary' Until 10th Jan 2010

'Cultex' Sat 30th Jan - Sun 18th April

'London Boutique Fashion - Hub summer of love'

 Sat 17th July - Sun 12th Sept

National Centre for Craft & Design
Navigation Wharf,
Carre Street,
Sleaford
Lincolnshire NG34 7TW

T: 01529 308710
E: info@thehubcentre.info
www.thehubcentre.info

Open: Daily 10am - 5pm

P
C
0%

The Hub National Centre for Craft & Design

1 Stuart Haygarth
'Cosmic Burst'

2 Christian Lacroix
*dress from
exhibition 'Denim the
fabric of our lives'*

3 'Waste not Want it'
*exhibition in roof
gallery*

4 Mathias Bengtsson
exhibition

5 'Automake &
Future Factories'
*exhibition in roof
gallery*

1
The Hub
licensed café & bar

2
Bathing Beauties'
exhibition

3
'Nuno'
felting course

4
Bathing Beauties'
exhibition opening

5
'Oyster Pleasance'
from 'Bathing
Beauties' *on tour at
the Midland Hotel
Morecombe*

The Hub National Centre for Craft & Design

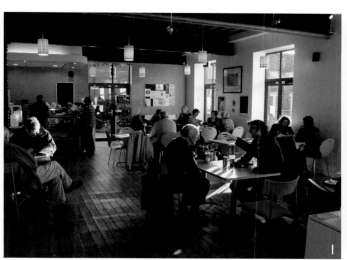

Grapevine Galleries

Selling contemporary crafts and art in a welcoming environment, the Grapevine Galleries are owned and directed by Alison and Peter Low, both architects by background

Since first opening in Norwich 2002, Grapevine has established a considerable reputation for the range and quality of the work shown and the friendly approachable character of both galleries. With an eclectic mix of ceramics, crafts, jewellery, sculpture and art – Grapevine's portfolio includes the best of the region's makers and artists as well as work from much further afield.

Norwich Grapevine has light and spacious displays on two floors and is situated just outside the City Centre - an easy 15 minute walk from The Forum. Burnham Grapevine occupies a beautiful building in Burnham Market located in the heart of North Norfolk.

Featured exhibitions are held regularly, with details on our websites which are regularly updated. At other times you may expect to see work by a selection of our many artists. We also have a large reserve collection of work, which is available to view on request. We accept payment by most credit/debit cards and are happy to arrange delivery.

Norwich Grapevine
109 Unthank Road, Norwich NR2 2PE
T: 01603 760660

www.grapevinegallery.co.uk

Burnham Grapevine
St. Andrews Cottage, Overy Road
Burnham Market, Norfolk, PE31 8HH
T: 01328 730125

www.burnhamgrapevine.co.uk

Open: 10am - 5.30pm, Tues - Sat (Norwich), most days incl. Suns (Burnham Market)

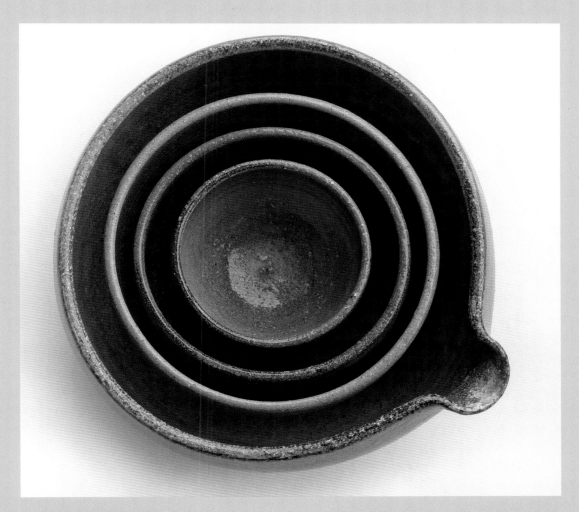

Jack Doherty pages 29 & 59

The House Gallery

Set in the beautiful market town of Olney in Buckinghamshire, The House Gallery showcases the very best of British Art and Craft. Since opening in May 2008, the gallery has already become a must see for collectors and visitors alike, with ever-changing collections of jewellery, ceramics, glass, fine art, and much, much more.

Work is displayed over two floors within the character stone barn, with each floor showing a variety of disciplines. The welcoming gallery is complemented by the brasserie and boutiques that surround it in the tranquil courtyard, and as well as our own exhibitions for both established and up-coming artists, the courtyard collaborates to hold a number of fabulous events throughout the year.

If you'd like to find out more about The House Gallery, please visit us online where you will find up-to-date information on all our artists and forthcoming events.

7 Rose Court
Olney
Buckinghamshire
MK46 4BY

T: 01234 711840
E: arija@thehousegallery.co.uk
www.thehousegallery.co.uk

Open: Mon - Sat 10am - 5pm
Sun 11am - 4pm

1
Helaina Sharpley
wirework pictures

2
Nina Parker
jewellery

3
Victor Stuart
Graham
mixed media

4
Sue Binns
ceramics

5
Paul Barcroft
glass

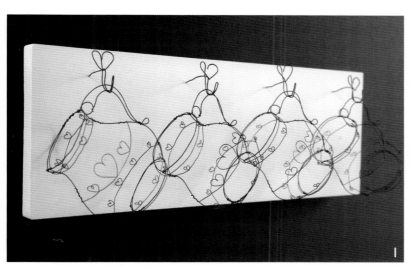

Primavera Gallery

Standing across from the historic spectacle of Cambridge's King's College Chapel, the Primavera Gallery is itself an old institution whose original values continue to bear fruit in the 21st century. The gallery is proud to continue exhibiting artists such as Dame Lucie Rie, Alan Caiger-Smith and Bernard Leach through its permanent displays. These have been joined by subsequent and current generations of makers: ceramicists Paul Jackson, Lawson Rudge and Robert Goldsmith (whose beautiful domestic ware is always very much in demand), studio glassmakers Peter Layton and Jane Charles, jewellers Malcolm Betts, Guy Royle and Diana Porter all feature among a dazzling array of the best crafts Britain has to offer.

Whether they have been coming to Primavera for decades or just weeks, the gallery has attracted many loyal customers who browse its three floors on a regular basis. For owner Jeremy Waller and his staff, there is a particular thrill in meeting people first brought here as children who return to the gallery year upon year to choose gifts and look at what is new since they last came.

In 2005 a spacious upper gallery was acquired by Primavera. Paintings and ceramics are all displayed in light and airy surroundings, along with a beautiful Weber grand piano that anyone is welcome to play.

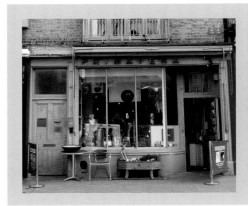
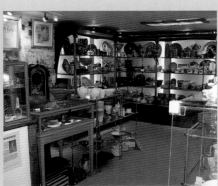

10 King's Parade
Cambridge
CB2 1SJ
T: 01223 357708
E: contactprimavera@aol.com
www.artandcrafts.co.uk

Open: Mon 10am - 3pm,
Tues - Sat 10am - 5.30pm,
Sun 11am - 5pm

P
C
♿
0%

Primavera History

In February 1946, Primavera was opened by Henry Rothschild at 149 Sloane Street with the objective of showing "the best things whether hand or machine made". This innovative mix of retail outlet and art gallery caught the imagination of both the public and the fashionable magazines of the day. From the outset, a diverse range of craft and design was put on display, including folk art from many countries.

In 1959 Rothschild opened a second shop in King's Parade, Cambridge, previously the home of the Cambridge Society of Designer-Craftsmen. The Cambridge gallery placed a much greater emphasis on fine art and regional work as well as dresses and jewellery. It particularly supported fine East Anglian artists such as the painter Mary Potter and the sculptor Geoffrey Clarke.

As well as functional stoneware from the Leach Pottery, the Winchcombe Pottery, Harry Davis's Crowan Pottery, Lucie Rie and Hans Coper, there were pots from nearly every other leading potter working at that time. Rothschild's support of the fine tin-glaze makers such as William Newland and Stephen Sykes and, particularly, the radical new hand-builders was vital to the development of studio ceramics.

Illustrations:
From far left - Ceramic & glass room, gallery entrance, downstairs gallery and piano room

1
*Perry Lancaster
wooden cats

2
Dame Lucie Rie
ceramics

3
Bernard Leach
ceramics

4
Wendy Edmonds,
Liz Brandon & Tess
Blondel
textiles

5
Robert Goldsmith
ceramics

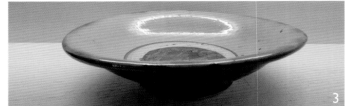

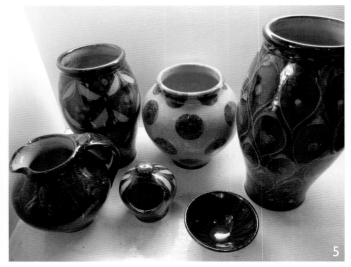

1
Shimara Carlow
jewellery

2
*Jane Charles
glass

3
Libby Edmondson
ceramics

4
Tolly Nason
glass sculptures

5
Guy Royle
jewellery

The Ropewalk

Ropewalk Contemporary Art and Craft is celebrating its 10th anniversary in 2010. The regionally acclaimed centre for the visual arts was opened in 2000 and now houses four galleries in the former rope making factory as well as an outdoor garden gallery.

The Craft Gallery permanently represents over 200 makers from throughout the country with an emphasis on contemporary jewellery and ceramics. The Box Gallery provides a showcase for individual makers as well as a series of small themed craft shows. Recent exhibitors include Richard Godfrey, Sarah Dunstan and John Maltby.

The Ropewalk also has a changing programme of temporary exhibitions in two galleries plus regular workshops for adults and children. Other facilities include a coffee shop, a bespoke picture framing department, a printmaking workshop, 12 artists' studios and a heritage display that documents the building's history.

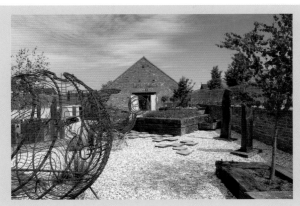

Maltkiln Road
Barton upon Humber
North Lincolnshire
DN18 5JT

T: 01652 660380 Fax 01652 637495
E: info@the-ropewalk.co.uk
www.the-ropewalk.co.uk

Open: Mon - Sat 10am - 5pm
Sun & Bank Holidays 10am - 4pm
Closed Christmas Day, Boxing Day & New Year's Day

P
C
☕
♿
0%

1
Richard Shaw
metal

2
Emily Ward
jewellery

3
Tydd Pottery

4
Pam Drysdale
baskets

5
Richard Godfrey
ceramics

Rufford Craft Centre

Rufford Craft Centre is situated in the heart of Rufford Abbey Country Park, once one of the great country estates in Sherwood Forest and one of Nottinghamshire's most beautiful locations. It hosts a changing programme of exhibitions and offers a wealth of educational workshops with professional artists and crafts people. Each summer Rufford also stages "Earth and Fire" an international ceramics fair where the best potters and ceramic artists come to sell there work directly to the public.

The 150 acre park is set around the remains of Rufford Abbey, founded by Cistercian Monks in the 12th century and transformed later into an imposing country house. The park contains a wealth of scenic walks, a picturesque lake, craft and gift shops and a garden centre. You can also stop for lunch at the Coach House café and the Savile Restaurant and visit the Apsidal Gallery within the Orangery which houses the Rufford Craft Centre ceramics collection. Rufford Abbey Country Park also has over 20 pieces of contemporary sculpture situated within the formal gardens and the collection is open daily to the public.

Rufford Craft Centre gallery is available for groups and individual artist and makers to hire and a full application pack is available.

Rufford Abbey Country Park
Nr Ollerton
Newark
Nottinghamshire
NG22 9DF

T: 01623 822944
E: artsadmin@nottscc.gov.uk
www.nottinghamshire.gov.uk/arts

Open: Tues - Sun times vary seasonally

1
Rufford
view in winter

2
Earth & Fire
International
Ceramic Fair

3
Sculpture Garden
Peter Randall Page
Photo: Toby Smith

4
Rufford View
Photo: Toby Smith

5 & 6
Peter Hayes
ceramic exhibition

7
Rufford Art Society
Exhibition
Photo: Toby Smith

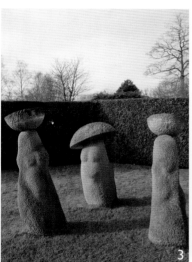

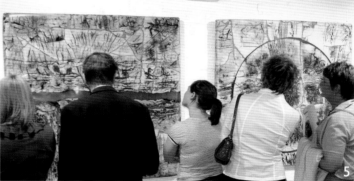

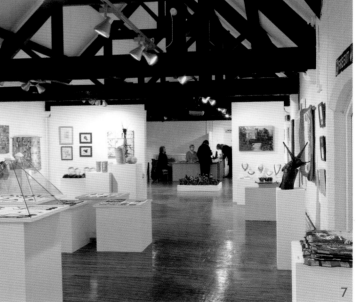

Mark Sanger - pages 72, 77, 149 & 199

Central

Artfull Expression

Artfull Expression was opened in a Victorian building in the heart of Birmingham's Jewellery Quarter in 1995 to provide a showcase for contemporary designer-makers in jewellery and other crafts.

It aims to be an alternative to the traditional jewellery shops which surround it. Most of the jewellery it stocks is silver, but ceramics and acrylics are also used.

Some of the jewellers have their workshops in the building. Repairs and commissions can be undertaken. Clocks, mirrors, prints, paintings, small sculptures (in bronze and in ceramics) and greetings cards are also sold.

Artfull Expression was included among the top 50 places to go in The Independent's Best of Birmingham 2001 section - a perfect example of the attractions to the discerning shopper of the Jewellery Quarter.

23/24 Warstone Lane
Hockley
Birmingham B18 6JQ

T: 0121 212 0430
E: sales@artfull-expression.co.uk

Open: Mon - Fri 10am - 4.30pm &
Sat 10.30am - 4.30pm

Barbara Quinsey

Barbara Quinsey draws her inspiration from the clean lines and basic forms of abstract modern art, particularly the faceted images of cubism. Her workshop is in Birmingham's Jewellery Quarter and she sells her jewellery from a number of retail outlets in the quarter and Birmingham city centre.

Barbara trained in precious metals design at the Birmingham School of Jewellery and has exhibited her work at the Royal Birmingham Society of Artists (RBSA).

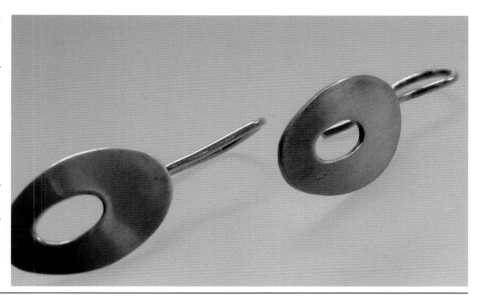

Katherine Campbell-Legg

Katherine Campbell-Legg's work is a subtle combination of silver and 18ct gold, employing a variety of techniques including rolling, stamping, hand- engraving and inlay.

She is influenced by natural forms, printed textiles, graphic images and geometrical shapes. These elements are put together to create wearable contemporary jewellery.

Anna de Ville

Anna de Ville has her workshop in the heart of the Birmingham Jewellery Quarter. She exhibits and sells her work throughout the British Isles.

Her jewellery is distinctive in its use of con- trasting oxidised and polished silver, with an emphasis on surface detail. The zig-zag has become a personal motif.

Much of Anna's work is inspired by fish, birds and animals. Her latest designs which include flower and vegetable forms are taken from her beloved garden.

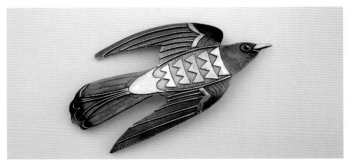

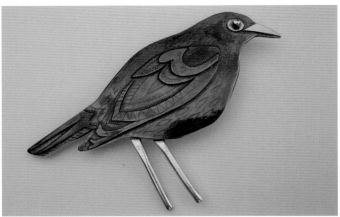

Penny Gildea

Penny Gildea loves the combination of precious metal and glass, the combination of these two materials creates an almost limitless medium of colour and texture on objects that can be functional as well as delicate and decorative. The traditional techniques of cloisonne, basse taille and champleve show off the relationship between transparent enamels fully and lately Penny has begun to use handmade kumihimo braids in silk instead of traditional chains to complement the finished pieces.

The range of her work includes jewellery, small objects: bowls and boxes as well as whistles.

The Gallery at Bevere

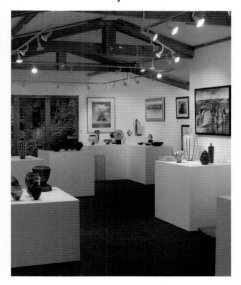

Bevere Lane
Worcester
WR3 7RQ
T: 01905 754 484
E: enquiries@beverevivis.com
www.beverevivis.com
Open: Tues - Sun 10.30am - 5pm
Please enquire for Bank Holiday
opening

The Gallery at Bevere is a major centre for the visual arts in an intimate setting, showing the best of modern/British studio ceramics, along with paintings and other crafts by top regional, national and international artists, glassmakers, wood-turners and ceramicists. There is a full programme of exhibitions with something new each month.

Also in stock are etchings, prints, woodcuts and a range of art and craft books, cards and magazines which are for sale.

The Gallery in the Garden Sculpture trail is open from June – August inclusive, exhibiting works for sale in wood, clay, glass, textiles and also stone. Refreshments from the Café Upstairs - café garden open in the summer. Full framing service.

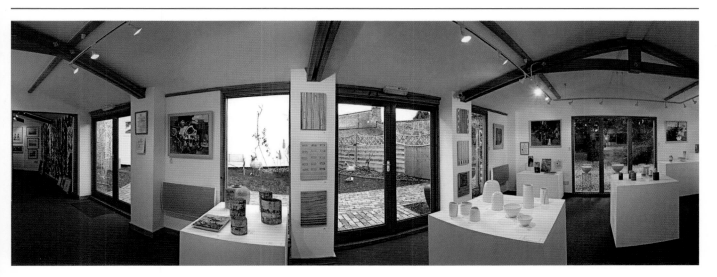

Bilston Craft Gallery

From its inception in 1937, Bilston Craft Gallery (then Bilston Museum & Art Gallery) has had a strong local presence, bringing work of national and international quality to the region. In 1999 the Gallery became the designated contemporary craft venue for Wolverhampton Arts and Museums Service and is now the largest publicly funded venue in the West Midlands region to be dedicated to the applied arts.

The Gallery has a lively programme of temporary exhibitions featuring the very best in crafts by international and national makers, as well as highlighting regional talent. With around five in-house and touring exhibitions a year in the main exhibiting space, the Gallery is fast developing a reputation for showing the finest work from the craft world today. Craftsense, the permanent exhibition, gives an introduction to craft from the eighteenth century to the present day, and features the world renowned Bilston enamels, alongside historical and contemporary items from collections across the country.

Mount Pleasant
Bilston
Wolverhampton
West Midlands
WV14 7LU

T: 01902 552507
E: bilstoncraftgallery@wolverhampton.gov.uk
www.wolverhamptonart.org.uk/bilston

Open: Tues & Thurs 10am - 4pm; Weds 10am - 7pm;
Fri 10am - 1pm; Sat 11am - 4pm

Helen Amy Murray

Helen Amy Murray's work is featured in our permanent exhibition Craftsense, which celebrates the links between 18th Century local industry and contemporary craft work.

Shown alongside regional examples of leather goods from the 1700's onwards, Helen Amy Murray's work highlights innovative ways of using leather. Helen uses a technique she invented herself to create 3D patterns in leather, which she then uses to upholster furniture.

Rebecca Gouldson

Rebecca's work is also included in our permanent exhibition Craftsense. A graduate of the University of Wolverhampton, Rebecca creates sculptural forms with highly decorated surfaces; 'drawing' into and onto the surface of metal with a palette of Acid-etching and Patination techniques. Her vessels can be seen in the exhibition alongside items from the Black Country's rich heritage of metal ware from the 1500's onwards.

The Blue Ginger Gallery

The Blue Ginger gallery is distinguished not only by its carefully selected range of art, crafts and objects of beauty featuring excellence in craftsmanship, but also by the attractive location in the grounds of a 16th century former hop farm.

Sue Lim, the owner, has an instinct for sourcing things that are infused with pleasure and delight, representing local, national and global interests – for instance the exotic 1970s kimonos from Japan, the jewellery and mud cloth paintings (known as bogolans) from Timbuktu, are the result of recent expeditions.

We offer delicious local and home made food in the café which is set in the relaxed, informal gallery environment that extends into the courtyard during summer months – B&B is available too.

Blue Ginger hosts a variety of craft related courses, workshops and special events, details of which are on our website and on-line newsletter.

Blue Ginger is easy to find when travelling along the A4103 between Hereford and Worcester, against the backdrop of the glorious Malvern Hills, with easy access from the M5:J7. A visit to Blue Ginger is a treat for the senses!

Home End Farm
Cradley
Malvern
Worcestershire
WR13 5NW
T: 01886 880240
E: sue@blue-ginger.com
www.blue-ginger.com
Open: Weds - Sun, plus Bank Holidays,
10am - 5.30pm, Mar - Dec &
by appointment

1
*Lynn Muir
driftwood sculpture

2
Jo Dewar
wire jewellery

3
Gilly Mound
mixed media painting

4
Frans Wesselman
stained glass

5
Cynthia Lea
frostproof ceramics
Jenny Pearce
willow baskets

Burford Woodcraft

Set in the medieval market town of Burford, gateway to the beautiful rolling hills of the Cotswolds, Burford Woodcraft has been one of the most well known and well respected galleries, specialising in contemporary British craftsmanship in wood, for over 30 years.

During that time its mission to source and sell a wide range of high quality, affordable items handmade by new and established designer-makers and artists has evolved into a superb and diverse collection. Wood is a very natural medium, incredibly versatile and tactile. Within each variety of timber every piece is different; by selecting from the huge range and combining it with their inventiveness and expertise the craftsmen achieve the best possible.

This means that Robert (one of the original furniture designer-makers) and Jayne Lewin are able to choose and offer items with an emphasis on attention to detail, outstanding design and quality of finish.

Beautifully creative, one off pieces of furniture, mirrors, carving and turning sit alongside practical kitchenware, desk accessories, jewellery boxes, clocks, toys and more. Not forgetting those useful little extras and the humorous pieces but that's another story….

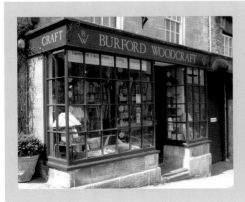

144 High Street
Burford
Oxon
OX18 4QU

P C

T: 01993 823479
E: enquiries@burford-woodcraft.co.uk
www.burford-woodcraft.co.uk

Open: Mon - Sat 9.30am - 5pm
Sun 11am - 4.45pm mid Feb - Dec

1	2	3	4	5
Mark Sanger	Dennis Hales	Roland Bartlett	Tim Atkinson	Norman Wood
wood vessel	*wood turning*	*parquetry*	*sideboard*	*Carolina wood duck*

1

3

5

*John Mainwaring

I was asked recently by someone who is thinking about pursuing a career in craftwork, would it be difficult to become a professional maker? I gave him a truthful 'yes'. Even after 38 years it's still hard work. If he had asked if it would be rewarding I would have said 'highly'. You have to love what you do, always learning, always discovering.

I am always encouraging students to experiment. Develop their own methods and techniques; create their own style that collectors will recognise; almost like a signature. Keep evolving new ideas to help keep your work fresh and lively.

Sue Navin

Sue carves horses, hares and gorillas in a variety of hardwoods, most recently walnut, apple and oak. Sue works with chisels and mallet, trying to keep a sense of life and movement in the carving and to show the beauty of the grain. Because of the nature of the carving process, each piece is an original, taking in excess of 40 hours. The carvings are usually left with a tooled finish and then finally polished with beeswax.

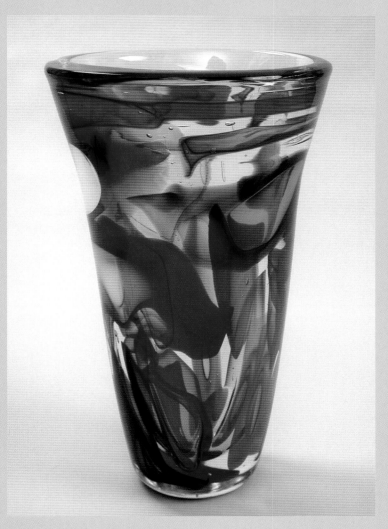

Adam Aaronson - page 118

Craft Gallery

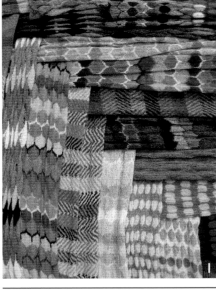

7 Goddard's Lane
Chipping Norton
Oxon
OX7 5NP

T: 01608 641525
www.craftgallerychippingnorton.co.uk

Open: Mon – Sat 10am - 5pm

Follow the A44 between Oxford and Evesham and cruise gently into Chipping Norton. This mellow Cotswold town is justly proud of its history, panoramic views and many connections with performing, visual and applied arts. The gallery is in the centre of the town within the triangle of library, theatre box office and Chequers pub.

We are a partnership of more than 20 respected designer-makers, from Oxfordshire and the surrounding area. You have a chance to meet one or more of us as you browse amongst the array of contemporary crafts and artists' original prints. The display is constantly refreshed as items are purchased and new designs are introduced. We showcase distinctive ranges of jewellery, ceramics, glass, textiles and wood and offer precious, decorative and functional pieces.

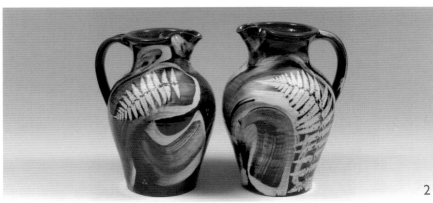

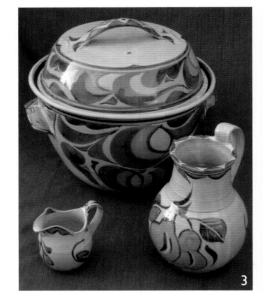

1	2	3
Alison Dupernex	Liz Teall	Andrew Hazelden
textiles	*ceramics*	*ceramics*

1
Annik Piriou
jewellery

2
Rose Hallam
*hand painted
jewellery*

3
Heather Power
glass artist

4
Kirstie Reynolds
jewellery

5
Valerie Mead
jewellery

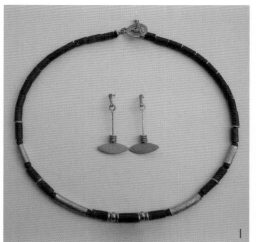

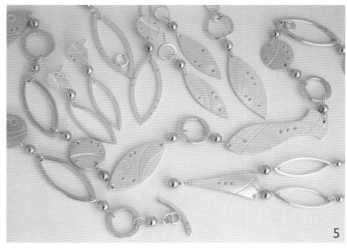

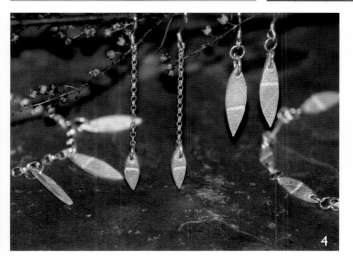

Fiery Beacon Gallery

The Fiery Beacon is situated on the A46 in the centre of the attractive Cotswold village of Painswick. The gallery occupies the ground floor of the owner's beautiful grade II listed building and the traditional architecture is an ideal foil for the exciting collection of contemporary work. The relaxed and welcoming atmosphere encourages the visitor to take time to browse the regularly changing displays of work by both new and well established artists.

Displays feature work across a range of different media including glass, ceramics, metalwork and textiles and you will always find an exciting collection of contemporary jewellery and hand made cards. While in Painswick take time to stroll through the village, known as the Queen of the Cotswolds, and visit the 11th century church with its famous yew trees. The village has a long association with the arts, being the home of the Gloucestershire Guild of Craftsmen and more recently the Painswick Centre Art Studios. Don't miss the Rococo Gardens on the outskirts of the village and you can take a walk along the Cotswold Way which runs through the village.

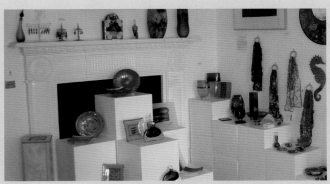

New Street
Painswick
Gloucestershire
GL6 6UN
T: 01452 812582
E: gallery@fierybeacon.co.uk
www.fierybeacon.co.uk

Open: Fri & Sat 10am - 6pm,
Sun 12am - 5pm.
Closed Jan - Easter, Sept & Oct

1	2	3	4	5
Elizabeth Hinton	Jules Jules	Loco Glass	*Pauline Zelinski	Lynn Walters
jewellery	*jewellery*		*ceramics*	*metal sculpture*

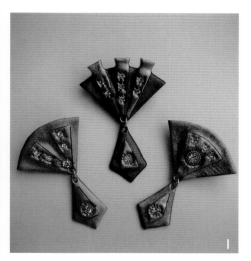

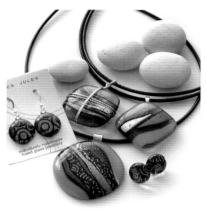

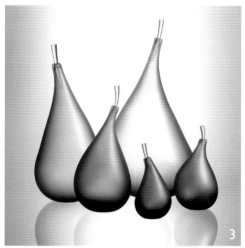

Janine Partington

Janine Partington's work combines the traditional craft of enamelling with fresh, clean, contemporary design to create framed panels and jewellery.

Enamelling is the art of fusing glass on to metal. Janine creates intricate hand-cut stencils which are then laid on to copper. Her stencils are inspired by trees, flowers, seedheads and the landscape. After sifting powdered enamel over a stencil she fires each piece in a kiln.

Janine is based in Bristol and spends much of her time designing and creating new panels for her collections. Her work is successfully exhibited and sold throughout the UK.

Stacey Manser-Knight

My work begins by throwing shapes, using brown earthenware clay. It is then coated with white slip, giving me a surface to illustrate, by drawing through the layers. I use piping techniques and model small items to create raised forms and texture. After the first biscuit firing, it is colour glazed, and fired again. It then receives highlights using lustres and on-glazes, and finally fired a third time. The aim of this is to create depth and fine detail.

I am inspired by happy memories and the humour I see in ordinary life. I grew up between Oxford and Long-Island, New York and now live in Sussex, with my wonderful, supportive husband and three children. I make my work between batches of sandwiches, school runs, and trips to the pick-your own farm.

The Gallery Upstairs, Torquil

Torquil was established by Reg Moon as a family business in 1960 and comprises a high street shop and workshop at the rear. Carey Moon makes and decorates porcelain dishes using abstract shapes and pictures inspired by figures, fish and still life subjects. Jayne Lucas makes paperclay vessels decorated with scratched lines and a palette of earth colours inspired by ariel views of various landscapes.

The Gallery Upstairs was first opened in 1985; the gallery promotes the work of young people 'setting out' alongside well established artists and makers. Although the gallery only holds two exhibitions a year, it is one of the most prestigious galleries in the Midlands, with its large mixed media group shows, including contemporary paintings, sculpture, ceramics, jewellery and glass. The atmosphere at these shows is relaxed and friendly – details and invitation on request from website.

The gallery overlooks a cobbled courtyard, which was once part of an Elizabethan coaching inn. An ancient yew arch leads to the garden – where sculpture and large-scale ceramics are displayed during the summer exhibitions.

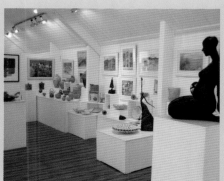

The Gallery Upstairs
Torquil
81 High Street
Henley-in-Arden
Warwickshire
B95 5AT
T: 01564 792174
E: galleryupstairs@aol.com
www.thegalleryupstairstorquil.co.uk

Open: Tues - Sat 10am - 5.30pm

P
C
0%

iapetus

At iapetus gallery you'll discover three rooms full of handmade jewellery and gifts from over 100 artists, designers and makers. All crafted with love, skill and a good dose of quirkiness you're sure to fall for something.

The gallery is located in the picturesque spa town of Great Malvern at the foot of the Malvern Hills. As well as offering a fabulous array of original jewellery from the likes of Nick Hubbard, Lyn Antley, James Newman and Adele Taylor, iapetus are also an official stockist of Kosta Boda art glass including one off and limited edition pieces by world-renowned artists, Bertil Vallien and Goran Warff. Other crafts include handmade textiles, ceramics and metalworks as well as gifts, home accessories, greetings cards and gift wrap. Prices start from as little as a pound, or you can blow your budget on some very special art pieces.

If you'd like to find out more about iapetus or fancy shopping with them from the comfort of your sofa then visit their friendly and easy to use website, iapetus.co.uk.

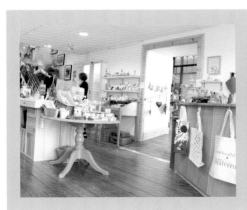
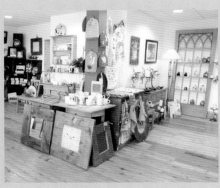

34 Belle Vue Terrace
Great Malvern
Worcestershire
WR14 4PZ

P
C
&

T: 01684 566 929
E: hello@iapetus.co.uk
www.iapetus.co.uk

Open: Mon - Sat 10am - 5.30pm

1
Belltrees Forge
metal

2
Bertil Vallien
glass sculpture

3
Poppy Treffry
textiles

4
Nick Hubbard
jewellery

5
Susan Horth
crab brooch

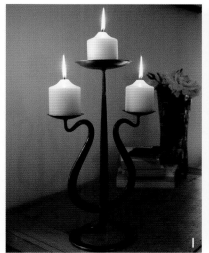

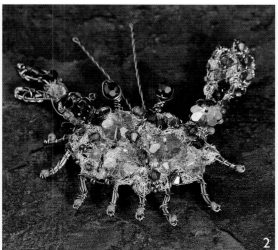

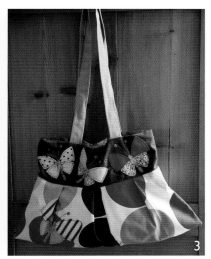

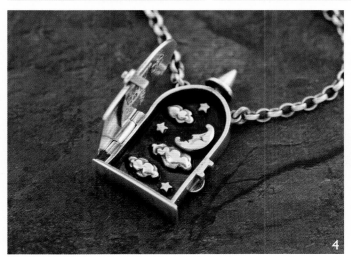

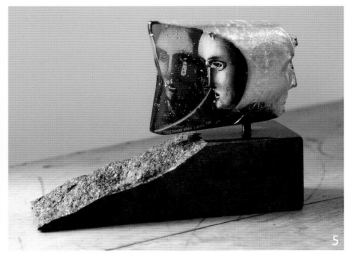

Montpellier Gallery

Montpellier Gallery has been established in the heart of Stratford-upon-Avon since 1991, and can be found opposite the Shakespeare Hotel near the centre of the town. Set in a 400 year old building, the gallery comprises three adjoining rooms opening to a delightful tiny courtyard which floods the rooms with natural light.

We have built a strong reputation for the broad selection of contemporary works we show, giving the gallery its visual excitement, colour and a refreshing stylistic diversity – whether ceramics, studio glass, paintings, printmaking or contemporary jewellery, pieces are always selected using a discerning eye for their quality, originality and form. We are strongly committed to promoting an awareness of the hand-made process and originality in all the media displayed.

The gallery always carries a comprehensive range of pieces from the artists and craftsmen we represent and regularly feature solo or group exhibitions by new and established makers.

The gallery is owned by Peter Burridge, a trained jeweller and silver-smith, also printmaker, bringing his broad knowledge of the fine arts and crafts to create the gallery's breadth of choice and selection.

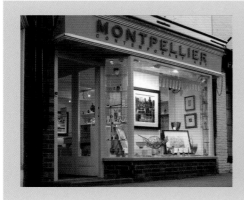

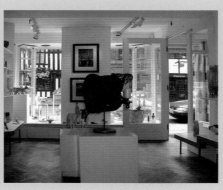

6 Chapel Street
Stratford-upon-Avon
Warwickshire
CV37 6RP

T: 01789 261161
E: info@montpelliergallery.com
www.montpelliergallery.com

Open: Mon - Sat 9.30am - 5.30pm

1
Jennifer Hall
ceramic

2
Paul Barcroft
glass

3
*Bob Crooks
glass

4
Lesley Strickland
jewellery

5
Nick Mackman
ceramic sculpture

6
David White
ceramic

1

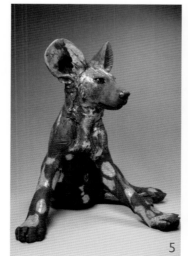

2

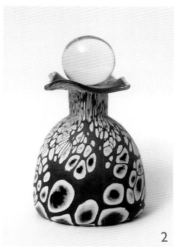

3

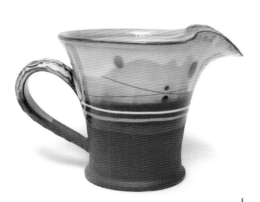

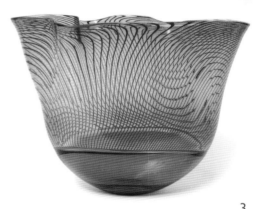

4

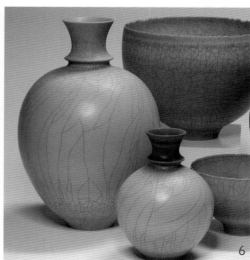

5

6

Victoria Jardine

Victoria works in stoneware at a range of scales and each piece is hand-built, predominantly coiled. She uses "I love the process of slowly building vessels from coils. It is partly the time taken in the making that brings me the most pleasure. The vessel emerges gradually over days and sometimes weeks. I find myself developing a powerful relationship with each curve and edge. Then suddenly, towards the end of this long process, the piece takes on a presence of its own. After hours of pummelling, cutting, scraping and smoothing, this thing, that was once just the air in front of me, looks back at me. It always takes me by surprise when this happens. I'm never expecting it and it always seems much more than of my own making. It's a magnificent moment.

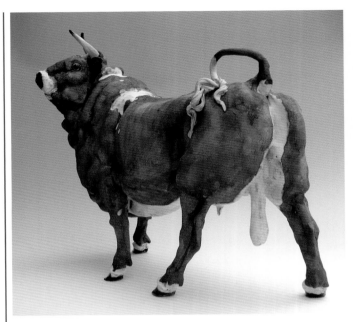

Elaine Peto

Elaine strives to capture the character and energy of each creature she makes, bestowing upon them their own individual personality. After graduating from Exeter in 1985 she continued to study livestock at agricultural markets and abattoirs to develop her understanding of animal anatomy and movement. Each sculpture she produces is individually made using rolled and highly textured clay sheets. After gently constructing, modelling and applying subtle details to the form she then adds oxides and glazes to the surface before finally firing to stoneware in her kiln. She says she is often amazed at how the material seems to take on a life of its own, imparting its own spirit to the finished piece.

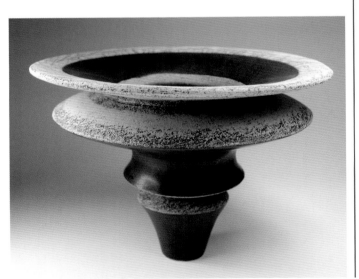

Stuart Akroyd

Having worked and developed his glassmaking skills at both Sunderland University and the Brierley Hill International Glass Centre, Stuart finally set up his own Studio in 1991. He now owns and runs a successful workshop in Nottingham and is considered one of England's leading glassmakers. Today the pieces he makes are fresh and confident, specialising in stunningly pure, asymmetrical designs executed in a wide range of vibrant colours, often inspired by natural forms. The cold working techniques introduced over the years - which include carving and polishing - give the surfaces of his pieces a wonderful pattern and movement, often with intriguing optical effects. Stuarts' work is represented by a number of leading galleries and larger more complex pieces can be seen in many private collections.

Matthew Chambers

Matthew Chambers' ceramic pieces are born out of his love of geometric and constructivist art, architecture, and design. Each piece explores the relationships between the constructed abstract shapes he uses, using subtle layering of circular sections within a single form. Traditional processes are employed in making these contemporary forms that are designed to create a visual and tactile beauty and intrigue.

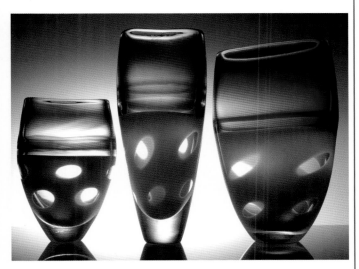

New Brewery Arts Craft Shop

New Brewery Arts, craft centre for the Cotswolds for 30 years, has recently reopened following a major £2.8M refurbishment with support from Arts Council England. A regional centre of excellence for contemporary craft we are now open to the public seven days a week with a thriving education programme, resident makers, a formal gallery space hosting seven exhibitions a year, an excellent new café, flexible performance space and a full outreach programme.

The New Brewery Arts Craft Shop is an emporium of British Craft. Represented are both new and established artists from around Britain working in wood, metal, ceramics, jewellery, textiles and glass. Discover everything from beautiful wedding rings, amusing animal sculptures, and architectural glass wall pieces through to practical mugs and bowls of ceramic buttons. As the craft shop is part of a larger centre we aim to cater for both the serious collector and the interested tourist. The emphasis is on a high standard of craftsmanship coupled with a friendly atmosphere. Knowledgeable staff are always on hand to give information about the pieces, the makers and the processes involved.

Interior photo: Robyn Liebschner

Brewery Court
Cirencester
Glos
GL7 1JH

T: 01285 657181
E: admin@newbreweryarts.org.uk
www.newbreweryarts.org.uk

Open: Mon - Sat 9am - 5pm,
Sun & Bank Holidays 10am - 4pm

P
C
0%

1
Daniella Wilson-Dunne
stained glass

2
Louise Parry
jeweller

3
Katherine O'Brien
bookbinder

4
Stephen Perkins
upholsterer

5
Studio Seven
textiles

6
Loco Glass

All photos on this page by Clint Randall

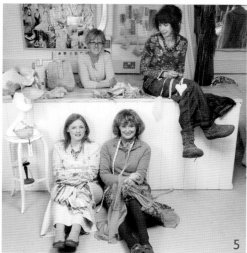

Shire Hall Gallery

The Shire Hall Gallery is the largest contemporary visual arts and crafts venue in Staffordshire. We hope to stimulate and inspire you through our temporary exhibition programme which showcases a wide variety of subjects, artists and designer-makers.

The gallery craft shop represents many leading British makers offering a wide range of contemporary craft, including ceramics, textiles, jewellery, wood, metal and glass as well as a great selection of greetings cards.

The gallery has a multi sensory room which offers visitors the opportunity to experience different light, sound and tactile sensations. The room is open to everyone, but we hope that it will be of particular interest to visitors with sensory impairments.

Our balcony coffee bar offers splendid views over the great hall where you can relax and enjoy tea, coffee and a lovely selection of homemade cakes.

- Level access from the street.
- Chairlift to the Courtroom (limited access) and coffee bar.
- Accessible toilets with baby-changing facilities.
- Induction loop system in main gallery space.
- Guide/hearing dogs are welcome.

0%

0%

Market Square
Stafford
ST16 2LD

T: 01785 278345
E: shirehallgallery@staffordshire.gov.uk
www.staffordshire.gov.uk/leisure/museumandgalleries

Open: Mon - Sat 9:30am - 5pm, Tues 10am - 5pm
 & Sun 1pm - 4pm

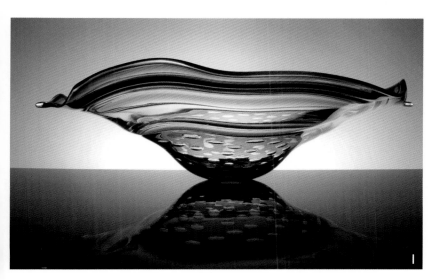

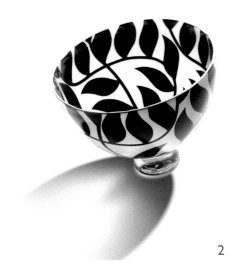

1
Stuart Akroyd
glass

2
Gillies Jones
glass

3
Sue Gregor
jewellery

4
Heidi Sturgess
textiles

1

2

3

4

The Gallery at Waterperry

The Gallery at Waterperry is housed in a restored 18th century barn in the beautiful grounds of Waterperry House and Gardens.

Previously the Art in Action Gallery, it opened in 1994 as a natural extension to the annual Art Festival, with the aim of specialising in high quality British-made art and craft. The gallery offers a wide range of affordable, contemporary work, including jewellery, glass, ceramics, sculpture, wood, textiles, paintings and prints. Visitors are encouraged to browse and enjoy the displays.

Raising the profile of local artists is an important part of the gallery's programme and quarterly exhibitions showcase selected work. A quarterly newsletter keeps visitors informed of exhibitions and special events including the various art classes, many of which are taught by exhibiting artists.

Just 40 minutes from London, Waterperry offers a perfect day out, with beautiful gardens to explore all year round, a quality plant centre and a teashop offering a freshly prepared, seasonal menu.

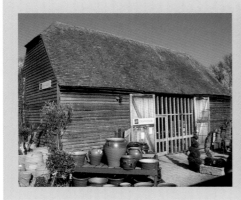

Waterperry
Nr Wheatley
Oxon
OX33 1JZ

T: 01844 338085
E: gallery@waterperrygardens.co.uk
www.waterperrygardens.co.uk

Open: Easter - Oct 10am - 5.30pm
Nov - Easter 10.30am - 5pm

1
Poppy Dandiya
*Green Tourmaline
ring, 24K gold
(opposite page)*

2
Lesley Maddox
McNulty
stoneware sculpture

3
Peter Layton
giraffe dropper, glass

4
Rachel Ducker
wire sculpture

5
John Leach
stoneware charger

6
Gemma Wheeler
silver jewellery

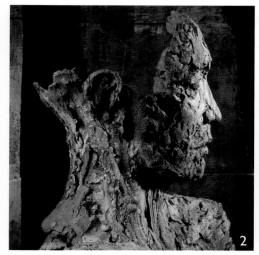

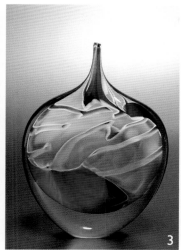

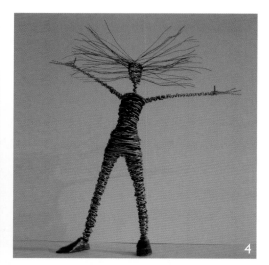

Bridget Wheatley Contemporary Jewellery

Established in 2000, situated a 10 minute walk from the city centre Bridget Wheatley Contemporary Jewellery is a haven of creativity set within the vibrant multi-cultural Cowley Road. The shop is set back slightly from the road with a light and airy interior. Customers are welcome to browse, there is a friendly service with help in finding the right piece of jewellery, either from stock or a specially made item.

Bridget creates her own ranges of jewellery and offer's a bespoke service for wedding and engagement rings. Choose from one of her collections or she will be happy to work with you to create your own design. The essence of her work is simplicity with attention to detail, influences are from Medieval and Celtic art. She likes to use irregular shaped freshwater pearls and richly coloured gemstones including tourmaline aquamarine, moonstone, opals and pink sapphire, combined with silver and gold to produce simple bold rings, elegant earrings and unusual lariat style necklaces. Wide bangles with wire detailing and a hammered finish are Bridget's signature pieces.

Alongside Bridget's own work the shop has jewellery from an eclectic group of artists using diverse materials and techniques to produce a stunning array of beautiful individual pieces. Colourful and bold wrapping paper and cards, some hand-made, are the finishing touch to the perfect present. Prices range from £18.

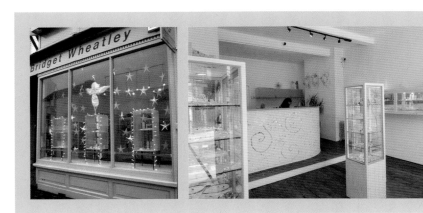

38 Cowley Road
Oxford
OX4 1HZ

T: 01865 722184
E: bridget.wheatley@ntlworld.com
www.bridgetwheatley.com

Open: Tues - Sat 10am - 5pm.

1
Bridget Wheatley
(+ other images)
rings, silver and 18ct
gold with moonstone
and tourmaline

2
4 rings 18ct gold
with diamonds and
crystal opal
Photos: 1,2 & 3
Nick White

3
Daisy necklace silver
and 18ct centre and
turquoise beads

4
Ring stack
Photo: Paul
Freestone - also
gallery exterior

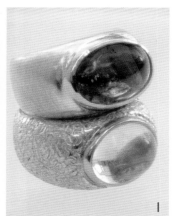

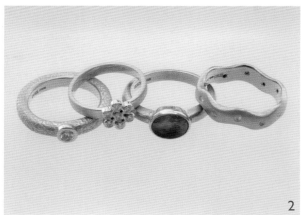

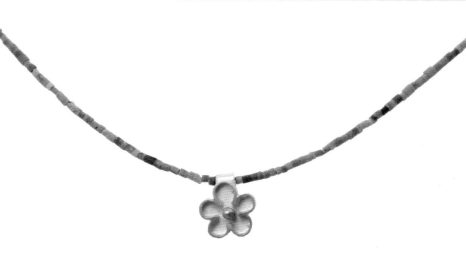

*Rachel Ricketts - page 179

West Midlands & Wales

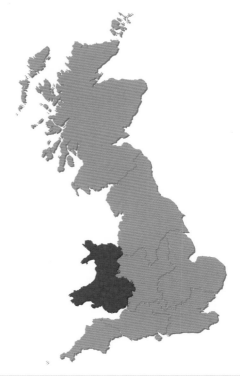

Court Cupboard Craft Gallery

The Black Mountains are set in the Brecon Beacons National Park, an area much appreciated by visitors all over the world. The Court Cupboard Craft Gallery is situated on the western slopes of the Skirrid Mountain close to the market town of Abergavenny and near castles, a golf course and falconry centre.

The Gallery is run by members of The Black Mountains Circle, who draw inspiration from the location where they live and work.

A comprehensive selection of high quality, collectable work is available throughout the year. Some members welcome visitors to their studios by prior arrangement and all accept commissions.

There is a well equipped pottery and a second workshop where an extensive range of courses for the public are run by the maker members of the gallery and other invited craftspeople.

A comfortable coffee shop offers a variety of refreshments and locally made cakes and in the Summer a terrace garden affords delightful views of the surrounding mountains.

There is free parking and a washroom with access for the disabled.

New Court Farm
Llantilio Pertholey
Abergavenny
Monmouthshire
NP7 8AU

T: 01873 852011
E: admin@courtcupboard.co.uk
www.courtcupboardgallery.com

Open: Daily 10.30am - 5pm.

P
C

1
Frances Lester
jewellery

4
Maggie Jones
*enamelling on
copper*

3
Louise Lovell
textile jewellery

5
Interior gallery

2
Sioni Rhys
handweavers

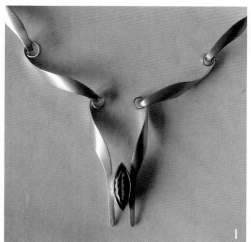

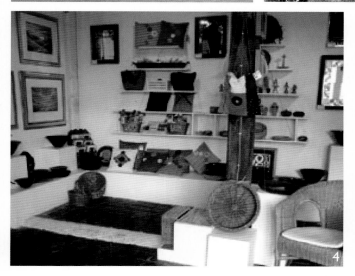

Hay Makers

The Hay Makers, located in the world famous book town of Hay-on-Wye, is a co-operative group of designer makers. Opened in the 1980s, it has gained an enviable reputation for selling an exciting and varied selection of high quality crafts at affordable prices and in a welcoming and friendly atmosphere. The gallery is almost always staffed by one of its members:

Chris Armstrong - woodturning and furniture: Pat Birks - tin-glazed majolica ceramics; Caitriona Cartwright - letter-cutting and stone carving; Jenny Chippindale - textiles; Dawn Cripps - embroidered jewellery and stumpwork; Sue Forrest - hand painted silk ties; Victoria Keeble - printmaking and textiles; Pauline Paterson - pottery and Gail Stokes Hayward - wire sculpture. The gallery also showcases the work of some of the finest contemporary craft makers from the British Isles in changing exhibitions throughout the year.

Since Hay-on-Wye was twinned with Timbuktu in 2007 the gallery has been an outlet for jewellery and leatherwork from Tuareg artisans. During this time the gallery has raised a considerable amount of money to help them trade their way to a more sustainable future.

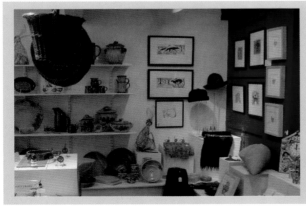

St John's Place
Hay-on-Wye
Hereford
HR3 5BN

T: 01497 820556
E: info@haymakers.co.uk
www.haymakers.co.uk

Open: Mon - Sat 10.30am - 5pm, Sun 11am - 4pm

1
Pauline Paterson
ceramics
Jenny Chippindale
felt and Dawn
Cripps *embroidery*

2
Victoria Keeble
etching

3
Chris Armstrong
woodturning and
Caitriona
Cartwright; *stone
cutting*

4
Dawn Cripps
embroidery & Gail
Stokes Hayward;
wire sculpture

5
Pat Birks
ceramics and
Sue Forrest
silk ties

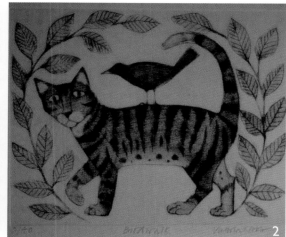

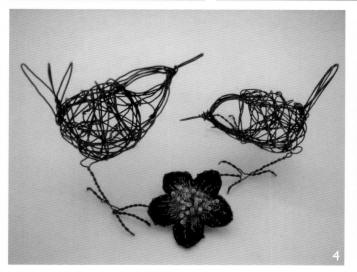

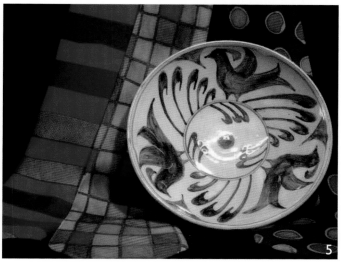

Lion Gallery

Situated in a grade two listed building in the historic town of Leominster, the previous Lion Gallery operated for ten years as a cooperative showing primarily the work of local designer makers.

After its closure the present gallery was opened under private ownership in 2005.It aims to maintain the high standard and promote quality contemporary local and British art and craft .

An extensive range of top nationally known designer makers are represented covering a wide variety of techniques. Fresh work is frequently introduced and featured artists are changed monthly.Print makers Sue Brown and Chris Noble are regularly shown, ceramics by Jennifer Hall and Bridget Drakeford, studio glass by Martin Andrews, Stuart Ackroyd and Julia Linstead along with whimsical painted figures by Lyn Muir. The area has an outstanding reputation for jewellery and local jewellers shown include Georgina Franklin, Louise Chesshire and Blake and Janette Mackinnon. Sculpture,textiles metalwork and painting are also represented.

The gallery aims to foster new talent and several of our regular exhibitors were first seen at degree shows at our local art college where a gallery prize is presented.

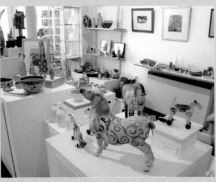

15b Broad Street
Leominster
Herefordshire
HR6 8BT

T: 01568 611898
E: info@liongallery.com
www.liongallery.com

Open: Mon - Sat 10am - 5pm

*Rachel Ricketts

With a background in painting, Rachel spent seven years restoring wall painting before deciding to work exclusively as a sculptor. She says "I miss colour but don't want to give up sculpture in order to reintroduce it in my work, hence the painted ceramic pieces."

Her imagination is fired by animals, vintage toys and literary themes, realized in clay and bronze.

Helen Cooper

After graduating from Bath College in 1989 and living and working around England, I have now settled in Ludlow where I make ragwork mirrors and a variety of ceramics.

My ceramics consist of earthenware mirrors, brooches and jewellery, decorated with intricate applied relief, painted with underglaze colour and then glazed.

For my ragwork mirrors I use recycled material, combined with small ceramic elements. Fish and hearts are prominent in my work.

Sue Brown

Sue Brown studied etching at degree level at Bristol and has since developed her work to include non toxic etching, collagraph and to explore the possibilities of combining the two disciplines. She works in very limited editions and each print has its own accidental qualities. Her inspiration is often drawn from natural observation but her subject matter is wide and varied. Printmaking for Sue is 'A liberating journey of discovery'.

Duncan Hill

A visit to a Victorian slate mine in Snowdonia was the inspiration for my latest collection which comprises of earrings, rings, pendants, necklaces, cufflinks and bangles so far. So fascinated with the surreal landscape comprising of thousands of tons of discarded slate from The Industrial Revolution, I just had to capture its unique texture, applying different surface finishes in silver, embellished with 18ct yellow gold detail and semi-precious set stones/beads.

Makers Guild in Wales

Craft in the Bay
The Flourish
Lloyd George Avenue
Cardiff Bay
CF10 4QH
T: 029 20484611
E: admin@makersguildinwales.org.uk
www.makersguildinwales.org.uk
Open: Daily 10.30am - 5.30pm

Home of the Makers Guild in Wales An historic Victorian dockside building houses Craft in the Bay, the home of the Makers Guild in Wales.

Showcasing and selling fine contemporary craft, the gallery, in the centre of Cardiff Bay, includes a retail area, exhibition space, workshops, café and conference room.

With an extensive calendar of activities the Makers Guild in Wales promotes the best of Welsh craft with a world-wide reputation for quality and creative innovation.

A membership of over 70 makers are profiled on the website. A host of disciplines offers a broad choice including ceramics, textiles, wood, jewellery, glass, paper, baskets, book binding and ironwork.

It is also the venue for a regular changing exhibition programme and various workshops.

Old Chapel Gallery

Established in 1989 by Yasmin Strube, Old Chapel Gallery has become recognised as a centre of excellence for the arts, where work by both reputable local and nationally known artists and makers can be seen alongside innovative work by talented newcomers. The emphasis is on quality and originality, from glass, ceramics, jewellery, iron-work, sculpture, furniture, to textiles and knitwear and a diverse range of original watercolours, oils, pastels, etchings and aquatints. The gallery hosts regular and ever changing exhibitions and showcases.

There is also an annual garden sculpture exhibition. A range of services are available through the gallery including commissioning and a "take it on appro" service for local and regular customers. The gallery has developed a website for on-line shopping, see below.

The gallery is selected for quality by the Crafts Council and is a member of the ICGA. Friendly and knowledgeable staff are always on hand to welcome you and help to make your visit informative, pleasurable and memorable.

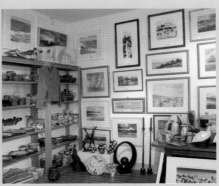

East Street
Pembridge
Herefordshire
HR6 9HB

T: 01544 388842
E: oldchapelgallery@googlemail.com
www.oldchapelgallery.co.uk

Open: Mon - Sat 11am - 5pm,
Sun - 11am - 4pm

P
C
0%

1
Stephen Kingsford
raku fired ceramics

2
Hilary Mee
papier maché

3
Syrah Jacobs
*felt/mixed media
including found
objects*

4
Beryl Turpin
enamel on copper

5
Neil Lossock
forged iron

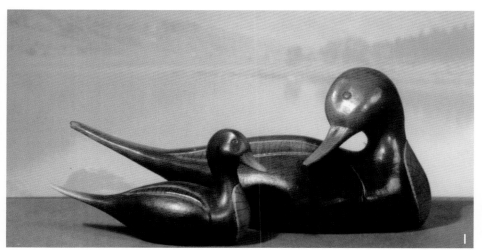

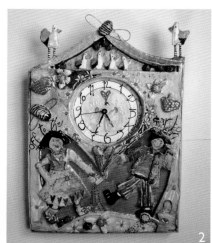

Oriel-y-Felin Gallery

An exciting gallery in the delightful village of Trefin on the Pembrokeshire coastal path. Oriel-y-Felin has been described by enthusiasts as a jewel in the artistic landscape.

Atmospheric works of this wonderful peninsula by St. David's artist Pauline Beynon, are shown with a constantly changing selection of carefully chosen paintings, ceramics, glass, bronzes, stainless steel works and jewellery. Notable regular exhibitors include painters Susie Grindey, Howard Birchmore, Clive Burnell and Peter Cronin with reknown makers such as Lawson Rudge, Andrew Bull, Martin Andrews, Michael Turner and Sarah Vernon to name but a few!

As you walk in to the gallery, you are met with a range of visual delights which overflow in to the tearoom where you can relax and savour freshly prepared food specialising in local Pembrokeshire produce at its best.

Owner Angela Samuel and her business partner Pauline Beynon, have always strived to give their visitors a warm welcome so are thrilled to have been awarded the Les Routiers British Café of the Year Award. High standards in Food and Art!

15 Ffordd-y-Felin
Trefin, Nr. St. David's
Pembrokeshire SA62 5AX
T: 01348 837500
E: gallery@oriel-y-felin.com
www.oriel-y-felin.com

Open: Daily 11am - 5pm Easter - end of Oct. Closed Mons (except Bank Holidays) and Suns (except in school holidays)

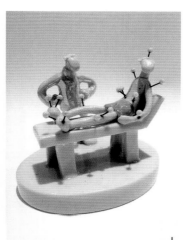

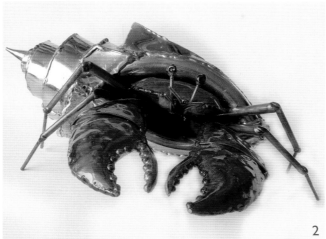

Parkfields Gallery

Set in the picturesque town of Ross-on-Wye, Parkfields Gallery exhibits a diverse and extensive range of the highest quality art and contemporary craft by established local artists and craftspeople, together with the very best of work from across the UK. Having celebrated our 10th anniversary in 2007, we continue to find fresh, new talent to exhibit alongside established makers. Work ranges from paintings, prints, pottery, glassware and sculpture to stunning jewellery, designer textiles and superb handmade furniture.

The changing exhibition programme, with a new, themed, multi-media exhibition each month, ensures there is always something different to view! With a welcoming, friendly atmosphere, visitors are encouraged to browse and enjoy the diversity of work on display.

Parkfields Gallery is happy to organise special commissions from the makers and operates the Own Art interest free Art Buyers Credit Scheme. Join Parkfields Gallery mailing list and you will receive their quarterly newsletter, keeping you informed about forthcoming exhibitions and events.

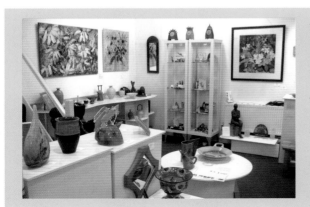

4 High St
Ross-on-Wye
Herefordshire
HR9 5HL

T: 01989 565-266
E: info@parkfieldsgallery.co.uk
www.parkfieldsgallery.co.uk

Open: Mon - Sat 10am - 5pm

C
&
0%

1
Angela Palmer
'Wye Talk'
sculpture

2
Rebecca Lewis
jewellery

3
Clio Graham
ceramics

4
Penkridge Ceramics

5
Ian Coleman
oil painting

The Potters' Gallery

P C ♿ 0%

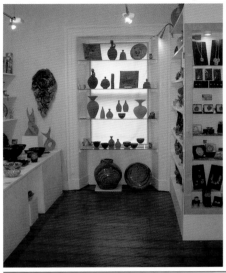

1 High Street
Conwy
North Wales
LL32 8DB

T: 01492 593590
www.thepottersgallery.co.uk

Open: Daily 10am - 5pm
(Oct - Mar closed on Weds)

The Potters' Gallery, Oriel y Crochenwyr, opened in 2003 in the medieval town of Conwy and is a co-operative, run by members of North Wales Potters. A wide range of quality ceramics is for sale from domestic ware that will grace any kitchen to rare collector's items, including sculptural pieces and jewellery. Friendly and welcoming the atmosphere in the Potters' Gallery encourages visitors to come in and simply browse. We are also an Information Centre, promoting knowledge and understanding of studio ceramics, so encouraging technical and aesthetic standards of excellence. We actively contribute to the cultural life of North Wales.

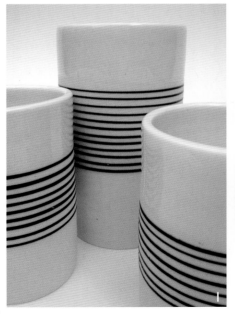

1. Annie Greenwood
2. Charmain Poole
3. Sue King

Alison Read - page 229

Rhiannon Gallery

A Welsh speaking family company, the Rhiannon Centre has been providing a showcase venue for high quality crafts since 1971. Over the years we have gained an enviable reputation as one of Wales' premier venues to see the very best in crafts made by leading Celtic craftspeople.

In our purpose-built exhibition workshops and jewellery show-room, visitors can see Rhiannon's renowned designs being handmade by our own goldsmiths. Rhiannon's original Welsh and Celtic designs are made in silver, gold and rare Welsh Gold. Our craft gallery is stocked with exciting new products sourced from all of the Celtic nations, as well as focusing on the very best from Wales and local craftspeople.

Suzie Marsh has developed an international reputation for her figurative animal sculpture. Although she works in a variety of media, here at Rhiannon we specialise in her cold cast bronze work, particularly the larger pieces, which make a striking addition to any home or garden.

Gwili Pottery has been creating domestic pottery for over 25 years, and has a wide variety of different designs. From vases and plates to jugs and lamp bases, each piece is individually hand-made.

For the past ten years **Luke Kite** has been developing his skills as a sculptor of metal. His work has matured and is now exceptional in quality and design.

Tregaron
Cymru/Wales
SY25 6JL
T: 01974 298415
E: post@rhiannon.co.uk
www.rhiannon.co.uk
Open: Mon - Sat 10am - 5.30pm. Sun July, Aug & Dec. Closed Christmas, Boxing, New Year's and St David's Days – open all other Bank holiday weekends including Suns.

P C

0%

1	2	3	4	5
Brian Eburah	Cowlinge Ceramics	Luke Kite	*Suzie Marsh	Gwili Pottery
jewellery		*metal sculpture*	*sculpture*	

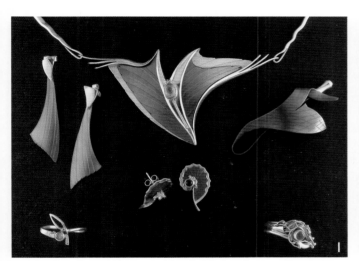

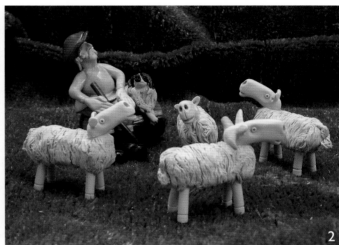

Ruthin Craft Centre

Is the most important gallery for contemporary craft in Wales. In the summer of 2008, this 25 year old institution re-opened it's doors in a stunning new building. Designed by award-winning architects, Sergison Bates, the new centre is a contemporary building inspired by the landscape that surrounds it.

The centre houses three gallery spaces with changing programme of exhibitions throughout the year. Objects in ceramics, silver, textiles, glass and recycled materials amongst others are presented by both Welsh artists as well as prominent makers from the UK and overseas. The retail gallery has a tempting display of contemporary craft for sale and to collect, while Café R offers delicious home-cooked food sourced locally. The central courtyard is a peaceful place to enjoy a coffee or have a bite to eat, while enjoying the new wooden furniture, hand-made for the centre by makers Jim Partridge and Liz Walmsley and viewing the stunning metal entrance gates designed by maker Brain Podschies. Visitors can also enjoy seeing artists at work in one of the studios.

Entrance is free and for those new to the area there is also a Cultural Gateway information point.

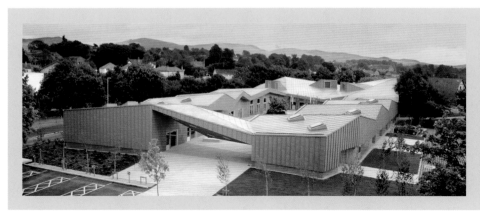

Park Road
Ruthin
Denbighshire
LL15 1BB

T: 01824 704774
E: thegallery@rccentre.org.uk
www.ruthincraftcentre.org.uk

Open: Daily Mon - Sun 10am - 5.30pm

1
Nancy Baldwin
ceramic
Photo: Dewi Tannatt
Lloyd also 3 & 5

2
Lucy Casson
recycled mixed
media

3
Claire Curneen
ceramic

4
Pamela Rawnsley
silver
Photo: Keith Leighton

5
Walter Keeler
ceramic

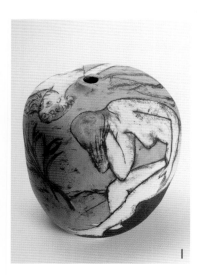

1

2

3

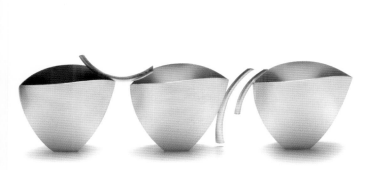

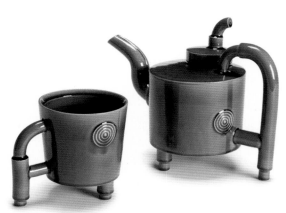

4

5

Wobage Makers Gallery

Since 1977 when Michael and Sheila Casson moved to Wobage Farm, the 18th century sandstone farm buildings have been converted into craft studios for seven craftspeople, allowing them to work individually, whilst sharing facilities.

There are four potters; Sheila Casson, Patia Davis, Jeremy Steward and Petra Reynolds. Woodworkers; Ben Casson and Lynn Hodgson and jeweller, Clair Hodgson.

Sheila's daughter Clare and son in law Andrew McGarva supply pots, tiles and terra cotta sculpture from their workshop in France. Lucy Casson, who makes tin sculpture at her London studio, also exhibits in the gallery at Wobage.

Special exhibitions are held throughout the year: in May, the exhibition has a distinctly "summer" theme, in September, the Gallery is open for the whole of the "Hereford Art Week" and starting in November, a show with Christmas in mind.

The gallery is staffed by the makers who can offer fascinating insight into their own techniques and inspirations. To visit Wobage is to experience a living celebration of craftsmanship and creativity.

(On B4224 Hereford Road)

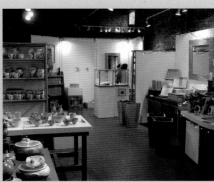

Wobage Farm
Upton Bishop
Ross-on-Wye
Herefordshire
HR9 7Qp
T: 01989 780 495
E: ben.casson@virgin.net
www.wobagecrafts.co.uk
Open: Thurs - Sun 10am - 5pm
Closed Jan & Feb - other times
by appointment

P
C

1
Jeremy Steward
woodfired soda glaze

2
Petra Reynolds
woodfired soda glaze

3
Sheila Casson
terra cotta sculpture

4
Patia Davis
porcelain

5
Clare and Andrew McGarva
stoneware

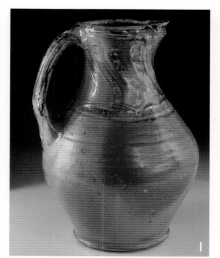

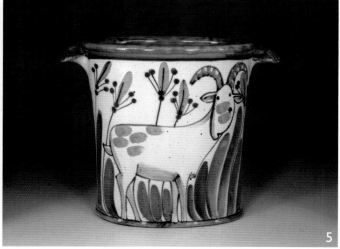

1
Ben Casson
oak bureau

2
Ben Casson
ash sideboard

3
Lucy Casson
*Tin sculpture
'Brushing'*

4
Clair Hodgson
jewellery

5
Lynn Hodgson
walnut candle blocks

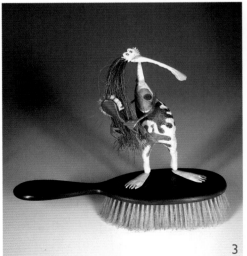

Northern

Anstey Galleries

Located in the delightful spa town of Harrogate since 1997, Anstey Galleries represents a variety of carefully selected contemporary artists and jewellers who create original works of art. In the ever increasing mass produced world that we live in, the gallery is determined to continue to support the special art market which offers so many genuine delights.

Anstey Galleries specialises in Sculpture but also exhibits Fine Art and Jewellery by talented local and national artists. It changes its exhibitions every month.

A variety of extra services are offered - a bespoke consultancy service which provides customers with advice and guidance to help source art; a gift list service which enables artwork to be requested as gifts for a wedding or special celebration; the Art Council's Own Art scheme which is an interest free art loan scheme giving customers a 'lending hand' to buy original works of art.

The gallery's website is designed to give customers an insight into an artist's personal style but information on current exhibits is available on request. It also provides seasonal opening hours and details of current exhibitions, see below.

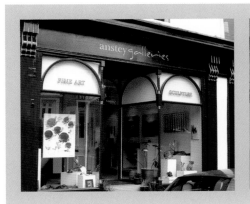

33 Swan Road
Harrogate
N.Yorks
HG1 2SA
T: 01423 500102
E: contact@ansteygalleries.co.uk
www.ansteygalleries.co.uk
Open: Wed - Sat: 10am - 5pm
Sun: 11am - 4pm and by appointment. Please check website for any seasonal amendments.

P
C
0%

1
Lenny Trines
*vegetable ivory
jewellery*

2
Paula Horsley
*mixed media mainly
acrylic*

3
Jo Stockdale
mixed media

4
David Cooke
sculptural ceramics

5
Mark Sanger
burr oak

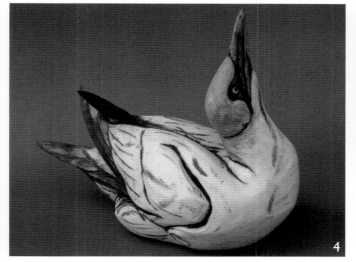

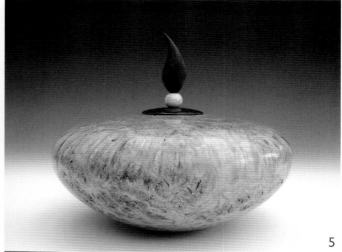

The Arc

The Arc is one of the Northwest's leading privately run contemporary craft galleries, established for over 15 years, and much loved by our regular and local customers. The Arc is easy to find, located close to the historic centre of Chester. From the central Cross take a few steps down Bridge Street and the first right into a narrow pedestrian lane called Commonhall Street, there you will find The Arc, housed in an 18th century brick and timber warehouse. The building is greatly admired by our visitors and creates a beautiful backdrop for the varied contemporary work we show.

Although we have a special emphasis on ceramics, textiles and jewellery you will also find leather wood, metal, original prints plus greetings cards and gift wrap. The Arc is a rewarding hunting ground for unusual gifts or special presents, with a welcoming friendly atmosphere, where you will find the best of British designers and makers.

The selection of work is based upon craftsmanship and skills which reveal the qualities of the chosen material, light through glass, glaze on clay, the grain and weight of wood., the curve of acrylic or spun pewter. Jewellery is selected for innovation and style, fashion and interior textiles for the glorious richness of colour and imagination. Through a varied exhibition programme we regularly introduce new work and champion emerging talent. Our web site gives details of news and forthcoming events. We hope to see you soon.

4 Commonhall Street
off Bridge Street
Chester CH1 2BJ

P
C
0%

T: 01244 348379
E: enquiries@thearcgallery.co.uk
www.thearcgallery.co.uk

Open: Mon - Sat 10am-5pm

Gallery exterior
Photo:
Andrew Arditti

1
Daiva Kojelyte-
Marrow
ceramics

2
Chris Taylor
ceramics

3
Amanda Ross
hand print on textile

4
Howcroft & Jordan
wood

5
Trisha Needham
textiles

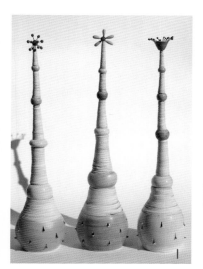

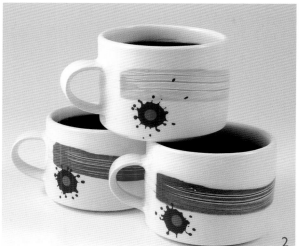

Lesley Strickland

I started making jewellery at evening classes some 30 years ago because I loved earrings. I went on to produce a range of work firstly in acrylic and more recently in cellulose acetate, which I love. I can create fluid forms in subtle colours, using the acetate, which after much filing and sanding have a wonderfully smooth finish. I strive for elegant simplicity and like the wearer to have a very tactile relationship with my work.

Photo: Sarah Straussberg

Lyn Pugh

Working from her garden studio on the Welsh border, Linda creates a wide range of beautiful felt handbags. Using the finest merino wool, which she felts by hand, Linda's handbags not only look stunning, but are also wonderful to touch. Linda finds inspiration during the many trips around Britain which she takes with her family, in their 30 year old camper van. Commissions are welcomed, where handbags can be matched with outfits for weddings, the races, or any other special occasion.

Photo: Andrew Arditti

Lorna Henderson

Lorna Henderson is a British designer of elegant contemporary jewellery, handmade in her countryside studio, using precious metals and semi-precious gems. Lorna's inspiration comes from her love of nature and is heavily influenced by the colour, form and texture of flora and fauna, which she translates into unusual and wearable jewellery. The jewels have diverse appeal, intricate designs of semi-precious gems woven amongst hand forged silver flowers contrast with simple everyday pieces.

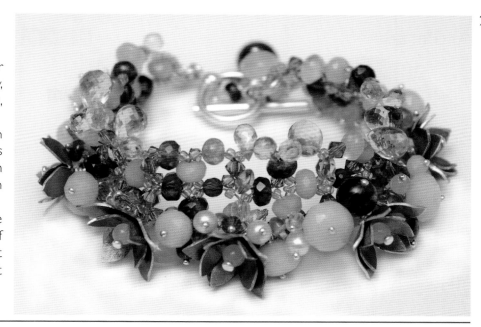

Adam Frew

I make functional pots and large expressive vessels using porcelain clay, fired in a wood or gas kiln. I love porcelain for its whiteness and my pots are a perfect ground for my inky cobalt drawings.

Ornament and decoration are special qualities that serve to captivate and charm. My decoration is spontaneous, inky cobalt narratives tell stories of idiosyncratic and contextually interesting imagery. I draw inspiration from people, nature and the environment. I want people to use my work and enjoy it.

ArtParade

 P C ♿ 0%

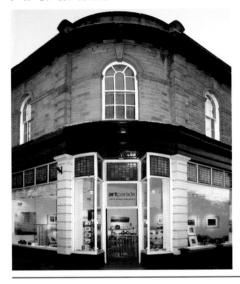

I Victoria Road
Saltaire
BD18 3LA

T: 01274 590619
E: info@artparade.co.uk
www.artparade.co.uk

Open: Tues - Sun 10am- 6pm
Closed Mon except Bank Holidays

This beautiful spacious gallery, in the World Heritage Site village of Saltaire, offers both contemporary designer crafts and original fine art photography and artist's prints.

"The gallery lends itself beautifully to displaying crafts on the ground floor, where the light floods in, and photography and prints on the lower ground floor, where we have two rooms and lots of wall space. It's a lovely environment, and amongst so many beautiful things, I only hope to be able to offer my customers a delightful experience. Our twin aims are to offer the highest quality work and to have the friendliest gallery you could ever wish to return to."

Craft Shop

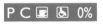 P C ▣ ♿ 0%

Royal Exchange Theatre
St Ann's Square, Manchester M2 7DH

T: 0161 615 6767
E: craft.shop@royalexchange.co.uk
www.royalexchange.co.uk/craftshop

Open: Mon - Sat 9.30am until the start of the performance

Established in 1981, the Craft Shop is a vibrant combination of quality and style. Work is handmade by individual makers working across the U.K. and includes jewellery, ceramics, glass, textiles, wood, metal and pictures. We also have a range of cards and stationery for every occasion.

Throughout the year we host a programme of changing exhibitions from new and established makers, complementing the work already displayed in the shop. Most of our makers welcome special orders and commissions, from ring sizing to bespoke gifts.

We are in an unusual location inside the Royal Exchange Theatre, in Manchester's busy City Centre.

The Beetroot Tree Gallery

P C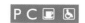

The Beetroot Tree Gallery
South Street
Draycott
Derbyshire
DE72 3PP

T: 01332 873 929
E: info@thebeetroottree.com
www.thebeetroottree.com

Open: Daily 10am - 5pm

'ART to covet FOOD to enjoy
SPACE to relax.'
 In the heart of the old village centre

of Draycott you will find a nationally renowned contemporary art gallery with workshops, landscaped garden, exciting art and craft materials, a framing service and a stylish and relaxing café. We source individually made works by named artists ranging from the traditional to the contemporary ensuring that our exhibitions are displays of excellence and distinction.

The gallery is set within a beautifully restored barn dating from the late 1600s and still features the original wooden beams.

1. Jean Picton *painting*
2. Steve Davies *glass*
3. Alysn Midgelow-Marsden *textiles*

The Artroom Gallery

The Artroom Gallery is situated in the picturesque, historic market town of Garstang, which nestles on the edge of the Bowland Fells, a designated area of outstanding natural beauty. The gallery specialises in original British contemporary art and craft. Established in 2007 by Helen Carr, selection is based on beauty, quality and originality, reflecting her passion for craft. Many talented local Lancashire makers are represented in the exciting range of paintings, ceramics, textiles, glass and designer-made jewellery.

This charming gallery has a relaxed light and airy feel. A friendly atmosphere puts visitors at ease, and they are always welcome to browse. The variety of original art and craft on display provides opportunities to acquire original gifts or distinctive focal pieces for the home.

Helen and resident artist Linda Robinson are happy to provide information about artists and their work. They work closely with customers and designer-makers on individual commissions.

The Artroom Gallery hosts a changing, contemporary exhibition programme, focussing on a theme or a collection of talented national and local artists, providing interest and diversity of choice. Details can be found on our website.

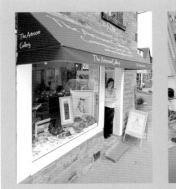
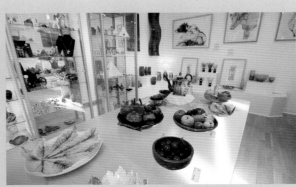

4, Oak Grove
Bridge Street
Garstang
Lancashire, PR3 1YB.
T: 01995 600400 www.artroom-gallery.co.uk
E: helen@artroomgallery.co.uk
www.artroomgallery.co.uk

P
C

Open: Mon - Fri 10am - 5.30pm,
Sat 10am - 5pm, closed Wed & Sun

1
Roma Vincent
jewellery

2
Linzi Ramsden
ceramics

3
Joanne Eddon
textiles

4
Stephanie Bowen
glass

5
Linda Robins
'Let's Chat'
collograph

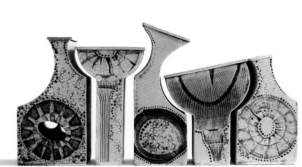

Joan Hardie

My aim is to produce ceramics that encourage people to look afresh at the natural world as well as being interesting, accessible and affordable. Inspiration comes from the colours, textures and forms of the natural treasures I find when walking in the Lake District's valleys and fells. Such treasures are often on a small scale, such as lichen on a wall top or the bark of a tree.

Every year I select the most inspiring photos of leaves, bark, shells, fungus and lichen to produce a "sketchbook" album. After a gestation period, which might be several months, I capture something of their feel in ceramic form. I might use impressions of real leaves, pinecones, shells or bark to make ceramics that are in sympathy with their shapes, textures and colours, or focus on one aspect in a more abstract piece. Every piece is different, being hand built. Wall collages, such as this one, made from London plane leaves, are amongst the most striking pieces

Jo Dix

Inspired by nature, industry and everyday life, I create contemporary designs for men and women that are functional, easy to wear and highly individual. Although I work predominantly in sterling silver, a passion for experimentation means a continual search for new materials and techniques. I discovered metal clay several years ago and now specialise in bespoke hollow forms and rings, exploiting the medium's immediacy and versatility. This reclaimed fine silver embodies "instant gratification" and is a fantastic material with which I love to work and teach.

Steph Black page 231

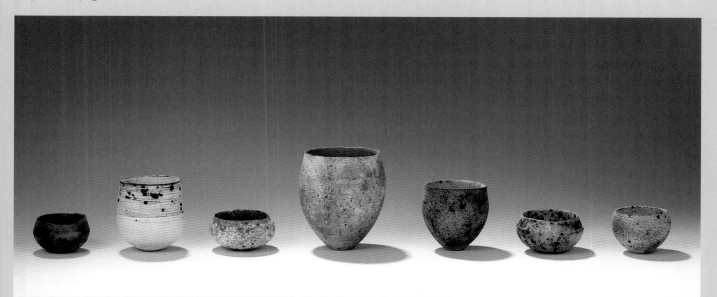

Booth House Gallery

The gallery focuses upon studio pottery and ceramics along side selected paintings and prints. Established in 1975, the converted 19th century barn provides studio space for Jim Robison and dramatic display areas. Natural stone walls and oak roof beams give an ideal background for art and crafts.

Featured exhibitions by invited Artists stand along side continuous displays of work by Jim Robison (Elected fellow of the Craft Potters Association) and others. Jim creates one off pieces, with particular interest in surface, colour and texture. He is also known for large public commissions and is author of 'Large Scale Ceramics'.

For daily use, there is a house range of functional pottery to choose from. Created with help by experienced thrower, Jane Barker, this colourful ware is both highly functional and a pleasure in use.

A family business, there is always a warm welcome. Visitors will find Jim and Liz, his wife (who writes for ceramics publications as 'Potter's Moll') and staff, happy to discuss all aspects of ceramics. You may view 'work in progress' and there are opportunities to learn skills during weeklong summer courses.

3 Booth House Lane
Holmfirth
HD9 2QT
T: 01484 685270
E: jim.Robison@virgin.net
www.jimrobison.co.uk or
www.boothhousegallery.co.uk

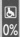
0%

Open: Sat & Sun 12 - 4pm. Weekdays when artist is present, but please ring to check.

1
*Garden Slab Vase
1 mtr tall*

2
*Selection of
functional ware*

3
*Landscape vase 40
cm. tall*

4
*Tatton Park Garden
Sculpture*

5
Vase detail

All by Jim Robison

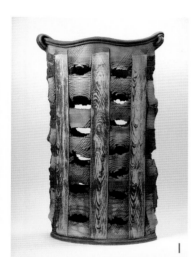

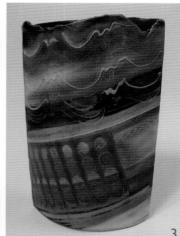

The Bottle Kiln

An oasis of calm and a rich source of inspiration, the Bottle Kiln provides both a welcome rest from the buzzing modern world and a tempting and varied collection of visual delights.

Built on the site of a former pottery containing a rare bottle-necked kiln, it comprises areas for contemporary craft - housed in and around the kiln itself - fine art, giftware, jewellery and home-wares, as well as an award-winning café selling teas, coffees and lunches. Outside a tranquil oriental garden provides an area to take refreshments in good weather.

In the crafts displays we show a range of ceramics and glass by regional and nationalmakers, and have a particular interest in hand-made contemporary jewellery, with the overall aim of extending a broad appeal both to experienced gallery-goers and total new-comers, whilst maintaining a high standard throughout.

The Bottle Kiln is over 20 years old and firmly established as a key arts venue, it is extremely popular both to visitors from the region and further afield, attracting all those who seek objects that are well-chosen, beautiful and unusual.

High Lane
West Hallam
Near Ilkeston
Derbyshire DE7 6HP

T: 0115 932 9442
E: nic@bottlekiln.co.uk
www.bottlekiln.co.uk

Open: Tues - Sun 10am - 5pm closed Bank Holidays

1
Will Shakspeare
glass

2
Jennifer Hall
ceramics

3
Sarah Vernon
ceramics

4
Abbot & Ellwood
metal sculpture

5
Rachel Barker
ceramics

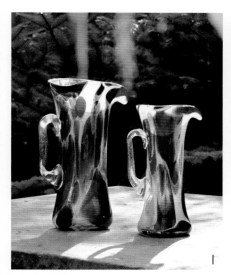

Chapel Gallery Ormskirk

The Chapel Gallery curates and installs a diverse programme of exhibitions including work by artists such as David Hockney, through the Hayward Gallery Touring Exhibitions and Julie Arkel, provided by the Ruthin Craft Centre.

Programmes also feature the West Lancashire Open Exhibition, the Youth Open Exhibition and Christmas Fine Art & Contemporary Craft Event.

The gallery's Contemporary Craft Shop offers a wide range of luxury items including handcrafted ceramics, glassware and jewellery, available through the Arts Council England's 'Own Art' scheme. The gallery Café is also worth a visit, its welcoming atmosphere and menu of light lunches, speciality coffees and luxury cakes is always a treat.

There are a variety of other events and services provided by the Chapel Gallery team. These include an Education Programme for schools and colleges, Family Friendly Activities, a well-established Art Club run by professional artists and Holiday Activities featuring visual and performance art workshops.

The gallery is situated in the town centre approximately 20 metres from Ormskirk Bus Station, a car park and is a short walk from Ormskirk Railway Station. Please contact the gallery for an Exhibition Programme or further information.

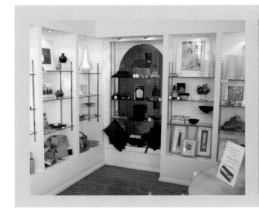

St Helen's Road
Ormskirk
Lancashire
L39 4QR

0%

T: 01695 571328
E: chapel.gallery@westlancsdc.gov.uk
www.chapelgallery.org.uk

Open: Tues - Sat 10am - 4.30 pm

Rachel Ducker - page 169

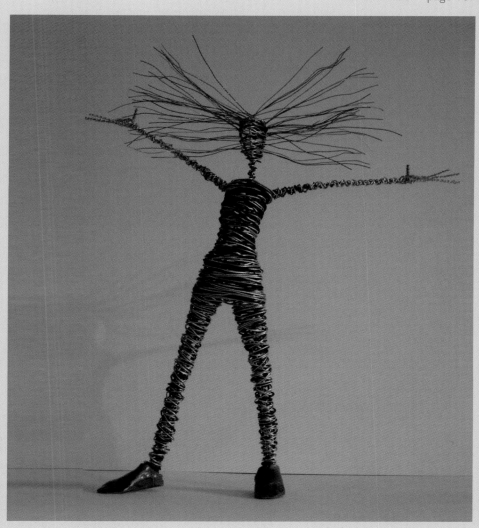

Created Gallery

Situated on the edge of the Peak District in Chesterfield, Created Gallery opened in 2008. The gallery is owned by Deirdre and Dominic Gage and developed from a joint passion for craft. Their daughter Clare Gage is an award winning ceramicist with a studio at the rear of 'four7nine'- the building which houses Created Gallery. Dominic is a potter and Deirdre is a feltmaker and it is this first hand knowledge that makes Created special.

The purpose of Created Gallery is to convey the inspiration, creation and passion behind the work of designer/makers while reaching out to people who are new to buying craft. Created has been described as 'the hidden treasure' as well as having 'something for everyone'. Artists are selected from designer/makers in Derbyshire and the surrounding counties as well as new and emerging artists with makers from further afield in the UK increasingly being included in the gallery. Since 2009 creative courses have been added to the gallery's programme of events.

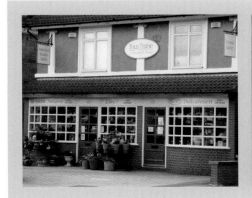
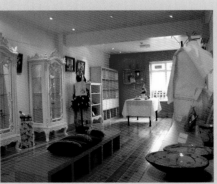

479 Chatsworth Road
Brampton
Chesterfield
Derbyshire
S40 3AD
T: 01246 232205
E: info@createdgallery.co.uk
www.createdgallery.co.uk
Open: Tues - Sat, 10am - 5pm
 Suns 11am - 4pm
 Jan - Ap closed Suns

Charlotte Brown

Clare Gage

Charlotte's jewellery collection incorporates sentimental poems and phrases, many taken from her Great Grandmother's school leaving book.

Working in silver and gold, each piece is handcrafted using traditional jewellery techniques and can be embellished with diamonds, pearls or paper.

Charlotte welcomes commissions, and will incorporate personally chosen words into any of her designs.

Clare Gage's elegant collection of tableware is an intimate fusion of hand-crafted textiles and delicate ceramics. Every piece is carefully formed from hand woven fabrics, transformed into tailor made moulds and created in porcelain. Each item is a modern day treasure, eclectic, individual and yet completely functional. Clare was awarded the 2007 Design Directions: Ceramic Futures award and is a fellow of the Royal Society of Arts.

Fibre + Clay

Fibre + Clay is an exciting new gallery that combines its owners' twin passions for contemporary ceramics and textile art. In the elegant market town of Knutsford, the light and airy ground floor space showcases work by leading British ceramicists and textile artists, emerging designer-makers as well as by internationally renowned crafts people based in the owners' previous home, South Africa.

Each piece is carefully selected for the originality of its design and high quality of craftsmanship, and sourced directly from the maker's studio. The ever changing collection is a true celebration of texture, colour, shape and form, and a treasure trove for the serious collector or anyone looking for unusual gifts, wearable art and both functional and decorative homeware pieces.

In addition to the gallery downstairs, you will find a knit studio on the first floor selling an extensive range of exquisite yarns for hand-knitting and crochet. All the latest pattern books and knitting or crochet accessories as well as an abundance of really special buttons are available in this Aladdin's Cave. The Knit Studio at Fibre + Clay runs a full knitting and crochet skills workshop programme as well as twice weekly informal knit gatherings. Whether you want to learn a new skill or brush up on a much loved hobby, the friendly and relaxing studio enables this for knitters and crocheters of all ages and both genders.

11-13 Minshull Street
Knutsford
Cheshire, WA16 6HG

T: 01565 652035
E: fibreandclay@aol.com
www.fibreandclay.co.uk

Open: Mon - Sat 10am- 5.30pm

1	2	3 & 5	4
Ronel Jordaan	Mi Te Project	Annabel Montgomerie	Jane Cummins
felt hanging	*textiles*	*felt & mixed textiles*	*felt & laminated wood bags*

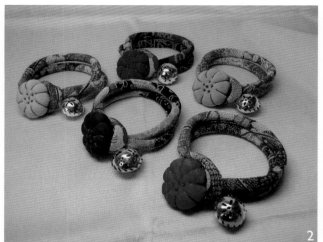

Fibre + Clay

1
Laura Walker
ceramic buttons

2
Allison Wiffen
ceramic cufflinks

3
Christina Bryer
ceramics

4 & 5
Vivienne Ross
ceramics

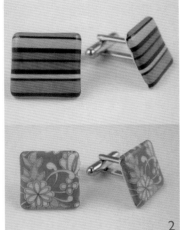

Harriet Appleby - page 117

The Gallery Masham

The Gallery is situated on the Market Square in the picturesque North Yorkshire town of Masham. Established over 15 years ago by artist Josie Beszant, The Gallery proudly showcases a range of British painters, printmakers, sculptors, jewellers and crafts people, a number of whom are from Masham and the surrounding area.

The artist-run gallery holds around three contemporary exhibitions a year often combining emerging and established artists. It also has many regular exhibitors and is a key outlet for a number of artists.

The Gallery more recently opened an exciting and inviting toy room, selling quirky and unusual British-made and fairly traded wooden toys.

Details of the gallery's forthcoming exhibitions, and information on its artists and makers is available via the website. The gallery offers the Own Art scheme, which allows for artwork to be paid for in ten interest free installments, and is one of the only galleries in Yorkshire to have a Hayvend machine, vending unusual contemporary art at only £2.

The Gallery
24 Market Place
Masham
North Yorkshire
HG4 4EB

T: 01765689554
E: enquiry@mashamgallery.co.uk
www.mashamgallery.co.uk

Open: Tue - Sat 10am - 5pm, Sun 1pm - 5pm

P
C
🖻
♿
0%

1
Ian Scott Massie
painting

2
Sally Page
fused glass

3
Elizabeth Price
sculptural ceramics

4
Hester Cox
'The Journey'
collagraph and solar
plate

5
Dee Barnes
jewellery

Heart Gallery

Heart Gallery is owned and run by Alison Bartram who has created a sympathetic design and interesting layout, achieving an inviting and serene space that complements the architecture of the building, a former Chapel, and also provides the perfect space to exhibit fresh, innovative and exciting contemporary crafts from both emerging and established designer/makers.

The warm ambience and decadent charm that greets you when you open the door of Heart Gallery encourages you to browse the ambi-tious programme of ever-changing showcases and exhibitions and to discover a haven from the predictability of the high street. Heart Gallery is a beautiful place, in a beautiful town and loves all things beautiful and once discovered, it's never forgotten.

Heart Gallery also incorporates two studios, which offer you the opportunity to meet Heart Gallery's resident designer/makers in leather-work and personal art works and to appreciate their expertise in creating new designs and commissions.

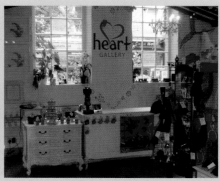

The Arts Centre
4a Market Street Hebden Bridge
West Yorkshire, HX7 6AA
T: 01422 845845
E: alison@heartgallery.co.uk
www.heartgallery.co.uk
www.greggmcdonald.com
www.hwilsonart.com
Open: Mon - Tues Closed.
Wed - Fri 10.30am - 5.00pm, Sat
10.30am - 5.30pm, Sun 12pm - 4pm

P
C
&
0%

Heather Wilson

Gregg McDonald

Heather's Name Pictures are painted to order, and can include details such as dates, special places, family, friends and pets, all copied from photographs provided. In a setting of anything from the seaside, a circus, gardens, or a favourite holiday destination, these pictures are wonderful keepsake for any age.

Heather also creates beautifully detailed Celebration Pieces, using those precious items we often keep hidden away in a drawer. She presents them on a stretched canvas or box frame to celebrate Weddings, Anniversaries, a New Baby, a holiday, or a touching memory of someone's life.

In addition, Heather embellishes hats and fascinators using fabulous feathers, ribbon and beads. Even a very small shark has been spotted basking in an underwater world of chiffon!

Gregg McDonald has specialised in designing and hand making leathergoods since 2006, fulfilling a dream to design, develop and make his own products. He trained at the prestigious Cordwainers College, London graduating in 2003. Currently his range includes mens' and womens' billfold wallets, numerous purse designs, card wallets, ID holders, shoulder bags, laptop bags, guitar straps and iPod cases. All pieces are designed with an eye for detail, usability and originality, and new designs can be commissioned to order. His precise workmanship is complemented by a discerning selection of materials, and all purses and wallets are fully lined. The considered and attractive detailing, colours and form give the products special appeal, making unusual and very personal gift items.

Amanda Cox

Having previously lectured in jewellery at Plymouth College of Art and Design, Amanda now creates jewellery at her studio based in West Yorkshire.

Her designs are inspired by simple organic forms and the tactile properties of metal.

In Amanda's ranges, which include the delicately beautiful 'Lily Collection' incorporating freshwater pearls of various hues, she has created not only elegant bridal and partnership pieces, but also bold modern chunky jewels available in a variety of finishes.

Clare Caulfield

Clare Caulfield is a Yorkshire based artist and printmaker who exhibits regularly in both solo and group shows throughout the country. Combining the processes of drawing, painting and various printmaking techniques Clare captures the excitement, life and vibrancy of many of the world's most enticing cities including Paris, New York, Venice, London and Prague. The magic of each location being recreated in Clare's very distinctive and appealing illustrative style of working.

From her workshop in Hebden Bridge, Sue produces individual contemporary tableware and accessories, hand-built from porcelain clay slabs and constructed as delicate boxes. Some designs are geometrical, others inspired by coastal and rural buildings, such as beach huts, lighthouses, piers and windmills.

All the pieces are hand-decorated in greys and blues, using sgraffito and inlay techniques, and finished with a transparent glaze. All her work is food-safe and waterproof.

Karen Faulkner-Dunkley

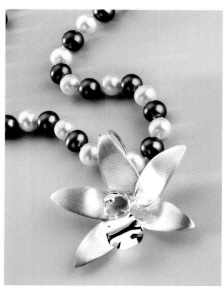

Karen Faulkner-Dunkley designs elegant jewellery in silver and gold under the brand of KFD Jewellery. Influenced by nature, many of her collections incorporate leaves or flowers such as lilies and orchids. The pebbled banks of Norfolk's beaches inspired the new Mellow Moods collection. Colour injects vibrancy into the range to evoke passion, serenity, tranquillity and contradiction. Each collection of jewellery consists of a full range of pieces to include necklaces, pendants, bracelets, earrings and rings.

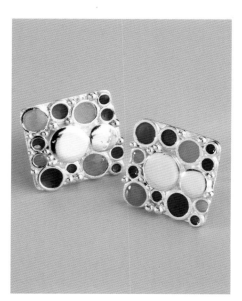

Leigh Shepherd

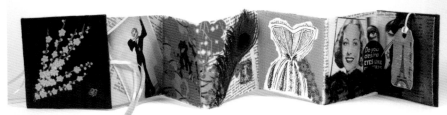

Leigh Shepherd designs… creative works with resin and paper. Inspired by vintage imagery and a desire to re-use or up-cycle, Leigh creates beautiful, individual pieces to wear and for the home.

Her pendants are made using vintage Mah Jong and Scrabble pieces along with vibrant Japanese papers.

Leigh's new Art-ccordion Picture Books are created with her own drawings and paintings and feature original vintage inclusions. The books are designed to be displayed open.

Kate Hamilton-Hunter

A love affair with old and cherished biscuit and sweetie tins has led to this extraordinary collection of designer jewellery. With a history of its own, a link to the past and to the comfort of tea and biscuits in days gone by, this collection connects our memories of childhood to this day in history. Designed and hand-made in North Wales in a small design studio. 12 jewellery collections, commissions and one-off gallery pieces.

1
Bronwen Tyler-Jones
metalwork Inventions & jewellery

2
Naive
textile art by Becks and Susan Jennings

3
Karen Thomas
silver jewellery

4
Sarah Terry
Guerilla embroidery

5
Alison Read
printmaker: relief, Intaglio and screen-printing

1

2

3

4

5

Lund Gallery

Lund Gallery was opened in 2005 by painter Debbie Loane and her husband. It occupies beautiful purpose designed, fully accessible premises in converted farm buildings 30 minutes drive north of the historic city of York. The gallery has quickly established itself as a venue for contemporary ceramics and fine craft by leading British makers and a range of these are always in stock. The gallery normally hosts between 4 and 6 themed or solo exhibitions a year as well as showing landscape paintings and drawings by resident artist Debbie Loane and other gallery artists.

New for 2009 is the 'Tractor Barn' exhibition and project space which will be used for a number of site specific exhibitions courses and projects. The space is also available for hire. Adjoining this is a delightful new courtyard space for displaying outdoor art. The gallery serves coffee and cake at weekends and there are many good restaurants and pubs in the surrounding villages. If travelling any distance please check that the gallery is open before setting off as we do sometimes close between exhibitions. Lund Gallery is a member of ICGA and operates the Own Art scheme.

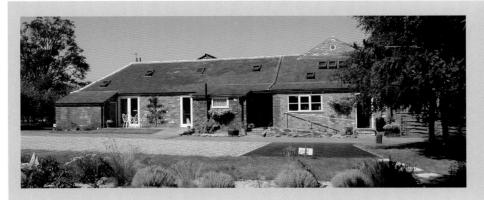

Alne Road
Easingwold
North Yorkshire
YO61 3PA

P
C
&
0%

T: 01347 824400
E: info@lundgallery.co.uk
www.lundgallery.co.uk
Open: Thurs - Sat 11am - 5pm
 Sun & Bank Hols 12 - 4pm

1
Debbie Loane
charcoal drawing
'From Dod
Northumberland'

2
Steph Black
ceramics

3
Sam Hall
ceramics
Flat form
ht 41cm w 36cm

4
Debbie Loane
pastel and water-
colour
'Northumberland
Coastal Journey'

5
Celia Smith
wire sculpture
Godwit Group

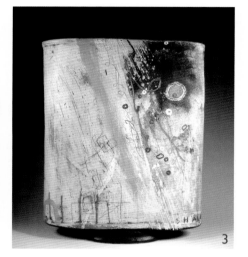

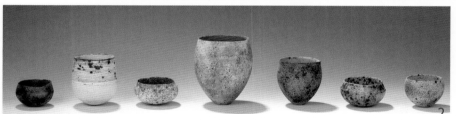

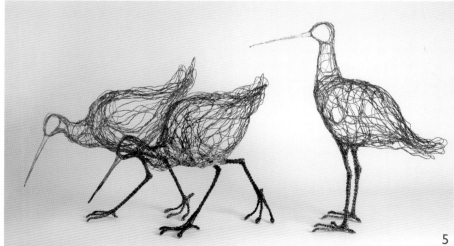

The March Hare Gallery

Set in the heart of the historic part of Ripon, minutes away from the Cathedral, The March Hare Gallery is nestled away in a Victorian style arcade which was once the City's Temperance Hall.

The gallery has a reputation as a place to find something unusual and of quality in a welcoming and friendly atmosphere. It showcases both the work of established makers from around the country and local artists, including glassmakers, ceramicists, jewellers and etchers. In keeping with the name of the March Hare Gallery, a wide selection of work in a variety of media based on the theme of the hare will usually be available amongst our displays.

The café upstairs is a perfect retreat where you can sample our coffee, cakes and home cooked food.

This year we are welcoming painter/printmaker Moira McTague on two days a week as our resident artist in the gallery. She has shown her work successfully with us and will help in our aim to specialise more in the work of contemporary original printmakers. For more information please telephone the gallery.

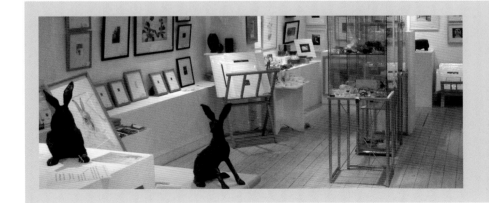

The March Hare Craft Gallery,
1 Ripon Small Shops
Duck Hill, Ripon
North Yorkshire
HG4 1BL

T: 01765 608833
E: alison.daji@btconnect.com
www.marchharegallery.com
Open: Mon - Sat 10a.m - 4.pm
 Café open every day

1
Sue Jenkins
ceramics

2
Moira McTague
'Poppy' etching

3
Richard Raby
ceramics

4
Sanders & Wallace
glass

5
Moira McTague
'The White Horse'
etching

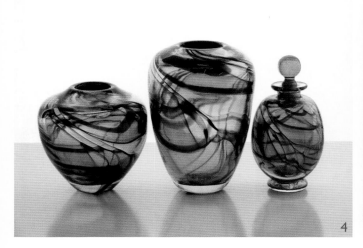

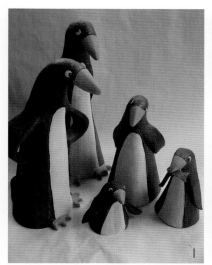

Opus Gallery

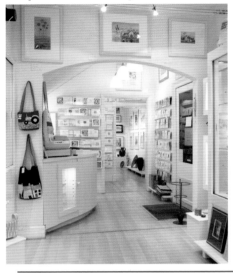

34 St. John's Street
Ashbourne
DE6 1GH

T: 01335 348989
E: enquiries@opusgalleryashbourne.com
www.opusgalleryashbourne.com

Open: Mon - Sat 10am - 5pm

Opus Gallery, situated in Ashbourne at the Gateway to the Peak District, has over the years become a landmark in the town for the best in British handmade art and crafts.

Its delightfully fresh and tranquil interior provides a perfect opportunity to browse for a special gift or to purchase the next adornment for your home.

In addition to many fine contemporary paintings by local and regional artists, Opus offers a feast of ceramics, textiles, glassware and jewellery and a wide selection of beautiful handmade cards.

A full list of ongoing exhibitions can be found on the Opus website. *www.opusgalleryashbourne.com*

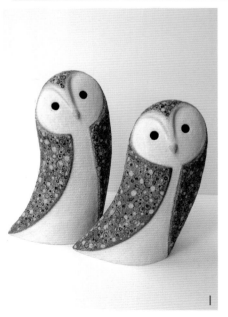

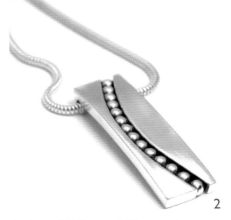

1. Russell Wilson *wildlife ceramics*

2. Rebecca Lewis *silver granule pendant*

3. Clare Caulfield *'Monmartre, Paris'*

Pyramid Gallery

Pyramid Gallery is a privately owned shop and gallery in the heart of medieval York, close to The Minster. Established in 1980, Pyramid offers one of the country's finest selections of British made contemporary crafts, jewellery and original prints, enthusiastically displayed in a 15th century building that is owned by the National Trust. A member of the Independent Craft Galleries Association, the gallery displays work by many leading British designers including over 50 jewellers plus print-makers, sculptors, potters, wood workers and glass makers. Displays are constantly changing and the two first floor galleries are used for exhibitions which are presented in detail on the web site.

Pyramid can be found on Stonegate, which is one of York's best known and prettiest shopping streets running between the south door of the Minster and Betty's cafe on St. Helens Square. Three great attractions five minutes apart, but you need to allow at least half a day! And we'll look after your purchases for you while you queue at Betty's.

43 Stonegate
York
YO1 8AW

T: 01904 641187
E: pyramidgallery2008@yahoo.co.uk
www.pyramidgallery.com

Open: *Everyday 10am - 5pm, Sun 11am - 4.30pm*

Platform Gallery

The Platform Gallery is situated in the historic market town of Clitheroe, Lancashire, and is run by Ribble Valley Borough Council.

The gallery is located in a prime position in the old railway station building, built in 1870. The gallery was awarded arts Lottery Grant in 2001 and was totally refurbished to provide an airy contemporary craft exhibition space, shop and education facilities.

The Platform Gallery hosts an exciting and varied programme of exhibitions throughout the year, including solo, group and touring shows. The emphasis is on high quality and innovative work by both national and local makers.

The gallery shop features a wide and ever-changing selection of ceramics, glass wood, textiles and jewellery to suit all budgets. Our experienced staff can also help with special orders and commissions. The gallery provides craft workshops and talks for all ages and abilities, throughout the year.

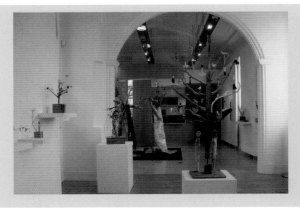

StationRoad
Clitheroe
Lancashire
BB7 2JT

T: 01200 443071/414556
E: platform.gallery@ribblevalley.gov.uk
www.ribblevalley.gov.uk/platformgallery

Open: Mon - Sat 10am - 4.30pm
 Please contact for other times

0%

Rose Hamilton

I find inspiration in both architectural and natural forms, creating bold, fun pieces that are a pleasure to own and wear. For me the creative process always begins with a series of drawings, creating fluid, curvaceous shapes that visually excite. The use of rivets enhances an industrial feel, complementing the curvaceous shapes and allowing me to create layered pieces. I add intense colour with vintage buttons on some pieces to compliment the matt silver and oxidised finish of the metal.

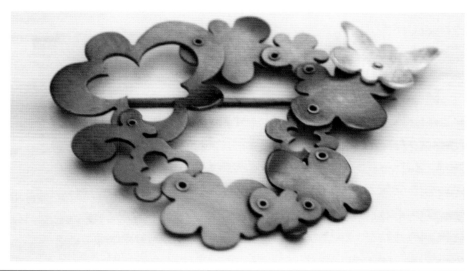

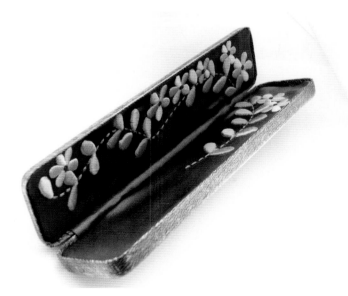

Lucy Smethurst

A contemporary twist on traditional embroidery. Creating seasonal collections both timeless and innovative, Lucy pays homage to traditional embroidery yet captures the imagination of a contemporary and discerning market. Hand dyed natural fabrics combine with vintage prints to develop subtle colour ways. From tiny floral hairpins to embroidered jewellery boxes, emphasis is placed on a love of hand and Irish machine stitch. Whoever she is designing for Lucy endeavours to create a bespoke alternative to traditional embroidery.

Radiance

As a designer/maker of paper cut lamps and shades Hannah Nunn dreamed of having a shop front of her own with a workshop attached. She was inspired by the work of many of her contemporaries who were working with light and thought it would be wonderful to gather it all together in one glowing space. The perfect premises became available and in 2005 Radiance was born.

Hannah has created a glowing emporium of table lamps, wall and floor lamps, lampshades, fairy lights, sculptural lights and candle holders alongside a growing range of beautiful crafts, home wares and unusual cards. There are lights made from paper, ceramic, wire, copper, wood, textiles, papier-mache, acrylic, and even bone china teacups!

Radiance celebrates and promotes the world of lighting and craft. Hannah's passion and enthusiasm is shown in the work that she stocks and in her lighting collection that she makes in her onsite workshop.

It is situated in Hebden Bridge, the perfect day out, with pretty walks, lovely shops and great cafes. Radiance also has a comprehensive online shop and work can be posted anywhere in the UK.

58, Market Street
Hebden Bridge
West Yorkshire
HX7 6AA

T: 01422 845764
E: hannah@radiacelighting.co.uk
www.radiancelighting.co.uk

Open: Weds - Sat 11am - 5pm, Sun 11am - 4pm

P
C

1
Hannah Nunn
'Allium Table lamp'
with paper-cut and
engraved design

2
Colin Chetwood
'Oak lamp' with
ochre tissue paper
shade and a
burnished oak base.

3
Helen Minns
Linen 'Hare
Lampshade' with a
screen printed design

4
Amy Cooper
'Holey Planet'
porcelain lamp

5
Karin Eriksson
'Gold Leaves' bone
china tea light
holder

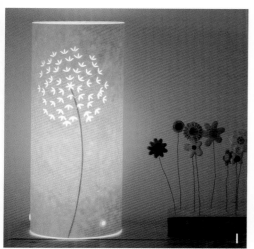

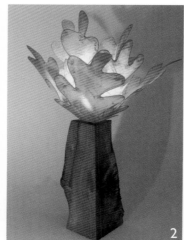

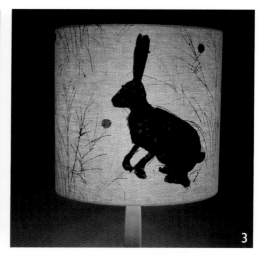

Wensley Gallery

The Wensley Gallery is housed in a grade II listed building in the heart of Ramsbottom, a bustling unspoiled Lancashire village with many specialist shops and a variety of places to eat, just 12 miles north of Manchester.

The gallery was first established in 1995 after the proprietor was introduced to the lady who ran Bury Art Society. On the opening of the gallery she became the art director for the next four years and still exhibits in the gallery along with many of the original artists.

With up to five individual exhibitions each month the gallery is able to introduce new artists along-side the more established exhibitors, keeping the gallery fresh and vibrant.

Within the gallery's 2,000 square feet you will find an extensive range of original art to suit all pockets and tastes. With paintings, embroidery, woodturning, ceramics, metal sculpture and jewellery almost every medium is represented. Having four general exhibitions and up to 60 individual exhibitions each year the gallery is constantly changing. Everything in the gallery is hand crafted so you are sure to find a totally individual addition for your home or a special gift.

6 - 8 Market Place
Ramsbottom
Bury
Lancashire
BL0 9HT
T: 01706 824772
E: staff@wensleygallery.co.uk
www.wensleygallery.co.uk
Open: Mon - Sat 10am - 5pm,
 Sun 10am - 4 pm

Aileen Barnard

I enjoy painting in my local area of Calderdale, not perhaps the prettiest bits but places of local history, the terraced streets and mills and railway stations. I love to walk in these places accompanied by my two dogs, it feels like stepping back in time.

I often paint in sepia where I can pick out the dark and light without the distraction of colour and in the finished painting it ages a modern view and reminds me that an older generation would have seen the same view, nothing really changes. When using colour I like to find something unexpected which adds to the scene.

Ramsbottom provides a wonderful day out for visitors. Peel Tower and Holcombe Hill provide breathtaking views of the surrounding countryside. For those wishing to combine a love of walking with art there is the Irwell Sculpture Trail, the largest public art scheme in the UK, with one of the major works, the 'Tilted Vase' situated outside the Wensley Gallery. There is also the East Lancashire Steam Railway that connects the village with Bury and Rawtenstall.

Carl Marsh

Each piece of jewellery designed by Carl is a piece of hand-crafted jewellery. Each piece is individually crafted using traditional techniques and finishes that make the pieces one off's.

When designing a piece he takes his inspiration from the things around him. That may be the latest trends, nature, people or striking lines of architecture.

He takes simple parts of the inspirational materials and turn them into unique hand crafted pieces of jewellery. Each piece is constructed with care and precision making the client feeling very special.

Barbara Webster

Working precious metals, is a process in which organic forms can, emerge before your eyes. Silver transforms under an intense heat allowing the imagination to play freely. Pure silver gradually builds up, like hoar frost, on the surface of the piece. Necklaces can twist and taper, starting out as blocks, becoming something far more sinuous as they are worked upon. Stones are added, as is gold foil, for intense colour and contrasting texture. The more controlled process of etching adds a three dimensional, decorative quality, creating recesses for further patination.

I have consciously avoided one single 'look' or style. I find inspiration all around me and also in our rich history. The medieval period, with its bold use of colour and imagery are a constant inspiration, as are the fabulous 'Treasure Hoards' of the Vikings and Anglo Saxons.

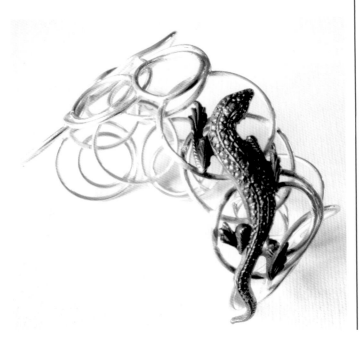

Bill Barnes

My inspiration comes from the infinite variety of patterns found in nature the grain of different woods its tactile surfaces and textures.

I work with English hardwoods and exotic hardwoods sourced from sustainable sources around the world.

My work includes bowls, hollow forms, platters, coloured, textured, carved and pierced pieces.

I can also make pieces to clients designs and specifications.

Robert Cox

Robert is a full-time and prolific artist, working primarily in oils he often introduces other mediums, including his own hand-made glass, and uses his own canvas sculpting techniques to achieve a desired effect. The peaceful location of his studio ensures minimal distractions and enhances Robert's ability to follow the creative flow and nurture the flux of ideas, the fusion of imagination with natures' influences as each painting evolves. His pieces can be powerful vibrant and colourful, or he may use simple gestures of lines and glass to create subtle and spacious compositions.

Chris Haworth

I am a self-taught artist, which has led me to achieve an individual style in all the mediums I work in. I love to paint vibrant, dramatic scenes with a sense of scale and depth. To me, the flick of a brush can say so much and is a powerful means of communicating my passion for painting. Mood and atmosphere are the very essence of how I like to portray my work and hope you get a sense of that in my paintings. Painting is a very deep passion for me and I enjoy the process, which at times can be just as painful as it is joyous.

Leo Carroll

My paintings have always attempted to convey the visual image using a personal colour interpretation without allowing too much intrusion of detailed drawing. The expression of colour interpretation, allied with closeness in tone values is now more important. "

Within his strong and confident paintings Leo always attempts to convey this approach in his paintings. Leo has always held texture, colour, and closeness in tone value to be of the up most importance. This has evolved through a desire to express feelings regarding the situations and experiences that have formed his life.

He exhibited several times in the Paris Salon Spring Exhibition and won an award in 1974 for his painting "Disagreement". He exhibited for over 25 years with the ROI at the Mall Gallery. He also exhibits with the Manchester Academy of Fine Arts, and has been an elected Academician of the Royal Cambrian Academy since 1984.

Rene Cryer

Rene's work manifests in many forms, creating a wide range of ceramic pieces including dishes, mirrors, water features, tables, vases and sculptures. Her work is decorative rather than functional and can have a range of finishes – shiny, matt, satin or even painted with a stone-like paint finish.

Much of her work is inspired by plant life, birds and fish, giving her ceramics an organic character both in form and colour. Rene has a personal style which is instantly recognisable, and collected by many, and is constantly coming up with new ideas – so look out for them.

Norman Eames

All my work utilises the mediums of wood and resin to produce a wide range of effects, combining the natural beauty of wood, from natural twig or log sections and commercially available hardwoods, with the brilliant colour possibilities available from pigmented resins.

All my work is original and hand made and includes functional items, such as coasters and candle holders, to the purely artistic sculptures and pictures.

Lita Narayan

Lita is a Lancashire based artist who has developed her very detailed perspective drawing techniques into an abstract art form.

She uses acrylic paints and a texture medium to create a collage of shapes. These range from very simple and elegantly balanced compositions to extremely abstract and involved city landscapes, which fire the imagination of the observer.

Lindsey Leeks

Lindsey is a versatile artist who has an approach which is perhaps derived from her background in graphic art and print-making. Her beautiful landscapes usually concentrate on Lakeland, Scottish, and Yorkshire scenes using seasonal and climatic colour changes as her inspiration to create mood and atmosphere in her paintings.

In contrast to her landscapes, Lindsey's floral paintings are much looser in style, which are collected and much admired in the area. There are a number of contemporary floral water colourists who have inspired her to experiment and develop her own particular approach.

Sue Jenkins

I'm mostly self taught although I've attended a few adult education classes, initially with the purpose of teaching children the delights of clay work. After acquiring a kiln, and giving up 'proper work' to have a family, I started making and selling work (ideal flexibility!) from Holmfirth craft market, this was an incentive to develop more work. As the family grew so did my passion for pottery and I started teaching adults the joys of clay 14 years ago at the local centre (which I'm still doing to this day). I have worked with some schools with mentally and physically disabled adults on specific projects, including the first piece for the Holme Valley Riverside Way.

I have been a regular exhibitor at Potfest and an exhibitor and organiser at Holmfirth Artweek for many years. I'm a member of the Northern Potters' Association and supply about a dozen shops and galleries.

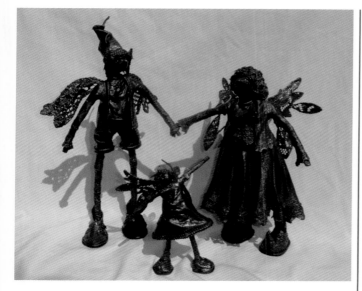

Karen Williams

Karen's work is all self taught; she deliberately avoided training so she could develop her own individual style. Her sculptures are all 'one-offs', so you are guaranteed to be getting a truly original highly collectable work of art. Karen's sculptures aren't meant to show an accurate representation, but more the spirit and character of the subject, with a touch of humour.

Karen works with a combination of recycled material and wire, which are treated to make them solid and hard-wearing, making them suitable for both home and garden, being weatherproof all year round.

Although her pieces may look fragile they are in fact very sturdy. Karen's sculptures include her ever popular fairies and pixies and her increasing range of quirky animals including dogs, cats, donkeys, sheep and pigs.

Sue Navin - page 150

Scotland & the Lake District

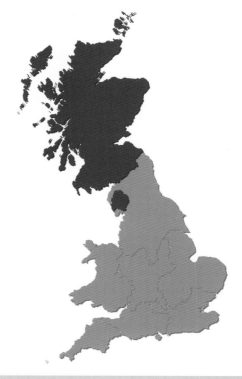

Castle Gallery

The Castle Gallery is situated in the lee of Inverness Castle. The building dates back to the early 18th century and has been sympathetically restored to provide an ideal gallery space on two floors.

The constantly changing exhibitions feature contemporary paintings, sculpture, hand-made prints, crafts and designer jewellery. A close relationship with key gallery artists ensures the finest possible selection of works from both established artists and emerging talent.

The Castle Gallery was described in the Independent newspaper as one of the best reasons to visit Inverness. It is one of the leading galleries in Scotland and has an enviable reputation for the quality of its artists and innovation of its shows. The staff are friendly and very informative, being able to provide details on any of the artists featured.

The Castle Gallery provides a welcoming environment where visitors may browse, enjoy and purchase the best in contemporary art and craft.

Illustration: Illona Morrice *bronze*

Castle Gallery
43 Castle Street
Inverness
IV2 3DU

T: 01463 729512
E: info@castlegallery.co.uk
www.castlegallery.co.uk

Open: Mon - Sat 9am - 5pm

P
C
0%

Blackwell
The Arts &
Crafts House

Blackwell is one of Britain's finest surviving Arts and Crafts houses and is located in the heart of the Lake District. It offers more than most historic houses; several of its first floor rooms have been adapted for use as galleries, and exhibitions are held throughout the year. The gallery rooms are perfect for showing contemporary work by established as well as emerging craft-makers and displaying historical exhibitions that explore different aspects of the Arts and Crafts Movement.

As part of our commitment to the work of craft makers, our craft shop at Blackwell stocks work selected by Blackwell's curator. You will be tempted by the finest pieces of jewellery, the sleekest leather handbags, fabulous textiles and ceramics, silver, glass, wood and metalwork for the home.

Entry to the craft shop is free, some of the gallery rooms may be closed, please see our website for exhibitions and house admission prices. Blackwell participates in the Arts Council's Own Art scheme, which makes purchasing contemporary works of art and crafts affordable for everyone.

House photo: Tony West
Illustration:
Gillies Jones *glass*

Blackwell,
The Arts & Crafts House
Bowness-on-Windermere
Cumbria
LA23 3JT
T: 015394 46139
E: info@blackwell.org.uk
www.blackwell.org.uk

Open: Daily 10.30am - 5pm
Closing 4pm Nov - Mar

P
C
0%

Galleria Luti

P C 🖬 ⬧ 0%

16 Ancaster Square
Callander
FK17 8BL
T: 01877 339577
E: info@gallerialuti.co.uk
www.gallerialuti.co.uk
Open: Mon - Sat 10:30am - 5pm
Sunday 1 - 5pm

Galleria Luti is a relaxed and welcoming contemporary art gallery based in the heart of Scotland in the picturesque town of Callander.

Owners Marsha and Sandie Luti decided to open the gallery through a shared enthusiasm and passion for high quality art work, and in particular paintings, ceramics, sculpture and hand-made designer jewellery. As a result, the gallery boasts a wide selection of fine Scottish Art from some of the country's most prolific artists and craftsmen

Galleria Luti hosts a varied programme of regular, changing and often diverse exhibitions throughout the year, and welcomes all visitors.

As a family run gallery, Galleria Luti strives to offer the very best of Contemporary Scottish Art at affordable prices.

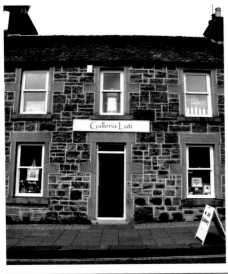

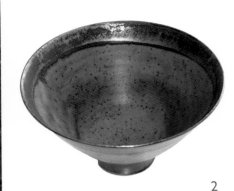

2

1. Robert Ryan - *glass*

2. Sarah Perry - *ceramics*

3. Peter Luti - *acrylic painting*

The Gallery West Kilbride

P ♿

75/77 Main Street
West Kilbride
Craft Town Scotland
North Ayrshire
KA23 9AP
T: 01294 829179
E: info@westkilbride.org.uk
www.westkilbride.org.uk
Open: Tues - Sat 10am- 4pm

The Gallery, Craft Town Scotland, showcases the work of established makers alongside recent graduates from Scotland, the UK and beyond. Established in 2005, the range of exhibitions has been recognised - it was one of the independent galleries highlighted in the Cutting Edge catalogue as "a place to see" craft in Scotland. 'Craft Town Scotland' is a community driven, registered charity that has regenerated the small rural town of West Kilbride and made it a better place to live, work and visit.

There are now eight craft studios in the town, each with its own display area including the following: silversmithing, jewellery, basket weaving, knitted, hand-stitched and felted textiles, fused glass, wool spinning and dyeing.

1. Elissa Stevens - *bone china*
2. Kirsty Eaglesfield - *silver*
3. Ruth Mae - *wood*
4. Suilven Plazalska - *jewellery*

J. Jardine Gallery & Workshop

The J.Jardine Gallery & Workshop was established in August 2008 to provide ceramic sculptor Julian Jardine with a place to work, teach and exhibit his work. The gallery now shows a selection of high quality contemporary fine art and crafts by makers in a very broad variety of fields including: painting, drawing, photography, wood, glass, jewellery, printmaking and ceramics. All the work is selected to complement the other exhibitors in the gallery with a common theme of nature, landscapes and organic forms. Prices from £10 - £1000.

The workshop area is open plan to the gallery and provides visitors with an opportunity to see Julian at work and discuss any of the pieces in the gallery in a friendly, relaxed atmosphere. Julian's ceramics concentrate on endangered species and cover a diverse array of animals. Each is individually made or created from press moulds, fired and finished in acrylics. The workshop runs regular children's and adult classes.

Situated five minutes walk from both the bus and train station in Perth, it is close to the Arthur Bell Public Library in Perth.

45 New Row
Perth
PH1 5QA

T: 01738 621836
E: info@julianjardine.co.uk
www.julianjardine.co.uk

Open: Mon - Sat 9.30am - 5pm

P
C

Juno Design Gallery

Visit this Design Gallery ideally positioned in the centre of Dunoon, Argyll. The beautiful Cowal Peninsula is happily situated on the borders of the National Forest and is easily reached by road or ferry.

The gallery was established in 2002 by Maria and Joanne Mackellar both graduates of Glasgow School of Art, specialising in textiles and jewellery design.

Drawing on their resources they acquired an exhibition space for their own work and that of other artists and designers throughout the UK introducing them to this area of Scotland. The outcome resulted in the opening of Juno Design, with a clear policy to source a high standard of contemporary art works not easily found in our high streets.

This bijoux gallery continues to offer visitors a professional and inviting exhibition space to view their fantastic selection of applied art, jewellery, textiles, prints, glass, ceramics, handmade cards and design-led gifts, including regular painting exhibitions by established contemporary Scottish artists, showcasing an eclectic mix of abstract and landscape paintings and much much more…...

Juno Gallery is a participant in 'Own Art' (typical 0%APR) The Scottish Arts Council's Scheme offering interest free loans on Art Works up to £2,000 over 10 months, details from the gallery.

Juno Design Gallery
159 Argyll St
Dunoon
PA23 7DD

P
C
0%

T: 01369 707767
E: jo@junogallery.com
View Exhibition Programme at
www.junogallery.com

Open: Mon - Sat 10am - 5pm

Open Eye Gallery

 C ♿ 0%

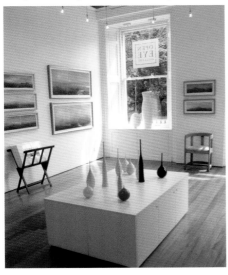

34 Abercromby Place
Edinburgh, EH3 6QE
T: 0131 5571020
E: mail@openeyegallery.co.uk
www.openeyegallery.co.uk

Open: Mon - Fri 10am - 6pm,
Sat 10am - 4pm

The Open Eye Gallery and Eye Two is situated in the heart of Edinburgh's New Town, equidistant between Scotland's National and Portrait Galleries. Applied arts are shown alongside work from new contemporaries and the established school to European and modern printmaking. For nearly 30 years, the gallery has mounted up to 25 contemporary crafts exhibitions a year, specialising in ceramics, wood, glass, jewellery and sculpture. A frequently changing programme of stock displays also features established and emerging makers. Included amongst the gallery stable of over 50 applied artists, are nationally recognised makers Malcolm Martin and Gaynor Dowling, John Maltby, Helen Carnac, Lesley Strickland, and Andrea Walsh.

Tighnabruaich Gallery

 P C ▣ ♿ 0%

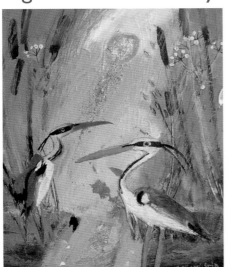

Tighnabruaich
Argyll PA21 2DR
T: 01700 811681
E: andrew@tig-gallery.com
www.tig-gallery.com
Open: Daily throughout the summer
10.30am - 4.30pm
July - August open until 8p.m
on Weds evenings only

Situated on the beautiful Kyles of Bute, Tighnabruaich Gallery provides an unexpected haven for local creative talent and offers an unusual range of jewellery, glassware, sculpture and textiles chosen for excellence in design. The gallery began as a painting sanctuary in the 1990s but moved into exhibiting pictures from well known Scottish artists such as Jolomo in the early 2001. New owners Andrew and Penny Graham-Weall plan to keep the excellent standard and reputation by supporting local artists and exploring those new to the gallery. This year the gallery is hosting a series of 7 exhibitions featuring pictures from many well known Scottish artists.

Illustration: 'Heron Pond' by Ingebjorg Smith

The Scottish Gallery

The Scottish Gallery has, over a long period, established a considerable reputation for showing the best in contemporary British, European and international objects.

We have been promoting contemporary Scottish art since 1842, exhibiting senior painters of the day alongside work by emerging talents. Situated in the heart of Edinburgh's historic New Town, the gallery also continues to deal in the paintings of many of the major 20th century Scottish artists who have exhibited with us at some point during their lifetimes.

We currently run a monthly programme of solo, mixed and theme exhibitions as well as changing displays of paintings and objects from our stable of artists and makers and exhibit at major Art Fairs and venues nationwide throughout the year.

Further details about the gallery, our artists and our exhibition programme can be found on our website, for details see below.

Illustration:
Julian Stair 'Teapot and Ten Cups on a Large Ground'.
Gallery photo: Hannah Louise Lamb

The Scottish Gallery
16 Dundas Street
Edinburgh
EH3 6HZ

T: 0131 558 1200
E: mail@scottish-gallery.co.uk
www.scottish-gallery.co.uk

Open: Mon - Fri 10am - 6pm
Sat 10am - 4pm

P
C
0%

OCG Arts

Set in the busy market town of Ambleside amidst the stunning scenery of the Lake District, OCG has over the last 15 years become one of the most respected and well known galleries in the north of England.

This spacious gallery displays on three floors all that is best in contemporary British art and craft by some of the countries leading and up and coming designer makers, the emphasis being on high quality craftsmanship and individuality.

OCG has a diverse and exciting range of glass, ceramics, furniture, metalwork, bronze sculptures and original paintings.

OCG also has beautiful, eminently wearable designer jewellery including silver with diamonds and semi -precious stones; vibrant acrylics through to wonderful Tahitian and South Sea pearls and sensational diamonds set in platinum and gold.

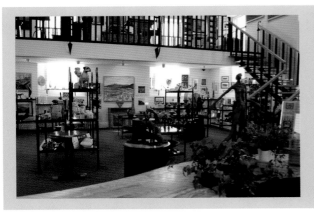

Old Courthouse Gallery
Market Place
Ambleside
Cumbria
L22 9BU
T: 015394 32022
E: andrew@ocg-arts.com
www.ocg-arts.com

P
C
0%

Open: Mon - Sat 10am - 5pm, Sun 10am - 4pm. Closed: Christmas Day, Boxing Day, New Year's Day & all Bank Holiday Mons.

1	2	3	4	5	6
Jeremy James	Alison Critchlow	Cemick and Wylder	Philip Hearsey	Rowena Park	Valerie Shelton
ceramic	*oil on canvas*	*bronze sculpture*	*bronze*	*acrylic jewellery*	*ceramic*

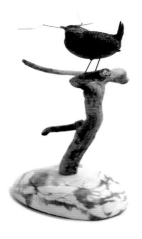

1

2

3

4

5

6

Touched by Scotland

Touched By Scotland is a relaxed, welcoming gallery selling contemporary Scottish paintings, ceramics, glass, jewellery, textiles, wood and sculpture. The 2500 sq ft facility showcases some of the best artists from Aberdeenshire and throughout Scotland.

Touched By Scotland was established in 2003 and was originally situated in a small building next door to their new purpose built premises which opened in December 2007. The new gallery, the largest venue of its type in Scotland, and adjoining restaurant, attracts visitors from all over Scotland.

Owners of the business and makers themselves, Robin Baird and Jan Hobbs, are genuinely interested in promoting traditional craft and raising awareness of the quality and quantity of handmade goods being produced in and around North East Scotland. "Touched By Scotland is a truly different shopping experience where you will find things that you just can't find anywhere else...and nothing that you will find everywhere else; and that goes for Gadie's Restaurant, which is situated next door, too", says owner Robin Baird.

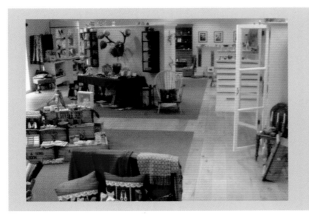

The Village of Oyne
Ryehill
Oyne
Aberdeenshire
AB52 6QS

T: 01464 851489
E: info@touchedbyscotland.com
www.touchedbyscotland.com

Open: Mon - Sat 10am - 5pm, Sun 1pm - 5pm

P
C

Edward Smith

Edward Smith was born and brought up in the busy fishing town of Buckie on the Moray Firth Coast of Scotland. The traditional fishing boats of the area have provided life long inspiration for his artistic work. Edward Smith trained in Graphic Design at Gray's School of Art in Aberdeen and went on to a career in Education.

Since graduating in 1965 Edward has exhibited paintings and prints throughout the United Kingdom, and has work in private and public collections around the world.

Edward first began making model boats 30 years ago as toys for his three young children. Since then the models have developed into a range for adult collectors. The models are now sold in museum shops, art galleries and design-led gift shops across the United Kingdom. Edward began his series of Fishing Boat Prints in order to capture and record the declining Scottish Fishing fleet, of which no other such visual record exists.

In recent years the fleet has been reduced in size. Some boats have been laid up, some sold off. Sadly, many have been decommissioned and destroyed. The main casualties have been those sturdy wooden-hulled vessels built in the 1940s and 1950s.

Kim Bramley

Kim graduated with a BA Degree in Fashion and Textile Design from Central St Martins School of Art in London before working as a freelance fashion and textile designer in Germany, France, Spain, New York and with Zandra Rhodes in London..

In 1992 she set up her own business making and selling handmade paper and cards before deciding she wanted a change of medium. Living on the Isle of Skye and excited by colour and light she decided to explore glass design and found she could fuse glass in a small pottery kiln that had been given to her.

In her work she plays with colour and describes 'the incredible beauty and grace of light which is created by the mysterious, sometimes harsh, yet enticing environment of Skye' as her constant influence.

She fuses layers of coloured glass to create plates, brooches and large glass hangings for interior spaces as well as double-glazed architectural panels to be used in windows and doors.

The Whitehouse Gallery

The Whitehouse Gallery is a contemporary art and craft gallery, based in the historic town of Kirkcudbright, South West Scotland. Kirkcudbright is known as an Artists' Town as it used to be a thriving artists' colony, and home to many a distinguished artist such as E. A Hornel. The town today is alive with its own generation of painters and craftworkers, making it a very exciting place in which to find creative talent. Kirkcudbright itself is a beautiful place, with its painter friendly light, rows of pastel coloured town houses, surrounding coastal landscape and breathtaking countryside which give it a certain charm to set it apart from other locations.

Since opening in 2004, The Whitehouse Gallery has gained a solid reputation for being a premier art and craft gallery in the region. With a friendly and inviting atmosphere, the aim is to exhibit high quality, contemporary art and craft from both established, as well as up-and-coming artists, in seven changing exhibitions throughout the year. Besides paintings, the gallery has a varying collection of original craft pieces, which include sculpture, ceramics, glass, furniture, basket-work and jewellery.

47, St Mary Street
Kirkcudbright
DG6 4DU

T: 01557 330223
E: rosie@whitehousegallery.com
www.whitehousegallery.com

Open: Mon - Sat, 10am - 5pm
 also on occasional Sundays, please phone ahead to check

P
C
🖼
♿
0%

Trevor Leat

Trevor Leat is one of the foremost creators of willow sculptures in the UK. Using traditional techniques combining beauty with functionality, Trevor Leat has been weaving willow to great effect for over 30 years. From lifesize animals and figures, through to giant willow sculptures. His works have been paraded and spectacularly burned at festivals and events such as The Wickerman Festival, The Edinburgh Hogmanay Celebrations and The Burns Light Festival in Dumfries. Based in Galloway, Trevor's work is always on show at The Whitehouse Gallery, from baskets, platters and small sculptures right through to life size sculptures.
Photo: Kim Ayres

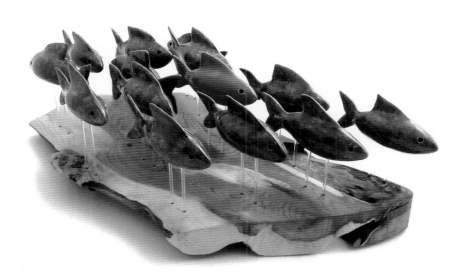

Urpu Sellar

Urpu Sellar was born in Finland, but moved to Galloway in 1980. Although she studied textile design and weaving, Urpu began pottery by chance in 1992, after failing to find bathroom tiles that she liked. She went on to experiment with clay, making slab-built bowls and then fish to hang on the wall. Combining the ceramic fish with wood, metal, glass, acrylic and anything else suitable, her work has since developed into three dimensional sculptural forms. Urpu now exhibits nationwide and her work is regularly shown at The Whitehouse Gallery.

Portfolio Graduates

In 2002 I included a section called Signpost at the end of the sixth edition of the Craft Galleries Guide. This was to allow new or graduate makers, not yet showing work with galleries, to have a chance to introduce their work. As I hosted them (rather than a gallery) I included Burton Cottage Farm as their contact.

It was a great success and a large number took part. The following year I created a new booklet called the Second Steps Portfolio, this gave new makers the opportunity to have whole page to promote themselves. Several editions of the Portfolio were published and mainly supplied to gallery owners. Lynn Walters explains how this helped her in her essay on page 35.

This selection of graduate makers, who have continued with their chosen career, is just a taste of those who took part in earlier booklets. Many of those are also successful, some have changed direction and others are still trying to find a starting point, I wish them all well.

Burton Cottage Farm
East Coker
Yeovil
Somerset
BA22 9LS

T: 01935 862731
E: cm@craftgalleries.co.uk
www.bcfbooks.co.uk

1
Lesley McShea
ceramic

3
Angie Young
*stacked cast willow
rings*

2
Kirsty Taylor
silver arboretum cuff

4
Sarah Lamb
*La mbbauble
necklace*

5
Natasha Kumar
*'The Conversation'
Oil on board
16"x24"*

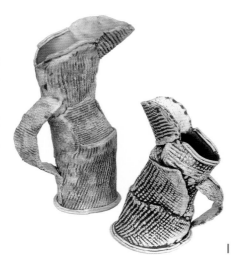

1

2

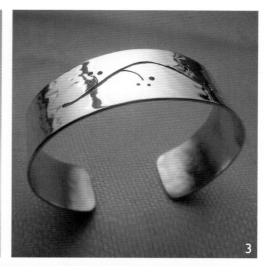

3

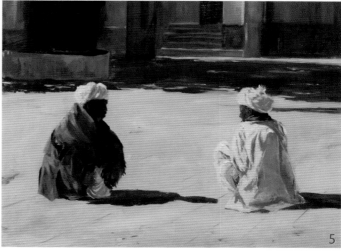

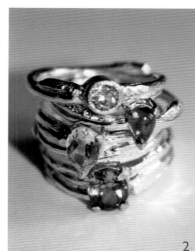

4

5

1 - www.lesleymcshea.com
3 - www.angieyoung-designs.com
2 - www.kirstytaylorjewellery.com
4 - www.sarahlambjewellery.co.uk
5 - www.natashakumar.co.uk

Carolyn Corfield

1

E: ccsculptor@btinternet.com

Carolyn Corfield is a mixed media sculptor specializing in small to life size figurative ceramic pieces, both wall mounted and free standing.

 Her work can be boldly contemporary but it is often seen as elemental and linked to myth. Carolyn exhibits throughout the UK and undertakes commissions, her work featuring in collections world wide.

1. 'Shaman Journey'
2. 'Antipodean'

2

Silver Kitsune – Heather Fox

www.silverkitsune.co.uk

The Sumptuous Silver Collection started off life as a selection of drawings of nature, leaves and plants. I've taken these drawings and translated the drawn line and transferred it into the metal. As this collection has evolved I have found I enjoy making pieces that can be worn in an unusual way, such as a brooch that is a necklace or the dual length necklace that can be worn full length at 32" or short at 16". I may have to change the name of the collection though as I've started to play with different coloured metals.

 I always colour in my sketchbook, whether it's doodling or designing a new range. It seemed like natural progression to use this colour within my jewellery. The Colour Feast collection takes a touch of inspiration from nature, added with a spot of texture and mixed with a splash of colour and just a subtle hint of Japanese and finally added to silver to create a playful collection of jewellery that is a colour feast for the eyes.

Sue Rawley

Sue began work as a graphic designer and illustrator, and in the 1980s turned to metalwork. Inspired by all things botanical, dragonflies and insect life, her pieces flow creatively into metalwork designs. She creates mirrors, frames, caskets, boxes, book bindings, and furniture, all embellished with semi precious stones and crystals sourced from around the world. Working from her West London studio/workshop, she offers a full design service with clients to their own specifications. Viewings can be arranged by appointment.

www.suerawley.co.uk

Lynn Walters

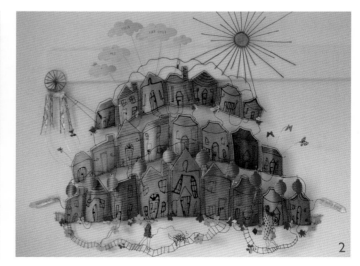

1. Houses 2. Festival www.lynnwalterssculptures.co.uk

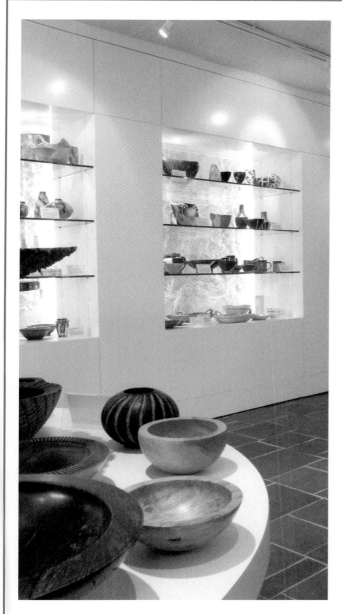

T.H.MARCH
INSURANCE BROKERS SINCE 1887

Craft Galleries Insurance

For full details contact:

T.H. March & Co Limited
Hare Park House
Yelverton Business Park
Yelverton
PL20 7LS

Tel: 01822 855555
Fax: 01822 855566
E-mail: insurance@thmarch.co.uk
website: wwwthmarch.co.uk

TH March is a trading style of
TH March & Co Limited
TH March & Co Limited is authorised and
regulated by the Financial Services Authority

Picture courtesy of the Devon Guild of Craftsmen
E-mail: devonguild@crafts.org.uk
website: www.crafts.corg.uk

designGAP was established in 1980 by designer/artist Shirley Frost. Thirty years on it is still
renowned for promoting the excellence of its selective variety of
independent designer-producers and artist-makers.
www.designGAP.co.uk
this comprehensive website is a mini search-engine for finding some of the best of British.

CRAFTS

THE MAGAZINE FOR CONTEMPORARY CRAFT

7 issues at the price of 6 for new subscribers only.

Quote GUIDE-09 for your FREE issue.

Subscribe with Direct Debit and receive a £3 discount on your first year's subscription – just £31 (UK clearing accounts only).

DIRECT Debit

SUBSCRIBE NOW & GET YOUR FIRST ISSUE FREE

Telephone
+44 (0)20 7806 2542
Email
subscriptions@craftscouncil.org.uk
Website
www.craftsmagazine.org.uk

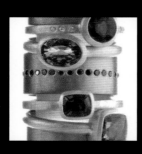

Gallery Index

274

A automata, **Ac** acrylic, **B** baskets, **Bk** bookbinding, **Cal** calligraphy, **C** ceramics, **Cl** collage, **DD** decoy ducks, **E** enamel, **E/P** etchings, prints & woodcuts, **F** furniture, **G** glass, **J** jewellery, **L** leather, **Li** lighting, **M** metalwork, **Mx** mixed media, **P** paperwork, **PM** papiér mâché, **Ph** photographs, **SC** sculptural ceramics, **S** sculpture, **Sl** silver, **St** stone, **T** toys, **Tx** textiles, **W** wood
The majority of galleries also sell original paintings and many sell cards

Maker's Index

Maker's Index

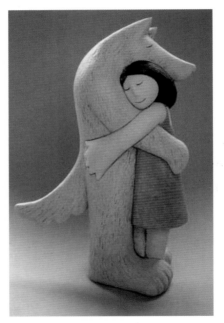

Paul Smith page 89